The Complete Guide to

DRAWING
& ILLUSTRATION

The Complete Guide to
DRAWING
& ILLUSTRATION

A Practical and Inspirational Course for Artists of all Abilities

PETER GRAY

Capella

Editorial: Diana Vowles, Nicky Hodge, Nigel Matheson
Design: Maki Ryan
Layouts: Dynamo Design

This edition published in 2007 by Arcturus Publishing Limited
26/27 Bickels Yard, 151–153 Bermondsey Street,
London SE1 3HA

ISBN: 978-1-84193-434-1

Printed in Malaysia

CONTENTS

Introduction

I often hear people say, "I wish I could draw". Perhaps you too have found yourself uttering those words. The response that immediately springs to my mind is "Why don't you?" Of all the pursuits open to us, drawing is perhaps the easiest to take up, requiring only minimal equipment: a pencil and some blank paper.

The fact is that nearly everyone draws already. Who has not sketched a rough map to give directions, or made doodles on a telephone message pad? In these activities are two of the essential elements of drawing: selection and simplification, and uninhibited mark making. The third element is observation. In ordinary life, people see what they have already learnt is likely to be there, but through the process of drawing, we overcome our expectations and notice subtleties of shape and structure, texture and pattern, light and shade. We develop sight into insight.

Drawing is a form of art, and art does not recognize boundaries or fit into neat pigeonholes. However, to make this vast and varied activity approachable, this book is divided into broad areas of subject matter. From simple object drawing we move on to tackle all aspects of our environment, people and animals. A certain amount of art theory will necessarily be introduced along the way, but I've tried to keep this to a minimum and explain things, wherever possible, through practical demonstrations.

The book is designed as a course, with each new subject following naturally from the previous one. To get the most out of it, work your way through from page one. Suitable for complete beginners, as well as those who have some experience, the book opens with the most elementary drawing exercises. You may be inclined to find you own way through the book and skip to subjects and techniques that suit your interests. With this in mind, a comprehensive index should allow you to check back to previous exercises and pick up any information you may have missed.

There is so much more to drawing than acquiring the facility to copy from a picture or object. It is also about developing your own subjects and compositions and finding individual means of expression. Unlike many other drawing manuals, this book aims to direct you towards imaginative end results, introducing in each subject area ideas for developing your sketches into various forms of illustration and design. When following the step-by-step exercises, try to resist simply copying mine. Find similar subjects of your own and work through the stages, to create new pictures rather than mere copies.

I hope to debunk some of the myths that persist around the practices and processes of drawing. It is true that some people are born with exceptional gifts, but these are rare and most artists achieve their proficiency through fascination and sheer persistence. You may look at an artist's drawings and think that they were produced effortlessly, but that's what they want you to think. Behind every successful drawing lie a great deal of thought, application and a history of mistakes and false starts. Even the most advanced draughtsman will always see their faults and strive for improvement. In that light, an accomplished artist's drawings are no different from your own faltering first steps; all are mere stages on a journey that has no end. Interesting discoveries await at every turn. The going may sometimes be arduous, but there will also be times when things click into place and you surge ahead. Above all, drawing should never be boring, so if you find a subject tedious, accept that it's not for you at that time, and move on. The best way to stay the course is to enjoy yourself. Like so much of life, what you get out of drawing is dependent on what you put in. It is an activity that calls for dedication, experimentation and play, and rewards you with self-satisfaction and a heightened appreciation of the world around you.

Peter Gray, Sudbury, 2006

THE FIRST MARKS

Before a drawing begins, the artist opens his or her sketchbook, chooses and sharpens a pencil, and then there comes a brief moment of anticipation, excitement and even fear. It takes something like courage to make the first mark on the virgin paper, but once that mark is made, the others come flowing.

This chapter deals with the first marks you make coming to the activity as a complete novice and aims to steer you around some of the mental stumbling blocks that could be awaiting you. From the very start you should aim to draw with confidence and expression, even at the expense of precision. Some very simple exercises should limber you up and get you comfortable with holding a pencil and pushing it about on the paper.

If you have some experience of drawing, much of the information contained within this short chapter will probably be familiar to you already. Whatever level you feel you are at, it never does any harm to be reminded of the basics, so I urge you to at least read the early pages, even if you choose to give the exercises a miss.

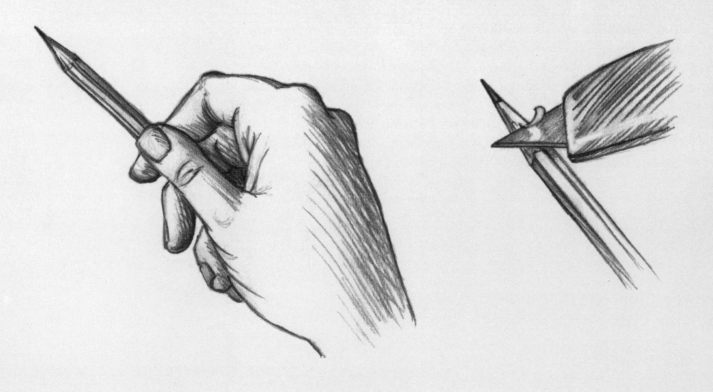

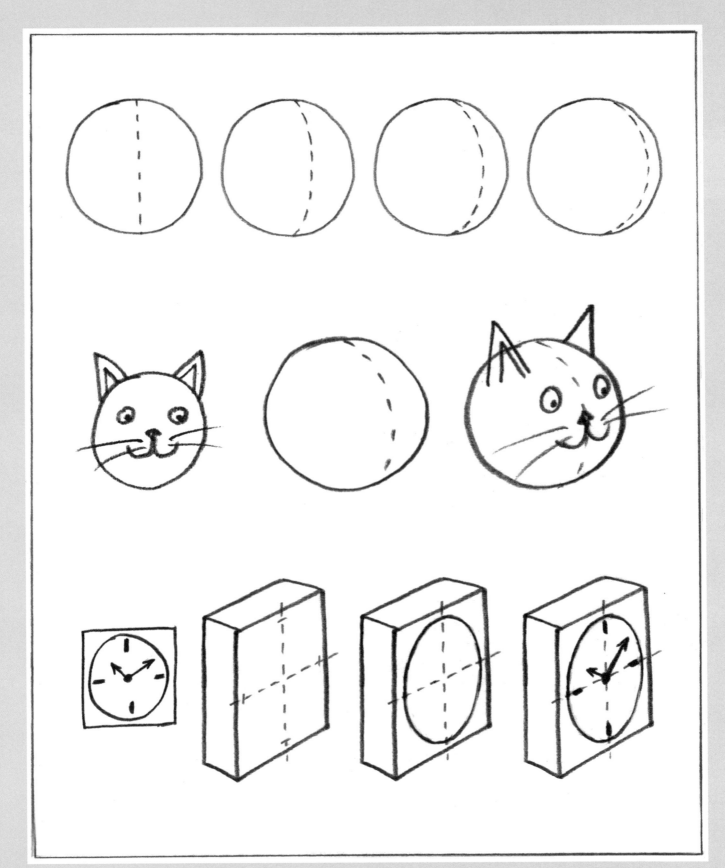

Basic materials and equipment

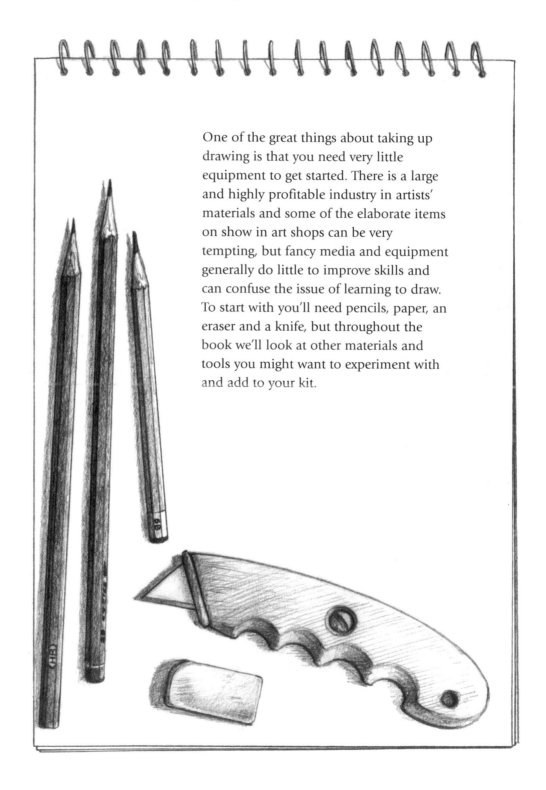

One of the great things about taking up drawing is that you need very little equipment to get started. There is a large and highly profitable industry in artists' materials and some of the elaborate items on show in art shops can be very tempting, but fancy media and equipment generally do little to improve skills and can confuse the issue of learning to draw. To start with you'll need pencils, paper, an eraser and a knife, but throughout the book we'll look at other materials and tools you might want to experiment with and add to your kit.

Pencils

Although any pencil will do for mastering the basics of drawing, cheap ones can be scratchy and unsatisfying to work with. It's well worth splashing out on a few good-quality pencils from an art supplies shop. They are graded from H (hard) to B (black) with a number prefix indicating the degree of hardness or blackness. A useful starting set would be H, HB, 2B and 6B.

Eraser

An eraser is a vital part of your kit. There's absolutely no shame in erasing mistakes and rough guidelines – they are an important part of the drawing process. Buy a good-quality eraser that is neither too hard nor too spongy; there are dozens of varieties on the market, but they all do essentially the same job. When the corners wear blunt, an eraser can be trimmed with a knife to produce a fine working edge. For fiddly erasing I often use a special eraser that comes in the form of a pencil and can be sharpened to a point.

Paper

At this stage, virtually any paper will do the job. A cheap A4 sketchpad would be good, but photocopy paper or even scrap paper will do fine. (If you're not using a pad, you'll need to find a piece of board a little larger than your paper to lean on.) The more your skills develop the more important the grade and type of paper will become, but at the novice stage expensive paper only serves to inhibit your freedom to make mistakes.

Sharpening

A sharp knife or scalpel is essential for fashioning the points of your pencils. For drawing, pencils are ideally sharpened to reveal a good length of lead, unlike the uniform point produced by a pencil sharpener. Keep the blade at an acute angle to the pencil, and always sharpen the pencil away from your body.

Before starting

Drawing is a process that involves the eye, the mind and the hand. It's important to give each of these elements the best chance to work well.

The eye

As far as possible, try to work in good lighting conditions – preferably in daylight or under bright, diffused artificial light. If you need spectacles, wear them!

The mind

It cannot be stressed too strongly that an element of enjoyment should accompany every drawing you make. You are going to make a lot of mistakes, and you will have to abandon a lot of drawings and start all over again. Try to be bold with your drawing, right from the start, and accept that errors are all part of the process.

The hand

Holding a pencil in your writing grip allows you control of small movements from the fingers. But for drawing, most movements will be made from the wrist, elbow and shoulder. Different grips will be necessary to free your pencil to make a full range of strokes. Shown here are a few of the ways a pencil might be held for different drawing techniques and effects.

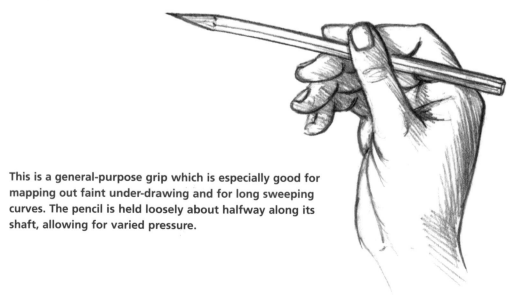

This is a general-purpose grip which is especially good for mapping out faint under-drawing and for long sweeping curves. The pencil is held loosely about halfway along its shaft, allowing for varied pressure.

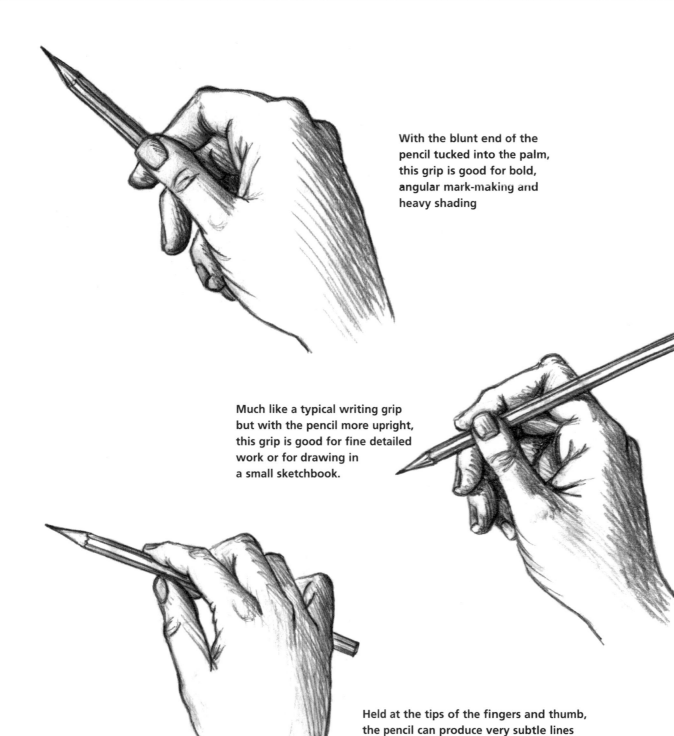

With the blunt end of the
pencil tucked into the palm,
this grip is good for bold,
angular mark-making and
heavy shading

Much like a typical writing grip
but with the pencil more upright,
this grip is good for fine detailed
work or for drawing in
a small sketchbook.

Held at the tips of the fingers and thumb,
the pencil can produce very subtle lines
and shading.

Lines and guidelines

Every drawing begins with a single line. Other lines of different weight, length, direction and shape are then added until an image emerges. If you haven't drawn for a while, take a few moments to try out these simple line exercises. They are aimed at freeing up your hand and encouraging you to be confident with the marks you make.

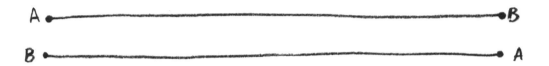

With your softest pencil (ideally 6B), mark out two points, A and B, on some scrap paper. Try drawing a straight line between them in one single fluid motion, moving your whole arm across the paper and trying to keep the pencil pressure firm and even. Then try it again in the opposite direction and up and down. Experiment with different ways of holding the pencil to see what feels natural for you.

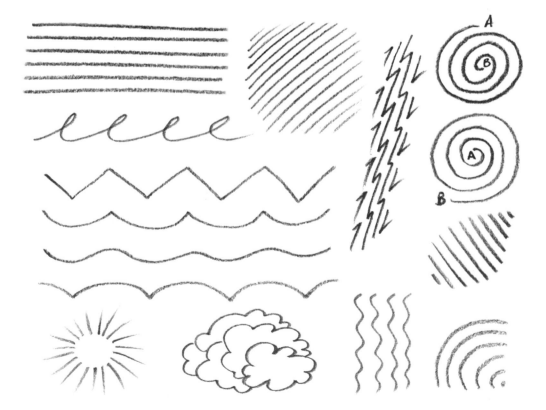

Experiment with drawing different lines, all the while keeping in mind the way you are holding the pencil and keep the movement of your hand articulated from the wrist, elbow or shoulder.

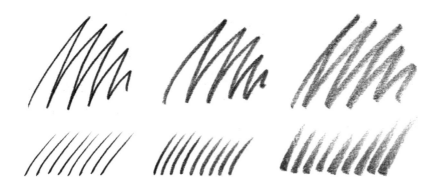

You probably noticed that the quality of your lines changed as the pencil wore down and your hand position altered. That variety can be harnessed for expressive effect in your drawings. Here are three sets of marks made with the same pencil, but with the tip held at different angles to the paper. The breadth and softness of the line can vary dramatically.

Guidelines

Very often, it is necessary to start a drawing with faint lines that act as guidelines for the stronger marks of the finished piece. This is where your harder pencils come in, to lay the foundations and do the exploratory work without making a smeary grey mess of the paper. Follow these steps and draw the lines of your own initials neatly and regularly.

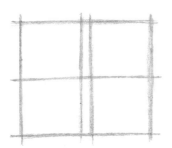

STEP 1
Start by constructing a framework. Your own initials might call for wider or narrower boxes. Use an H pencil or similar and don't use a ruler.

STEP 2
Within the framework, still using your hard pencil, draw the curves and lines that make up the letters.

STEP 3
With a softer pencil, you can now follow the guidelines with a bold touch.

STEP 4
With the guidelines carefully erased, you are left with letters that are much neater than you could have achieved without the preparatory work.

Shapes

Children's drawings tend not to be accurate, but they have qualities of directness and free expression that adults would do well to capture. Indeed, Picasso stated that he had spent most of his career striving to draw like a child. With this in mind, I want to take you back briefly to kindergarten.

With a soft pencil, fill a sheet of scrap paper with 30 or 40 simple pictures, shapes and motifs. Draw them straight out of your head, using simple lines and making each one as direct and confident as you can.

Your drawings may look something like this. While you won't want to hang it on the wall, you probably enjoyed the exercise and began to feel comfortable with the pencil. Keep your drawings for future reference; we'll return to them later.

The third dimension

The chances are that most of the motifs you drew were flat, two-dimensional shapes. In real life, objects are far more intricate and require close observation to be drawn accurately. Equally essential to the accuracy of a drawing is the creation of the illusion of solidity on the paper's flat surface.

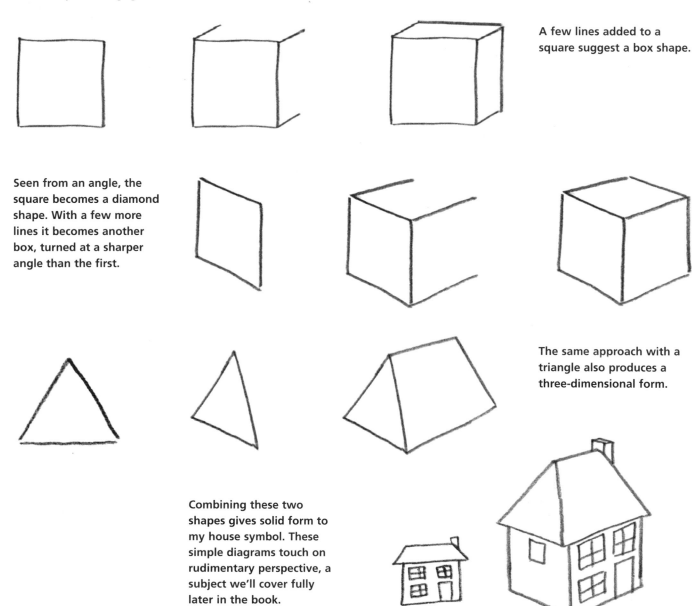

A few lines added to a square suggest a box shape.

Seen from an angle, the square becomes a diamond shape. With a few more lines it becomes another box, turned at a sharper angle than the first.

The same approach with a triangle also produces a three-dimensional form.

Combining these two shapes gives solid form to my house symbol. These simple diagrams touch on rudimentary perspective, a subject we'll cover fully later in the book.

Spheres and ellipses

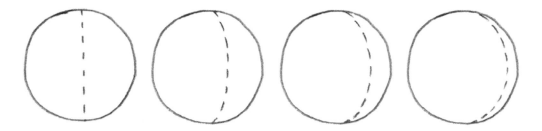

Although the overall shape remains the same, details upon a sphere will change according to our viewpoint. A line down the middle of a ball changes to a curve when the ball is turned away. The further the ball turns, the more pronounced is the curve.

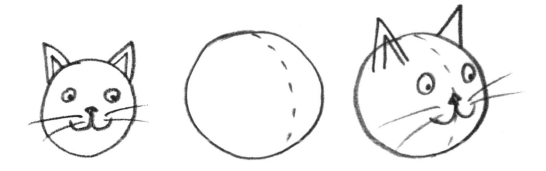

Understanding this principle allows us to construct guidelines for placing elements on a sphere's surface, such as the features of my cat symbol, drawn from a three-quarter view.

Curves like this are effectively partial ellipses. Imagine the sphere cut precisely in half. The shape inside, when viewed square on, would be a flat circle but viewed from any other angle it becomes an ellipse (oval). These can be quite tricky to draw.

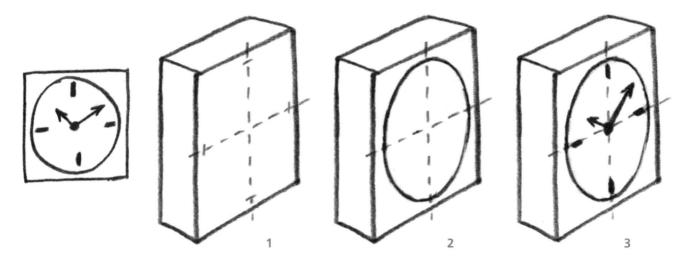

My flat clock symbol provides a useful introduction to ellipses. To draw it three-dimensionally, construct a shallow box and add faint guidelines midway between the vertical and horizontal outlines of the front. Just inside the outside edges mark four dashes, to provide the outer points of the ellipse (1). Filling in the ellipse, draw faintly or use a harder pencil at first and try to make as smooth a curve as possible, running through each of the four guide marks (2). The guidelines also serve well for placing the markings and hands of the clock (3).

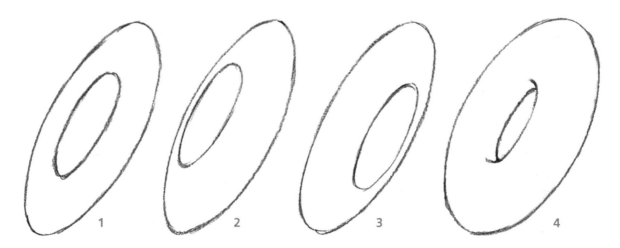

Used in combination ellipses can suggest solid forms. Moving the inner ellipse of example 1 makes the form appear to bulge in (2) or out (3). A slight adaptation to the inner ellipse conveys a convincing doughnut shape (4).

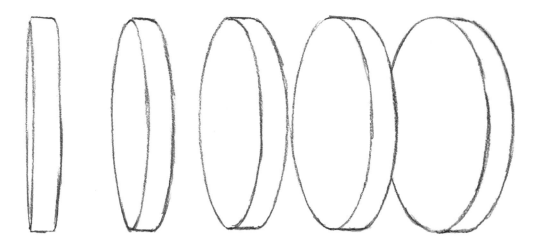

The depth and curvature of ellipses changes according to your angle of view. Think of this diagram as a row of coins balanced on edge and parallel to each other. The first coin is viewed almost side on and the others are viewed from progressively steeper angles.

Have a go at copying this simple outline drawing of a cup. Take your time to copy the curves and dimensions accurately. Draw it faintly at first, with a hard pencil.

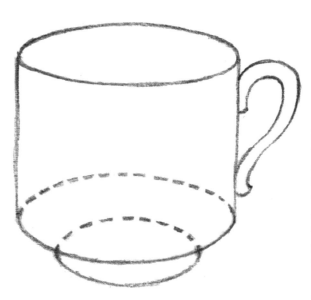

It is good practice to draw the full curve of ellipses, even when they are only to be partially visible in the finished drawing. Here you can see that the ellipse at the top of the cup is shallower than those that form the bottom. That's because of the downward angle of our viewpoint.

Common errors

Even in the most rudimentary copying exercise there are opportunities to make all sorts of mistakes Try to avoid falling into the following pitfalls when drawing the ellipses of your cup as well as its proportions and angles.

Don't allow the edges of your ellipses to be pinched into points.

At no point along an ellipse will the curve flatten into a straight line.

Don't become so focused upon getting the ellipse right that you fail to pay attention to the dimensions; the cup should be neither too tall nor too short.

With the exception of advanced perspective drawings, vertical lines should always be drawn strictly vertically This is one of the important rules of drawing, and any divergence from it will produce distorting effects.

OBJECTS & OBSERVATION

Leaving elementary theory behind, we need practical subjects to draw, and so we turn to still life. This is a convention that goes back at least as far as Roman times and refers to small collections of inanimate objects arranged in a decorative fashion. As the term suggests, a still life is drawn from life – in other words, it is observed rather than conjured from the imagination.

Making successful observational drawings begins with the act of seeing. In our daily lives we necessarily react quickly to what is around us, but when drawing, we have to slow down, not just look at a subject, but really see it, as if for the first time. Take another look at the page of simple symbols and shapes you drew (page 16) and compare your drawings to the real objects, which are, of course, infinitely more complex than your quick approximations of them.

As you progress, the activity of drawing and scrutinizing will enrich your perception of the visual world. The better you train yourself to see, the more fascination you will find in even the most mundane things around you.

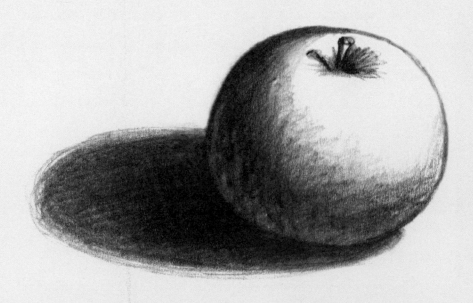

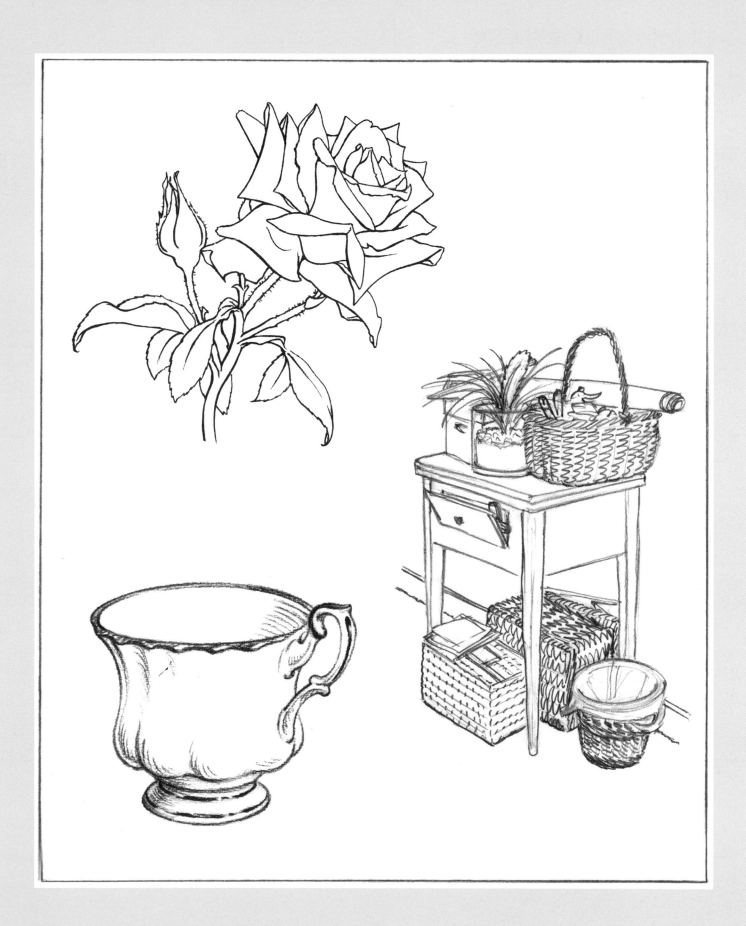

Line drawing – boxes and cylinders

There are a great many methods, rules and hints that will eventually help you to make fully realized observational drawings, but that would be too much to take on board at this early stage. For the time being, it's best to restrict ourselves to drawing the bare outlines of objects.

Line drawing is about leaving out surplus detail in order to produce pure descriptions of form, a process of simplification, but not necessarily unsophisticated.

As the example of this cup shows, it is possible to convey a lot about an object's decorative form as well as suggesting solidity, tone and lighting using nothing more complicated than line.

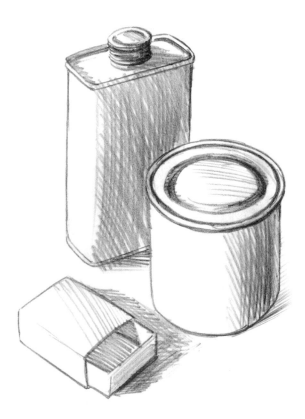

For our first exercise in line drawing, find two or three simple objects similar to mine: manufactured, boxy and cylindrical. Place them on a tabletop, directly in front of you, at least an arm's length away.

Take your time here because many important drawing techniques will be employed and explained over the course of this exercise.

Make sure that you are sitting comfortably and can see both your paper and your subject without moving more than your eyes and head. Lean your sketchpad against the tabletop so that you are looking at it full on. (With your paper flat on the table you would view it from an angle, which would lead to distortions in the drawing.)

You may find a small drawing board helpful. With your paper fixed to it, you can rest it in your lap so that you need not hold it steady with your other hand. A piece of light plywood about 30cm x 50cm (12 x 20 in) is ideal, but any flat board will do.

STEP 1

Using a hard pencil (H or HB), lightly sketch the general mass of the objects. Make sure that each object is roughly the correct size in relation to the others. Try to fill the paper; don't restrict yourself to a small area in the middle of the sheet, which will tend to make your drawing tight and stilted from the start.

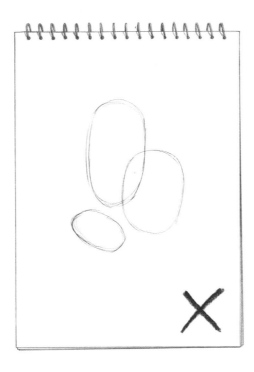

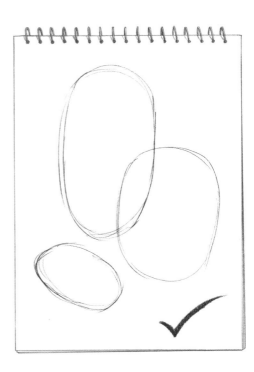

STEP 2
This step is crucial to making a successful drawing. Here you have to map out the essential lengths and angles of the lines that will provide a frame for the rest of the work.

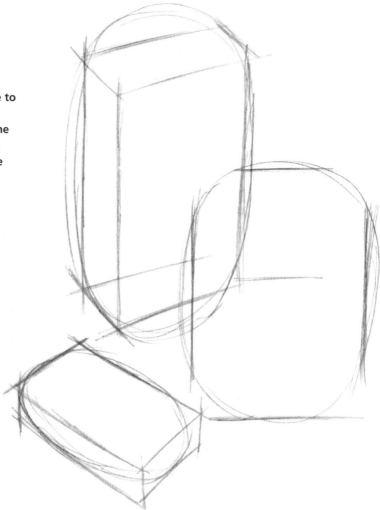

Judging the angles

As we have seen, vertical lines should be drawn strictly vertically. Other angles can be trickier, but your pencil can be used as an aid. Hold it vertically about 30cm (12in) in front of your eyes then tilt it left or right until it lines up with an object. Holding that angle, move the pencil down to the relevant area of your drawing.

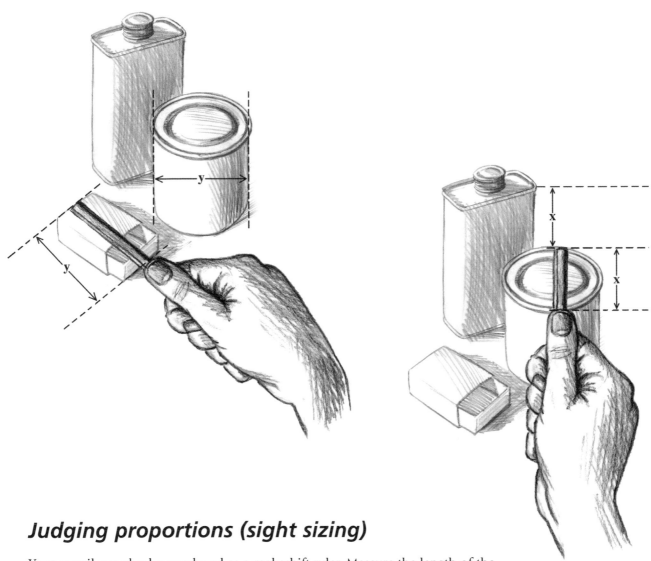

Judging proportions (sight sizing)

Your pencil can also be employed as a makeshift ruler. Measure the length of the object as it appears along your pencil and mark the length with your thumb. That measurement can then be used to check the relative lengths of other lines. You can see from my picture that, from my angle of view, the total length of the matchbox is about the same as the width of the round tin. The depth of the large ellipse is about the same as its distance from the corner of the tin above it. Each dimension can be checked against others.

STEP 3

Having measured the width and height of the large ellipse, it was quite easy for me to add a smooth curve within the lines already drawn. Drawing a full ellipse for the base of the tin helped me to make the curve smooth and also to check that the tin sits comfortably in front of the oblong tin.

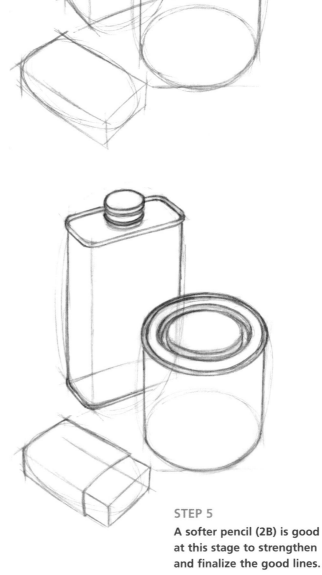

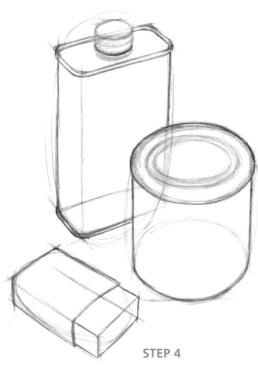

STEP 4

With the hard work out of the way, I can enjoy refining the details.

STEP 5

A softer pencil (2B) is good at this stage to strengthen and finalize the good lines.

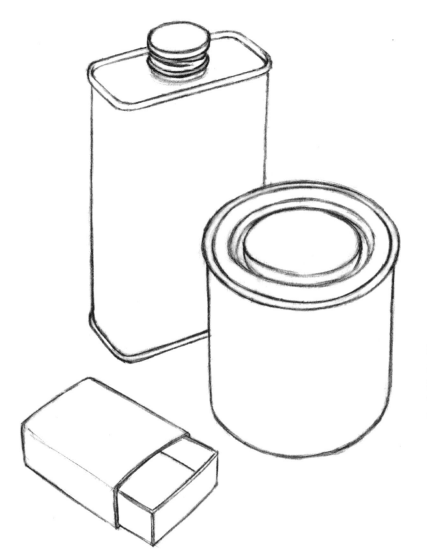

STEP 6
All the scruffy marks, mistakes and guidelines are removed carefully with an eraser. Use the corner of the eraser for detailed work.

Keeping it simple

This is the simplest form of line drawing, showing only outlines and constructional details. Do not be tempted to add anything more to your drawing at this stage, but try to appreciate the simplicity of line. In my drawing I erased the guideline separating the two faces of the oblong tin, but the angles and curves of the upper and lower rim are enough to describe a curved edge. Although there is no design or text on any of the objects, their shapes and relative sizes tell the viewer what they might contain.

An artist can never draw every minute detail of a subject and decisions will always have to be made about what to leave out. It can be useful sometimes to remember just how little information is needed. It's a good rule of thumb to always lean towards making fewer marks rather than too many.

Organic form

So far the objects we have drawn have been man-made, or synthetic, and regular in form. As you will have discovered, there is a degree of discipline involved in drawing them accurately. Natural, or organic, objects are less rigid in form and can be less exacting to draw. Because apples, for example, vary in size and shape you need not draw the contours with precision to produce a convincing drawing of an apple.

For this exercise, gather a quantity of fruit and vegetables, preferably fairly smooth in shape and texture, and place them in a bowl. Take some time organizing them so that the arrangement is pleasing to the eye.

A drawing usually starts with the broad masses, the artist working towards smaller details as the drawing progresses, and the steps here follow that traditional pattern.

STEP 1

With a hard pencil, map out the rough shapes of the items in your still life. Remember to draw the complete ellipse of the bowl and to fill the page with your composition.

STEP 2

It is important to draw the ellipse of the bowl accurately as it is the largest element within the picture; just as it holds the vegetables inside it on my tabletop, it also holds together the ingredients of the picture. Here I've drawn a frame around it to help me draw the curves symmetrically and evenly.

STEP 3

With the bowl in place, you can relax and enjoy working on the shapes of the vegetables. Roughly following your initial guidelines, study the shapes and sizes and refine them, still drawing quite lightly. Don't be afraid to move the paper so that your hand can naturally follow the curves.

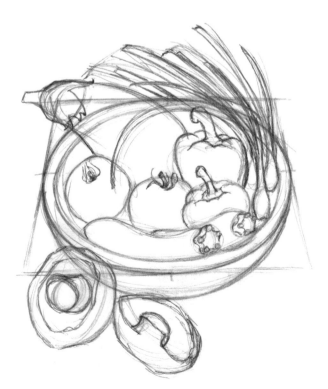

STEP 4

Now work on the details of the stalks, which give the individual vegetables identifiable characteristics. Study each stalk to see how it is constructed.

STEP 5

When you're quite happy with your basic drawing, erase the guidelines and rough marks. Try to think of your eraser as a drawing tool, drawing white paper inside the shapes you have made. With complicated areas, such as the stalks of the spring onions, keep looking at the subject so as not to erase the good lines.

STEP 6

Continue the process of firming up the lines and cleaning up the drawing. Switch to a soft pencil, and sharpen it regularly. Try to vary the outlines for the different items: wobbly lines, smooth curves, sharp edges, and anything else that seems appropriate to capturing the essence of each shape. The other important thing here is to draw the lines boldly. You've done all the tentative work, and now you have the satisfaction of using a soft pencil with confidence.

TIP

It's all too easy to smudge a drawing with your hand as it moves across the paper, especially when you are using soft pencils. As you get towards the end of a drawing, lay a clean piece of paper between your hand and the drawing.

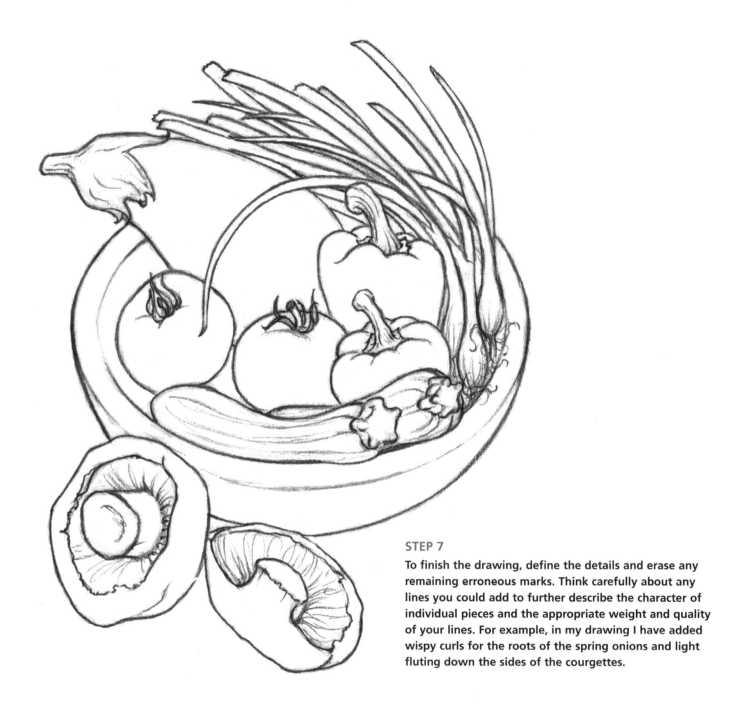

STEP 7

To finish the drawing, define the details and erase any remaining erroneous marks. Think carefully about any lines you could add to further describe the character of individual pieces and the appropriate weight and quality of your lines. For example, in my drawing I have added wispy curls for the roots of the spring onions and light fluting down the sides of the courgettes.

Though it is not noticeable, my drawing is not completely accurate to the objects on my tabletop. For example, I drew the main stalks of the spring onions and then made up the others. My aim was to convey the distinctive qualities of the different objects. It is unnecessary (and less enjoyable) to get bogged down with precision when the picture does not call for it, and the more you practise, the more short cuts you will discover or invent.

Composition

Composition is the most important single factor in a picture's success or failure. In simple terms, this means the relative placement, scale and weight of elements within a picture. With a strong composition a picture will never be a complete failure, however badly handled the final result may be; but a weak composition will never make for a great picture, no matter how much care is lavished upon it.

The pictures featured so far in this book have been vignettes, in other words objects of free shape that are not contained or truncated by the sides of a frame. In this first examination of composition, let's look at the arrangement of objects for a pleasing still life vignette.

A loaf of bread, a block of butter and a jar of spread. This layout might be appropriate for a grocery catalogue, but it makes for a dull picture.

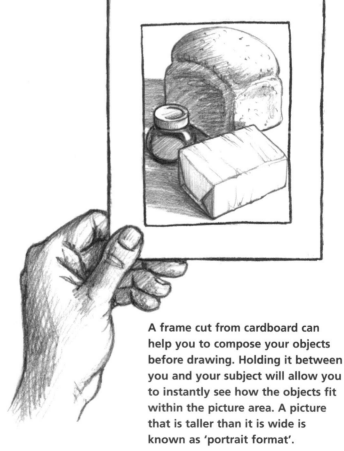

Turning the objects greatly improves this arrangement. It shows more of their surfaces and details and also brings more interesting angles to the picture. The objects overlap, which unifies them as elements within a single image rather than separate entities. But the picture still looks weak.

A frame cut from cardboard can help you to compose your objects before drawing. Holding it between you and your subject will allow you to instantly see how the objects fit within the picture area. A picture that is taller than it is wide is known as 'portrait format'.

After some trial and error, I arrived at a more pleasing arrangement within the bounds of the rectangle.

Here I've used the frame the other way round. This is known as 'landscape format'.

It's important for a composition to have a sense of balance. Here the objects are literally balanced on top of each other and the symmetry of the arrangement gives the picture balance too – but it's very dull.

Even though the objects themselves might look a little precarious, the picture retains a balance because there is about the same amount of space around the objects on either side.

Pictures can be composed using more than one device to achieve balance. Here an arc is employed within the rectangle.

This composition is square in format and employs a spiral to arrange the objects.

In this section I've only touched on the possibilities for arranging three simple objects. Try basing compositions on triangles, circles, pentagons and other geometric shapes; the geometry will probably not be visible in the finished drawing but such devices can give your picture a sound foundation. They also help you to make decisions when you are faced with a daunting range of compositional options.

Texture

We have touched on the way that lines of different weight, thickness and quality, even in an outline drawing, can help to describe different objects by conveying something of the surface along with the shape. The suggestion of texture is one of the more subtle, yet highly effective, means of expression in drawing.

To make a textural still life, gather some objects that are varied in their surfaces and forms. I've chosen to mix organic and man-made objects and keep them within a theme. Whatever objects you choose to draw, there are no definitive rules about what marks you make to describe them. Observe surfaces closely and devise your own shorthand. The important thing is that you keep the different surfaces distinct from each other, and you may even find yourself exaggerating the qualities of the marks you choose to make.

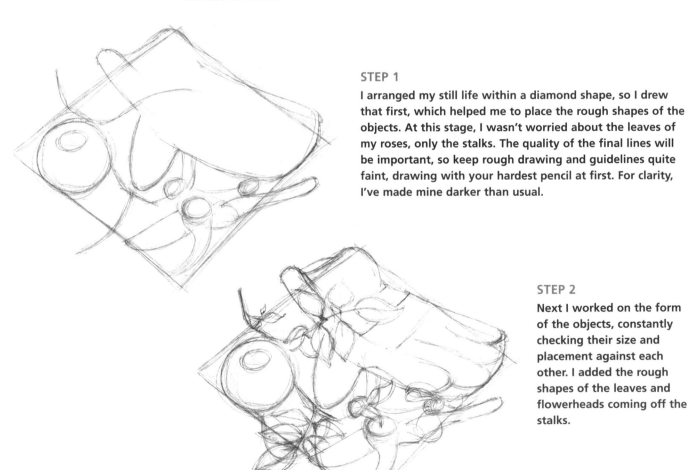

STEP 1

I arranged my still life within a diamond shape, so I drew that first, which helped me to place the rough shapes of the objects. At this stage, I wasn't worried about the leaves of my roses, only the stalks. The quality of the final lines will be important, so keep rough drawing and guidelines quite faint, drawing with your hardest pencil at first. For clarity, I've made mine darker than usual.

STEP 2

Next I worked on the form of the objects, constantly checking their size and placement against each other. I added the rough shapes of the leaves and flowerheads coming off the stalks.

STEP 3

Once I was happy with the general shapes, it was quite easy for me to add and refine details. I paid particular attention to the direction of the string wrapping around the ball. Remember that all this work should be drawn quite faintly.

STEP 4

At this stage, I cleaned up the drawing as much as possible, carefully erasing any unwanted lines and marks. I also worked on some of the finer details of the string, secateurs and flowerheads. I wanted to set every element of the drawing in place before the finished line work.

It is surprising how much plant material moves as it dries out. There comes a point in a drawing when you have to settle on the shapes and positions of such things.

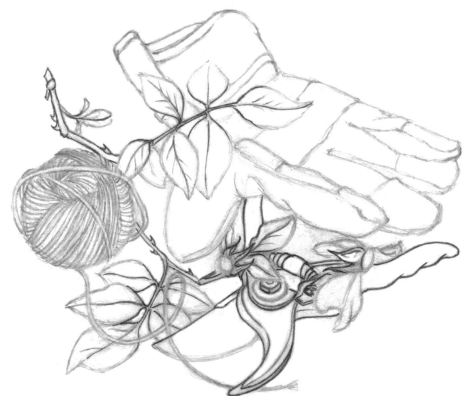

STEP 5

I started the final line work with the hard edges and smooth surfaces of my subjects. I needed a line that was dark but not too thick or soft, for which a well-sharpened HB or 2B pencil is suitable. With firm pressure, in long flowing strokes, I followed the underdrawing of all the smooth and unbroken lines, cleaning up stray lines with the point of an eraser as I went.

STEP 6

Without changing my pencil, I started to pick out the hard-edged detail. Drawing serrated edges on the leaves gave them the distinctive look of rose foliage without the necessity of observing every serration. The glove was made from more than one fabric and I wanted to convey the difference in their textures in the lines of the drawing. Here I have worked on the braid and cloth, suggesting the weave. Though the difference is subtle, I deliberately used different kinds of line to those I used for the secateurs to show that the surfaces are different.

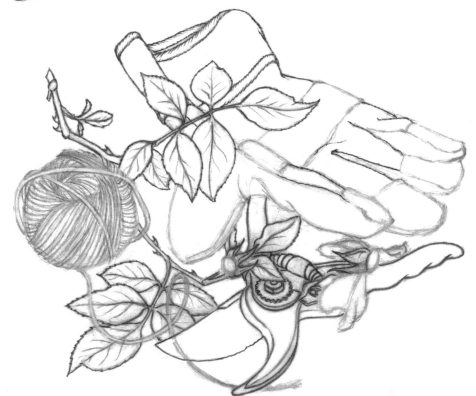

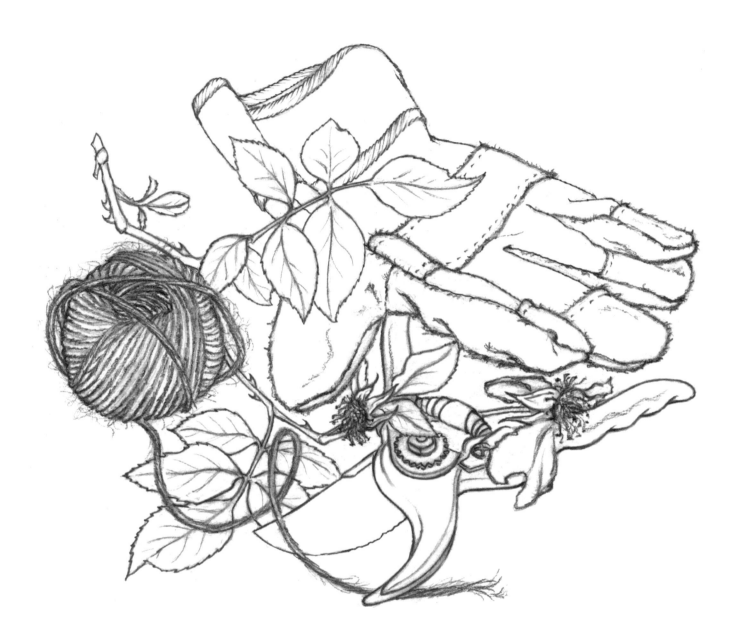

STEP 7

For the softer lines a softer pencil was required, so I switched to a 6B and rubbed the point down on scrap paper. For the suede of the glove, I used broad, fluffy marks to describe the weight and texture of the material. Similarly, the string needed its own kind of mark.
Here I went over the lines several times with short, soft strokes of the pencil. After a bit of cleaning up, I added a wispy halo effect and immediately the ball of string seemed to come to life.

Introducing ink

Ink, from a pen or a bottle, produces a dark and clean line that can be employed for very precise artwork. When dry it cannot be erased, which is convenient when cleaning up pencil marks, but also means that mistakes are difficult to rectify. Ink can also be applied with specialized pens or watered down for certain effects, subjects we'll look at later in the book.

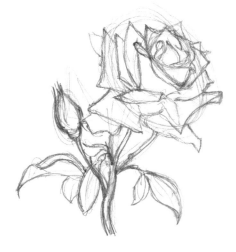

Finishing and cleaning up this rough drawing in pencil could be quite time-consuming.

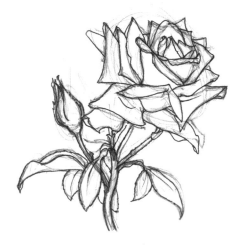

Here I've used a fine-tipped drawing pen (0.1mm) on top of my pencil work. These pens are not very expensive. They come in a variety of thicknesses up to about 1mm.

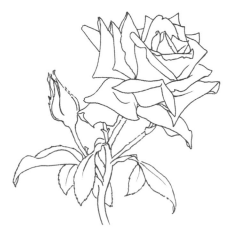

The pencil marks can be easily erased in broad strokes across the whole picture area, leaving a clean outline. However, the even line of a pen can look clinical and uninteresting.

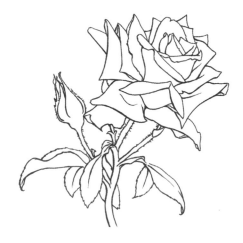

Going over some of the lines again with a slightly thicker pen (0.5mm) lends the line some variety and grace. The drawing looks more finished.

Using a brush

Good-quality drawing ink is a versatile addition to your drawing kit. A small bottle
will suffice; a little goes a long way. It can take a while for ink to dry so do make sure
that it is not still wet before you attempt to use an eraser over the surface. For line
work you'll need a round watercolour brush with a good point. Well looked after, a
good-quality brush will serve you well for dozens of pictures, so go for the best quality
you can afford. Fine work can be done with a wide brush if the tip is good, whereas
the finest brush with a ragged tip will let your work down. Always clean a brush
thoroughly after use and re-form the point while it is still wet.

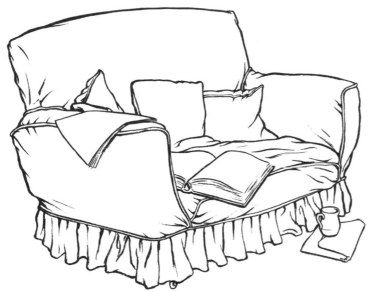

**A brush and ink naturally produces lines of varied
width. I used a No. 4 sable brush with a fine
quality tip, which allowed me to produce a very
clean rendering, yet convey something of this
subject's scruffiness.**

**If you cannot get hold of artists' pens or brushes,
interesting line drawings can be produced with
cheaper materials. This toy was drawn with a
very old and cheap felt-tip pen. (The lines added
under the shoes, hand and ear help to ground
the monkey and stop him from seeming to float
in space.)**

A certain amount of practice is required to master the lines and marks made by a brush. Practice by drawing lots of small and simple objects such as these copied from earlier in the book. I used a medium (No. 6) round sable brush. The challenge is to control the breadth of line and use it appropriately, as well as keeping the line fluid and graceful. You'll need to turn the paper constantly to allow your arm to follow its natural arc. Small mistakes can be corrected with white drawing ink.

Brush and ink is great for producing clean areas of solid black. Intelligently applied, solid black can bring a sense of design to your line drawings. In these examples I've also used white ink on top of the black to restate certain details.

Brush and ink is a good medium for trying out a graphic approach to drawing. This design is based on my earlier rose drawing. Find a motif in one of your earlier drawings and follow these stages to give it a similar treatment.

STEP 1

My interest was in a strong design rather than a realistic study, so in the rough pencil stage I simplified the rose. The leaves are arranged aesthetically rather than naturally.

STEP 2

The first stage of inking was concerned with the outlines only. For the serrated leaves, the point of the brush was laid on and dragged backwards.

STEP 3

Filling in with black was easy enough, but I was careful to leave myself some reminders of where the outlines would go.

STEP 4

I then painted on white drawing ink to pick out the details, correct mistakes and complete the design. To allow for the white ink's thick consistency I used a fairly fine (No.3) brush.

A decorative design

Line drawing, especially with ink, offers many creative possibilities beyond depicting observed objects. From simplification it is but a short step to arranging and manipulating forms and lines for aesthetic reasons, in other words, drawing as creative design.

For this next exercise I developed the rose motif into a carefully organized piece of designed drawing. Based on a square, I created the sort of design that might be used to decorate a cushion or tile. Other shapes, such as circles and diamonds, lend themselves well to this kind of design and provide a solid structure to work within.

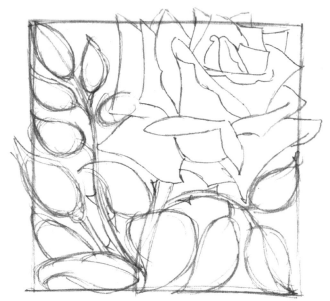

STEP 1

I traced my rose (there was no point in redrawing it) and marked around it the square format I had set myself. Then I redrew the leaves, stems and bud to fill the square right up to the corners. I deliberately allowed the rose and bud to extend beyond the frame.

STEP 2

Next, I went over the lines with a felt-tipped pen, adding the leaf serrations as I went. I erased the pencil marks to leave a clean outline.

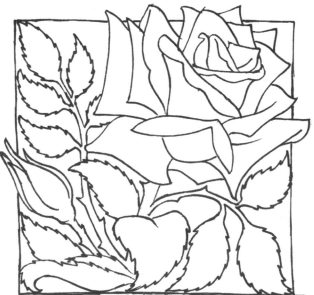

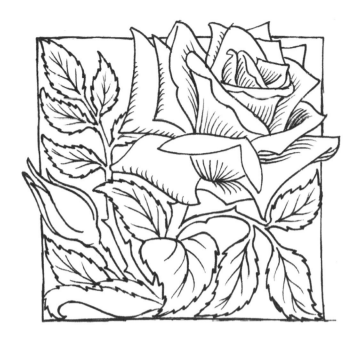

STEP 3

With some leaf detail added, the rose looked weak, so I stroked some shading onto the underside of the petals.

STEP 4

A simple background texture really made the design stand out. I chose small circles as a contrast to the plant's spikiness. It took a lot of time, but it was worth the effort.

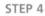

STEP 5

After filling in the solid black border, I went around the edges of the drawing with a thicker pen to make the rose stand out against the heavy background.

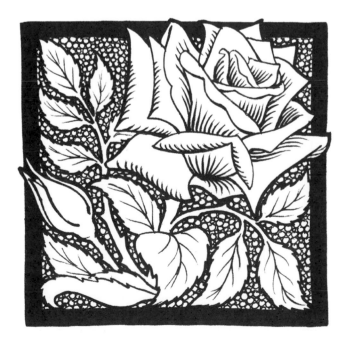

Designing a border

This next exercise is quite complicated, involving not only a decorative arrangement of shapes but also careful thought and planning. The idea was to make a simple design that could be duplicated to form a continuous repeating pattern. You could use one of your earlier drawings to base a design around. I chose to develop the vegetables from pages 32–33.

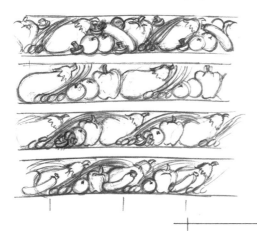

STEP 1

Working out a design like this is not easy and there may be many failed sketches before you're happy. From top to bottom, my first effort is too jumbled and the second too sparse. Number three is better but is too uneven in that some areas are too busy and others too empty. The bottom design has a nice flow and balance, so I decided to use that one.

STEP 2

Precision was required in drawing up the artwork, so I marked up a grid into which I could fit my design.

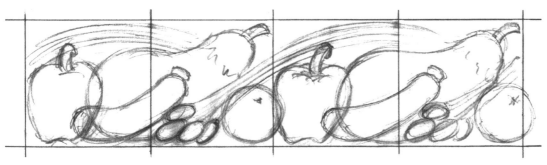

STEP 3

I roughed in about twice as much as I needed for this repeating pattern.

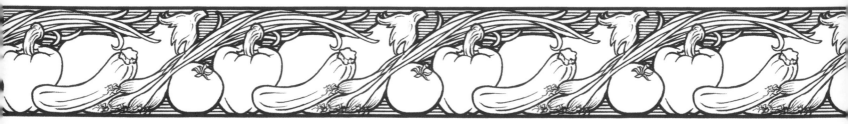

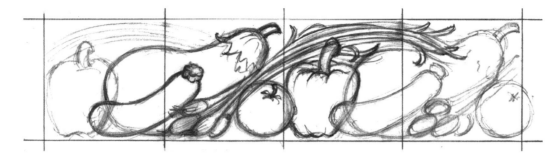

STEP 4

From the rough stage I could work out the best places to make the joins in the design, avoiding complicated parts of the drawing. Then I worked up the parts I needed.

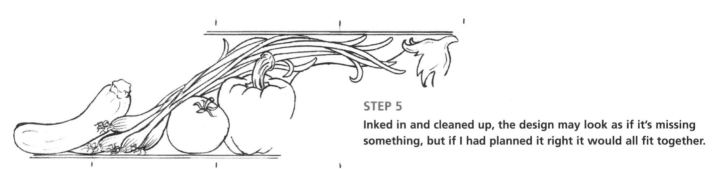

STEP 5

Inked in and cleaned up, the design may look as if it's missing something, but if I had planned it right it would all fit together.

STEP 6

Strengthening the outlines made the design considerably more polished, and a background helped the vegetable forms to stand out clearly. I reviewed the outside edges and made a few small adjustments so that the design would repeat itself seamlessly.

STEP 7 (BELOW)

I scanned my design into a computer to test the repeat pattern and it fitted together perfectly, which is very satisfying. If you don't have access to a computer, you could make several photocopies of your design, cut them out and stick them together. Alternatively, you could use the traditional method and trace your design repeatedly onto a long piece of paper.

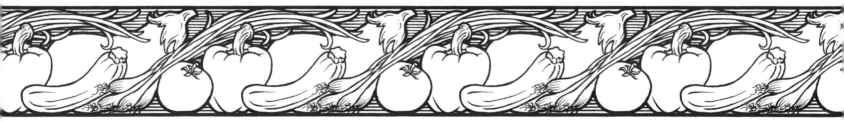

Tone

By now you should have built up some confidence with line drawing and conveying shape, scale and texture, as well as suggesting solid form. However, to more fully create the illusion of solidity it is necessary to master 'tone', or shading.

Understanding tone means analyzing the effects of light falling upon objects and the shadows cast by them. The angle, strength and quality of light affect the way an object looks as much as its own shape, texture and colour. Look out of your window: you probably think of the window frame as white, but against the brightness of the sky, it will appear to be virtually black. When drawing with tone, nothing can be taken for granted. Tone is quite a big step forward so it's worthwhile spending a little time on the basic theory of the subject.

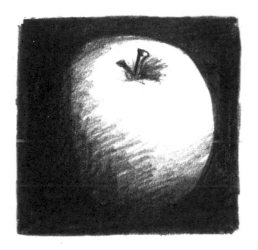

This is a simple tonal drawing of an apple on a black surface against a black background. Very little line is involved; the form is described by the shading and the outline is merely the dividing line between black and white. Interestingly, the lower and left-hand portions of the shape blend into the background and are not drawn at all, but the mind fills in the blanks and recognizes a complete form. The roundedness of the apple is conveyed in the shape and blending of the tones.

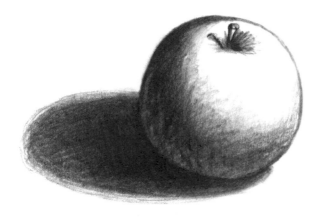

Objects are rarely seen spotlit in darkness and the apple here is a more common view. With the white background, the whole outline of the apple is visible, as is its cast shadow. Note the way that the shading is lighter towards the underside of the apple. This is because it is also lit from the reflected light bouncing off the pale surface on which it rests. Note also that the cast shadow is darker under the apple and becomes lighter further from it.

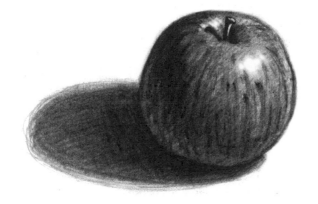

The tone of the previous drawings dealt only with the effects of light and shadow. In this version, I've applied the apple's local tone, that is, its inherent tonal value. This allows me also to show the highlights on the surface, where the light bounces off the apple's shiny skin directly at us.

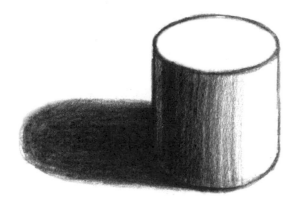

It is the shape of an object that most strongly determines the form that its shading and cast shadows will take. Compare this cylinder to the apple (or sphere) and you can see that the light bounces off its surface in a different way.

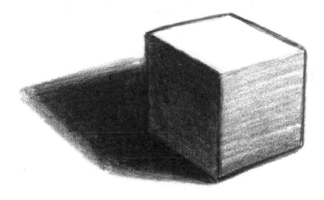

Light and shade rarely fall evenly across any surface. Even though the sides of this block are flat, each plane's relation and proximity to light sources, whether direct or reflected, will affect the shading.

Tonal still life

Applying tone or shading to your drawings can be simplified by tackling it in stages. For this exercise, find a few simple objects, preferably pale, and place them on a white surface. Work in a dimly lit room, illuminating your subject with a table lamp, to show definite shadows from a single direction. I've chosen objects that represent the most elementary shading patterns: a box, a cylinder and a sphere, as well as the more complicated shape of an old key to provide some interesting shadows.

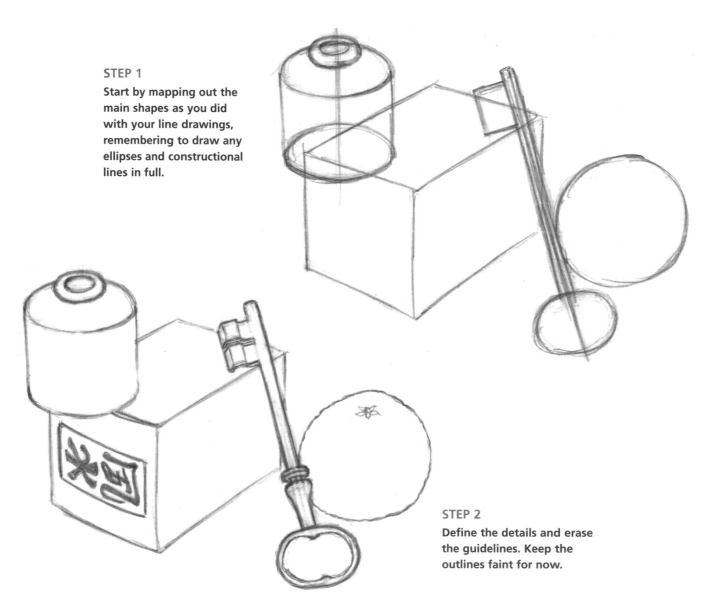

STEP 1
Start by mapping out the main shapes as you did with your line drawings, remembering to draw any ellipses and constructional lines in full.

STEP 2
Define the details and erase the guidelines. Keep the outlines faint for now.

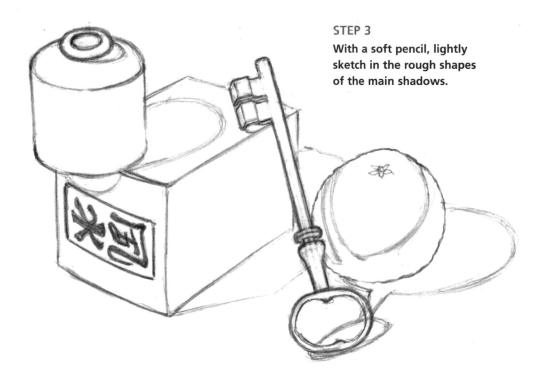

STEP 3

With a soft pencil, lightly sketch in the rough shapes of the main shadows.

STEP 4

Using the side of your soft pencil, shading in a single direction, fill in the main areas of shadow and darkness. Try to maintain an even pressure. Don't worry if you go over your guidelines.

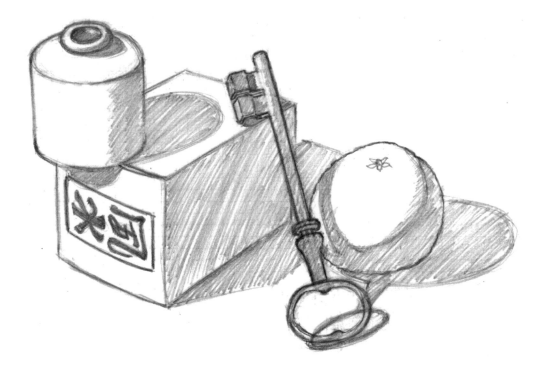

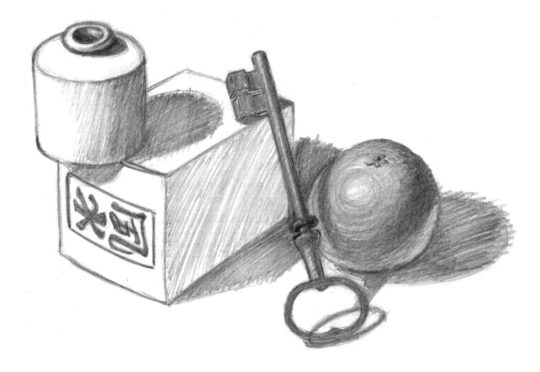

STEP 5

Some shadows will naturally appear darker than others, so strengthen those areas by shading again, this time working at a slightly different angle. In this second stage of shading, you should also consider local tone. In my drawing, the orange is naturally darker than the box or the bottle, so I shaded it all over, working in a circular motion to help convey its roundness. The local tone of the key is darker still.

STEP 6

Now refine the tones by working over the whole drawing, building up the layers of shading to depict the whole range of tones from the brightest white of the paper to the deepest shadows. A very helpful practice is to squint your eyes as you look at your still life; it makes tonal subtleties much easier to identify. Sharpen your soft pencil and use its point to define details.

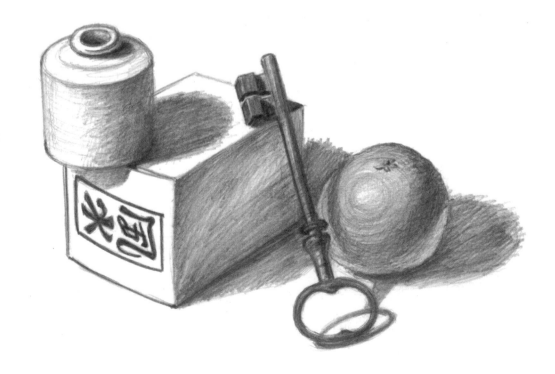

STEP 7

This is where the drawing really comes to life. Use your eraser to clean up around the edges where your shading might have gone astray. Then use a corner of the eraser to carefully pick out highlights on shinier objects. Look very carefully for reflected light; gently dabbing your eraser will lift off unwanted shading. You might also use a finger to smudge around some of the shadows where the edges are indistinct.

shadows are darker when close to the object

highlights

local tone

reflected light

shade is not usually even across a flat surface

TIP

To show how this picture works as a composition in tone, I have simplified it to slabs of pure tone and removed distracting details. Note how these abstract shapes follow a diagonal from upper left to lower right. The shape of the smaller mass echoes the larger mass of tone, itself echoed by the little shadow at the neck of the bottle. So there is a rhythm within the picture and also a sense of tonal balance in that the masses of tone are evenly dispersed across the picture area.

Composition – tone

We have seen that composing even a simple line drawing needs some careful thought. When tone enters the equation, the whole subject of composition gets more complex – but fortunately most of us have a natural ability to detect tonal imbalance and once it is noticed it can be easily rectified. It's a good idea to test all your compositions by reducing them to blocks of tone on a scrap of paper (see page 53); it only takes a moment to make such sketches and it can save you from wasting hours over drawings that may have been doomed from the start.

A COMPOSITIONAL PROBLEM

Consider this sketch from our earlier composition lesson. The weight and placement of each object is nicely balanced, but there's something not quite right about the tones.

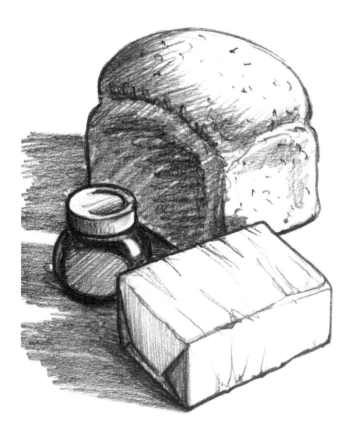

Let's imagine a frame that marks the edges of the composition and cuts off the shadows neatly. With some felt-tipped pens I've reduced the main areas of light and dark to almost abstract shapes. Thus we can see quite clearly that virtually all of the tone is in one half of the picture, creating a sense of imbalance.

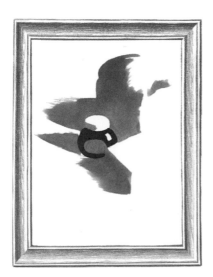

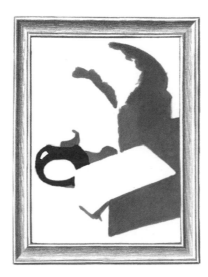

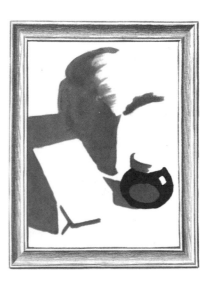

SOLUTION 1

By taking a wider view of the subject, effectively zooming out, we can arrive at a composition that is better tonally balanced.

SOLUTION 2

Another option is to change the lighting. Here I've lit the scene from the other side. Though this pushes all the shadows into the opposite sides of the picture, the local tone of the jar is dark enough to redress the balance.

SOLUTION 3

Leaving the light source unchanged, some or all of the objects can be moved around until a more balanced composition is arrived at. As with the previous solution, there is a block of white in the dark area and a block of black in the white area.

TIP

Think of the ancient symbol of Yin and Yang as an example of black and white in perfect harmony, with a spot of each in the other.

In composing your pictures, you should try to think of shadows and shading as abstract shapes and tones. The point at which the frame or the edge of the paper may cut them off must be considered for the good of the whole composition. Shadows can also be thought of as an essential part of the subject, as in this example where the shapes of the shadows are as important as the objects that cast them.

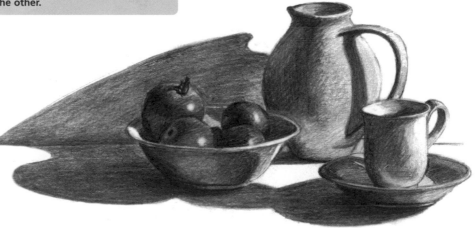

Shine and reflections

Drawing with tone does not only involve shadow and local tone. As we have seen, reflected light and highlights have to be considered too and never more so than when dealing with shiny or polished surfaces. Here's a drawing of a still life that involves some of the more intricate reflective effects you might come across. Remember that squinting your eyes will help to make sense of the bewildering range of light and shade in shiny objects.

STEP 1

This drawing started much like the others we have seen so far, with outlines for the main shapes. I also drew the shape of the main shadow because that will be an important element of the overall composition. You'll notice that I've drawn the ribbon as if it is transparent. Visualizing objects like this helps to produce free-flowing and convincing curves, as we saw with ellipses.

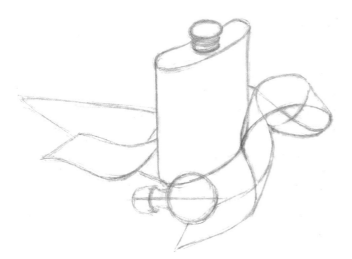

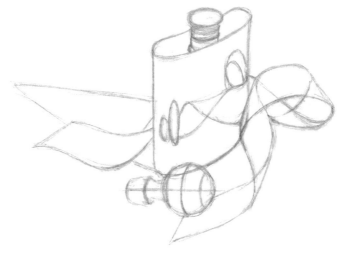

STEP 2

Because the hipflask is made of polished metal it acts like a mirror, reflecting an image of the objects in front of it. These reflections should be drawn as carefully as the real things – a picture within a picture. The lid of the hipflask is reflected in the top surface

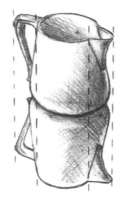

TIP

This jug is standing on a mirror and it shows that reflections in a level surface fall directly vertical. It's also worth noting that there is no shadow cast upon a mirrored surface.

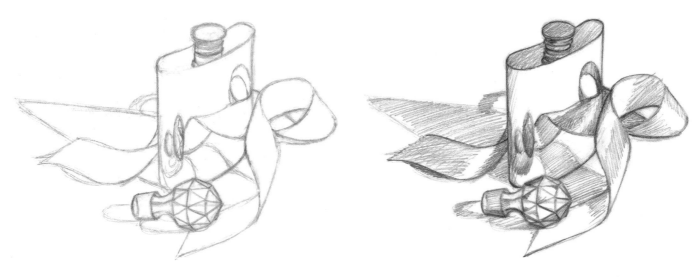

STEP 3

After erasing the ribbon guidelines and detailing the facets of the glass, I drew in the shapes of the shadows.

STEP 4

This is the first layer of shading to establish the main blocks of tone.

STEP 5

It takes quite a long time to work up the layers of shading in a picture like this. Each surface reflects the light differently and deserves close observation. The light source here is not a direct spotlight, as in the previous pictures, but diffused daylight. The ribbon catches highlights directly from the light source and those reflected from the hipflask and other surfaces. The tone modulates along the length of the ribbon. It's not as complicated to shade the glass stopper as you might think. The individual facets break up the surface into easily observable sections. There is a whole symphony of light bouncing around inside that defies analysis but careful copying can produce a passable impression of it. Light is allowed partially to pass through the glass, which faintly illuminates the stopper's shadow.

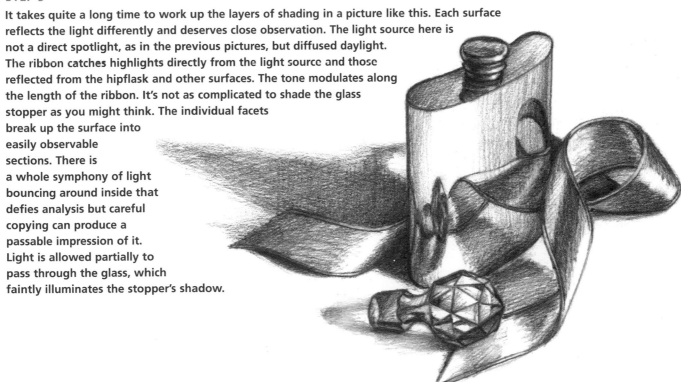

Light sources

Light, as we have seen, is fundamental to any drawing that attempts to convey solidity and is also an important compositional consideration. The nature and direction of lighting also influences the feel of your finished drawings.

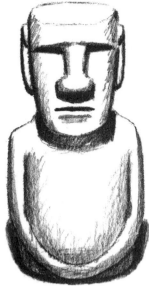

Lit from the front, this statuette is symmetrical and the harsh light largely bleaches its features out. The starkness of the lighting creates a direct engagement with the viewer.

With the light shifted over, the modelling of the statue becomes clearer so we see the figure in more detail. The shadow further conveys a sense of the statue's solidity.

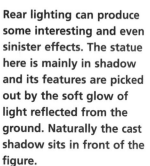

Rear lighting can produce some interesting and even sinister effects. The statue here is mainly in shadow and its features are picked out by the soft glow of light reflected from the ground. Naturally the cast shadow sits in front of the figure.

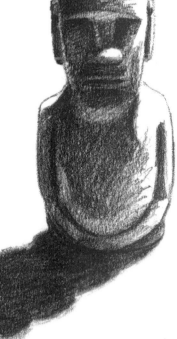

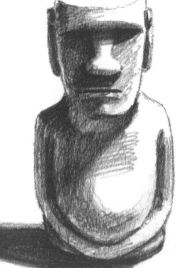

Side lighting casts longer shadows across the statue and throws its form into stark relief. Although based on exactly the same drawing, this shading pattern almost seems to change the character of the statue.

As well as the direction of light, the quality of light can vary, affecting your approach to a drawing. This is the light source for each of the previous examples. From a distance of a few feet a direct light source will cast predictable shadows from small objects.

When an object is closer to the light the shape of its cast shadow can be distorted, widening with distance from the base of the object. This effect is not noticeable from a distant light source, but is exaggerated with increased proximity.

Quite often more than one light source will be illuminating the objects that you draw. Multiple light sources produce multiple shadows. In this simplified diagram you can see the general effect. Shadows cross each other and are weakened by the presence of the extra light source. This effect is known as penumbra and the areas of deeper shade where the shadows cross are called umbra.

The light from a large source, such as a fluorescent tube, an overcast sky or a window affects shadows similarly to multiple light sources. With light flooding in from all angles, only a small portion of the shadow will be full umbra and the penumbra can be very weak and spread out.

Shading patterns

Once you become proficient at analyzing and drawing with tone, you may want to experiment with different methods of applying shade.

The shading here follows the form, curving around the contours of the subject. This is difficult to achieve, but can be quite effective in helping to describe the shape and depth of objects.

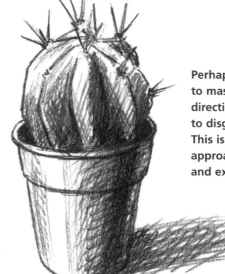

Perhaps the easiest shading to master, done in random directions with no attempt to disguise the pencil marks. This is not the subtlest approach, but it is energetic and expressive.

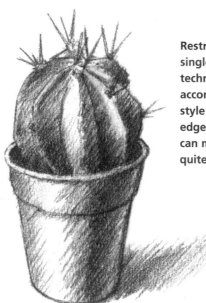

Restricting the shading to a single direction is a simple technique that produces an accomplished finish. This style tends to soften the edges of the drawing and can make the picture look quite flat.

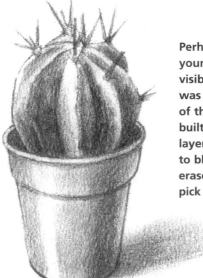

Perhaps you don't want your pencil marks to be visible at all. This picture was shaded with the side of the pencil and the tones built up in painstaking layers. A fingertip can help to blend the tones and an eraser is especially useful to pick out soft highlights.

Similar techniques can be employed to shading in ink. Bear in mind that you cannot erase pen marks, so think carefully before committing ink to paper – but do try not to be timid. Mistakes can easily be rectified with white ink.

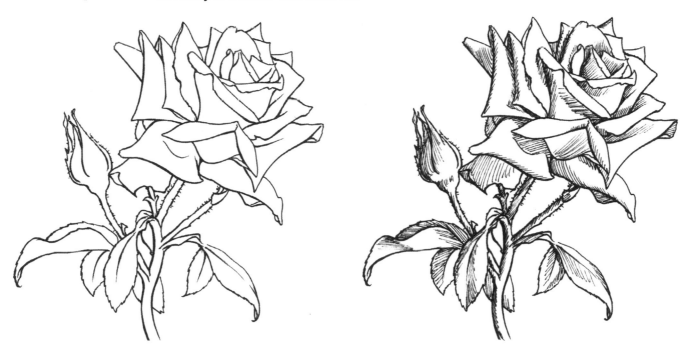

Random shading direction is an easy introduction to shading with ink. Here's the rose outline I drew on page 40. With a fine drawing pen (0.3mm) I started the shading with evenly spaced strokes over all the general areas of shade, roughly following the form of the plant. Already the drawing is coming to life.

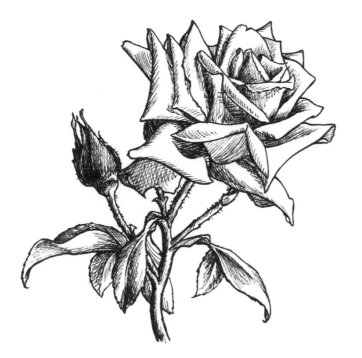

To complete the shading, I looked more closely at the subject and identified the variations of shade. Where the shading was darker, I adjusted the angle of the shading and stroked evenly spaced lines on top of the existing ones. A black pen cannot describe very pale tones, so they should be left white.

Drawing with charcoal

For tonal drawing, charcoal is ideal. These sticks of burnt willow allow you to cover the paper in tone more easily and with more flexibility than any other medium. Charcoal can be drawn with, smudged, painted, blended and mixed with chalks and other media. An eraser pulls out highlights easily, but don't brush away the eraser shavings as you'll smudge your pictures; blow the drawing clean instead. Charcoal is messy and unstable – but then that only adds to the pleasure.

When finished, a charcoal drawing can be sprayed to stop it smudging. Artists' fixative spray is expensive but hairspray does the job quite well and is much cheaper.

Where I've drawn outlines here, they vary in breadth and also in darkness. Charcoal is very pressure-sensitive, which also allows it to be used for more subtle marks, like the shading on the jug. I broke off about 2.5cm (1in) from a stick of charcoal and used it on its side in single confident strokes. Other shading was done similarly and I used my fingertips to lift and blend the charcoal in places.

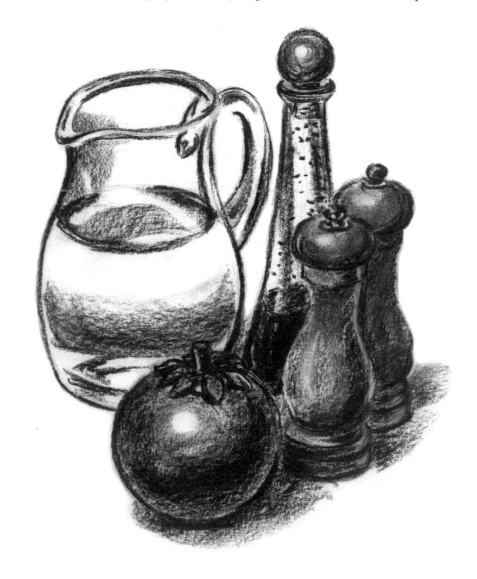

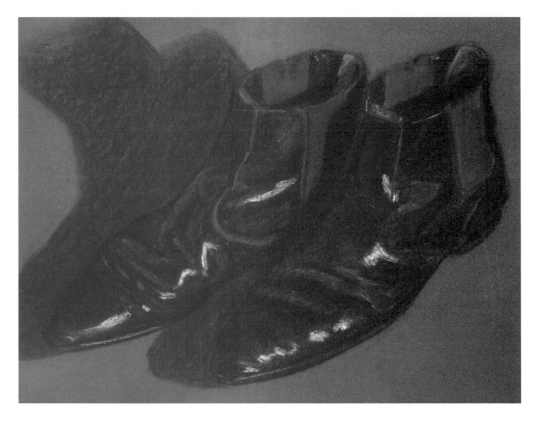

Working on a dark-toned paper, I drew and shaded these old boots with charcoal and added the highlights with white chalk. Cheap blackboard chalk is as good as artists' pastels for most pictures.

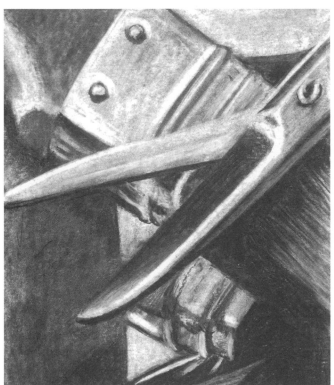

Here charcoal has been used for a more full tonal rendering, utilizing its capacity for deep, velvety black, a full range of greys and highlights erased to reveal the white of the paper. I drew this quite large, at about A2 (four times A4). This extreme close-up is an example of a picture that fills the frame with only parts of the objects visible.

Filling the frame

Still-life drawing need not be limited to small objects on a tabletop; a background or setting can also be included as an integral part. By necessity, pictures that include background details usually have definite edges, rather than the vignettes that we have concentrated on thus far. To help you select and compose, a cardboard frame (see page 34) will be an invaluable tool.

I have used a drawing pen for this picture, with a couple of extra ingredients: white ink and grey paper, torn from a scrapbook. Papers of any tone or colour can be bought from an art supplier, although cardboard or brown paper is perfectly good as a cheap alternative. A dark drawing surface is often called a 'toned ground'.

STEP 1

After considering the composition and my best viewpoint, I drew the main shapes of the objects and background in pencil, paying special attention to the angles of the window frame.

STEP 2

There are effectively two layers to this picture: the window and objects on the windowsill, and the details outside the window. I inked each layer separately at first to avoid confusion, beginning with the interior. I knew I was going to draw the big feather in white, so for now I only drew its stalk.

STEP 3

Once I was satisfied with the indoor elements, I added the outdoor objects, keeping the line fine to make the background distinct from the foreground.

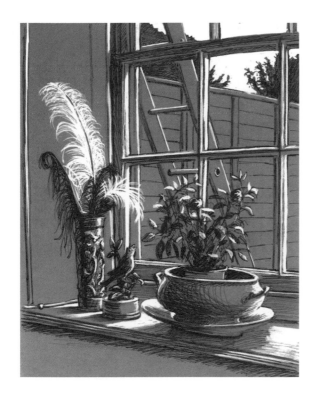

STEP 4

Using my fine watercolour brush, I painted in the areas of brightest highlight with white ink. This gave the drawing an immediate lift. Try not to get carried away with the white, though; it's easy to overdo it.

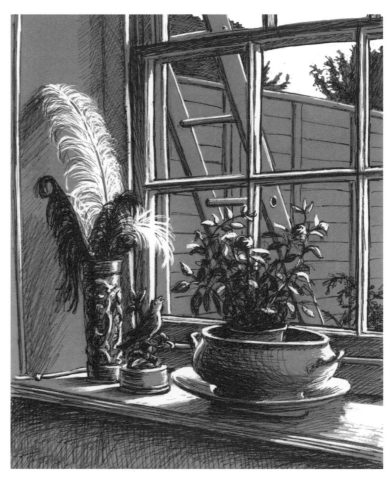

STEP 5

With the white in place, I could see what final bits of black line and shading I needed to finish the picture.

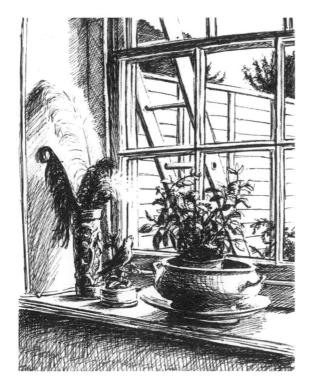

By comparing the results with this version on white paper, you can judge the effectiveness of the toned ground and white ink.

Sketching around the home

Setting up still-life subjects can be time-consuming and frustrating when you just want to get on and draw. But, if you look around your home, you'll find many potential drawing subjects waiting for you.

The sketches on these pages were all done in one evening with three thoughts in mind: to rearrange nothing, but to position myself to achieve an interesting view and composition; to use a medium appropriate to the subject; to avoid getting bogged down in precise detail and make the drawings fresh and spontaneous. This is our first entry into free sketching, which will feature large as we move on to landscapes, in the next chapter.

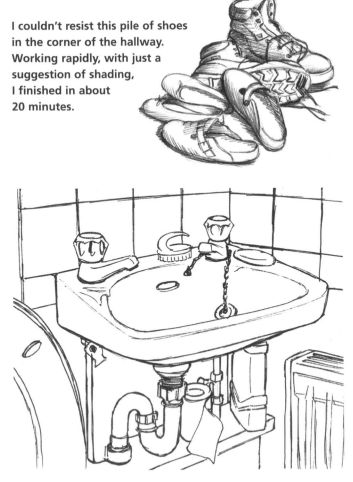

I couldn't resist this pile of shoes in the corner of the hallway. Working rapidly, with just a suggestion of shading, I finished in about 20 minutes.

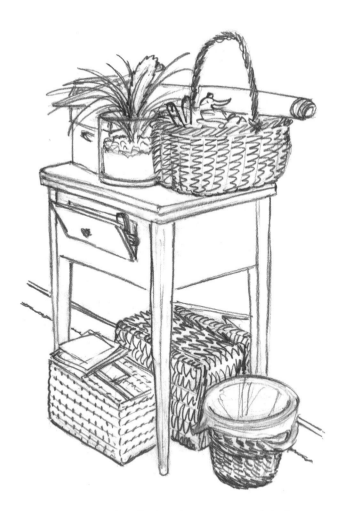

On top of a minimal underdrawing, I went straight in with a very soft pencil. This took about 40 minutes.

This was drawn quite thoroughly in pencil before I applied the black felt-tip line. It took just over an hour.

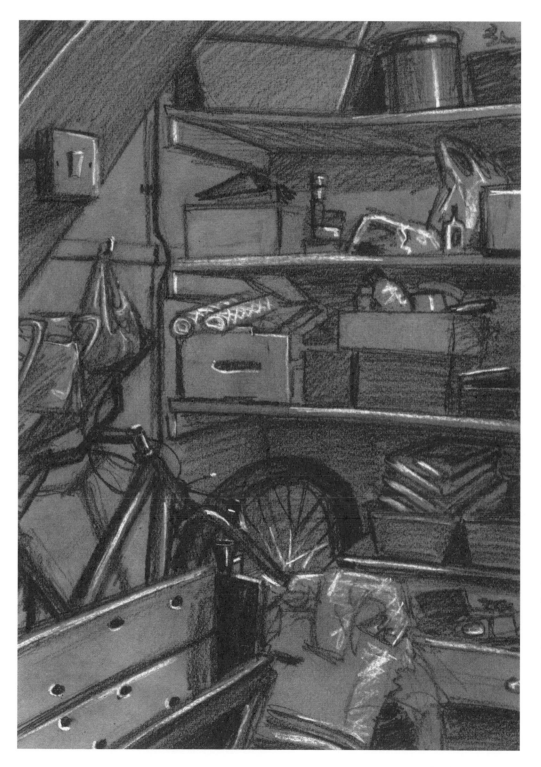

This might look complicated, but it was actually quite quick to complete, finishing in about an hour. The toned paper gave me a head start, I then used a graphite stick which worked up the dark tones in no time. I added the highlights with a white chinagraph pencil, which will just about make a mark on top of graphite.

NATURE'S LANDSCAPE

When you venture beyond the comfort of the home or studio, the lessons learnt from drawing still life subjects will give you an excellent grounding for tackling the challenges that landscape holds.

You will find it a great pleasure to draw in the outdoor environment, as long as you take a few practical measures for the sake of your drawings and your physical comfort. Outdoors, the practice of sketching comes into its own, as a means of gathering information and of developing your skills. Sketches done in the field can be developed at home into artwork, but portable materials are also perfectly sufficient for producing finished pieces on location.

The scope of the natural world is rich indeed, and whether you have access to coasts, mountains, forests, fields or wastelands, there is always something worthy of your artistic attention. It's down to you to decide what it is about a landscape that interests you, and then to capture something of your delight on paper.

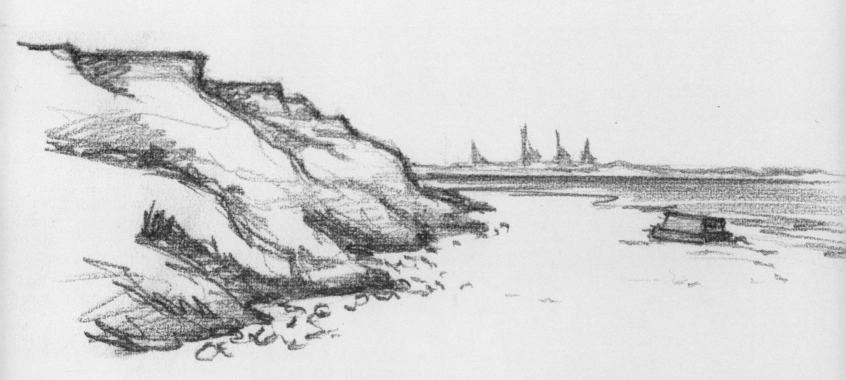

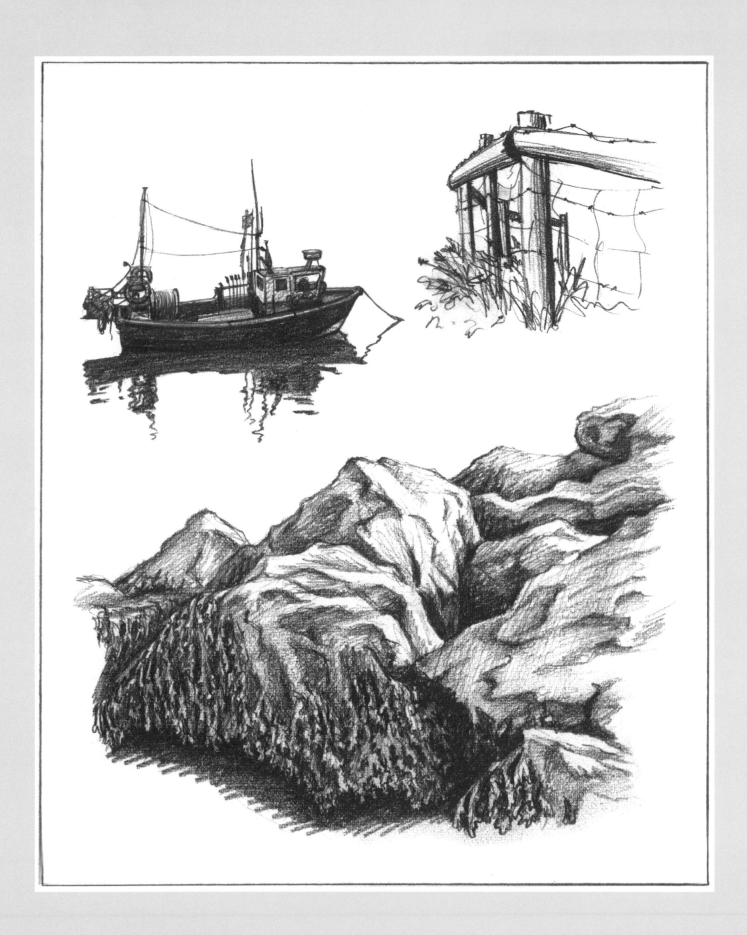

Composition – dividing the frame

As we examined in the last chapter, the composition of a picture is probably the most important single factor in its success, and this is particularly the case in landscape drawing. Landscapes usually fill a frame, and so decisions must be made about where to place elements within it. These seascape drawings, free of confusing detail, will illustrate some general principles.

The horizon – the line where land or water meets the sky – is clearly an important element of landscape composition. A true horizon, uncluttered by land features, is always perfectly level, or horizontal. In this composition it is placed in the middle, giving equal weight to each half. The result is an uninteresting picture.

Setting the horizon higher in the frame suggests that a decision has been made to make a drawing about the sea, with the sky of secondary concern. Crucially, it also feels better in terms of design. Dividing the picture area into approximate thirds, rather than halves, is a good rule of thumb.

Dropping the horizon to the lower third works equally well, compositionally. In this instance, the sky dominates the picture, creating a different mood or effect.

The same principle applies to vertical divisions of the frame. To add a boat as a centre of interest, placing it in the middle seems somehow weak and indecisive.

Placing the boat about a third of the way into the picture gives a more graceful result. Here the boat has space in front of it, implying movement and purpose.

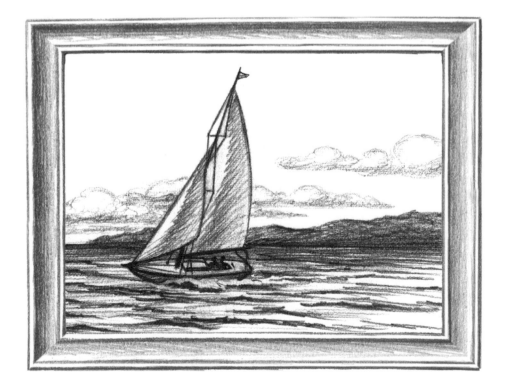

Placed in the other third, the composition is still strong, but there is a subtly changed dynamic. The boat seems faster, as if the frame can't keep up with it.

Changing perspectives

As well as being compositionally important, the horizon also gives the pictorial elements of a landscape drawing a sense of height and placement within a scene.

Here's a cast-iron fact for you: the horizon is always perfectly level with the eye-line of the artist. As a demonstration of this, I made these quick sketches of the sea with a headland in the distance and a cliff in the foreground, scrambling further down the cliff for each one.

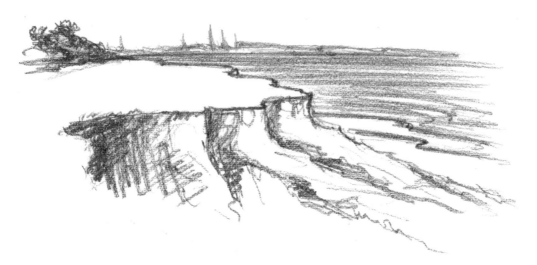

From my stance at the clifftop, the sea was visible over the top of the cliffs. The bushes and trees to the left extend above the sea level because, though distant, they were higher than my eye level and therefore also above the horizon from this view.

Further down the cliff I could no longer see the flat surface of the clifftop. The horizon has moved down with me to a point below the clifftop. The sea is now a shallower segment of the picture, the beach is more visible and an old blockhouse comes into view on the beach.

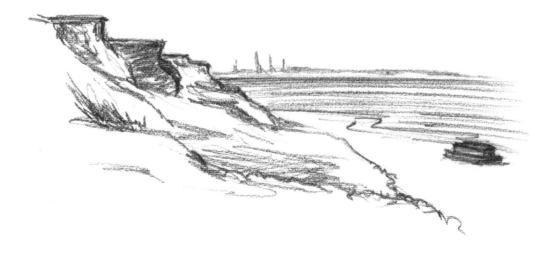

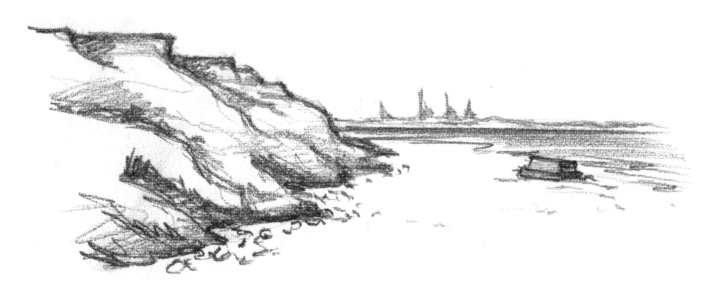

Closer to the beach the foot of the cliff is visible and the horizon drops still lower. The amount of sea visible is further reduced with the change of eye level. Note that the features of the distant headland remain unchanged throughout; that's because they are so far away that the differences are too slight to be noticed

Standing on the beach gives a very shallow view of the landscape. The sea is reduced to little more than a line and the contours of the foot of the cliffs are less distinct. Higher than my eye-line, and therefore above the horizon, are the clifftops and now the blockhouse too.

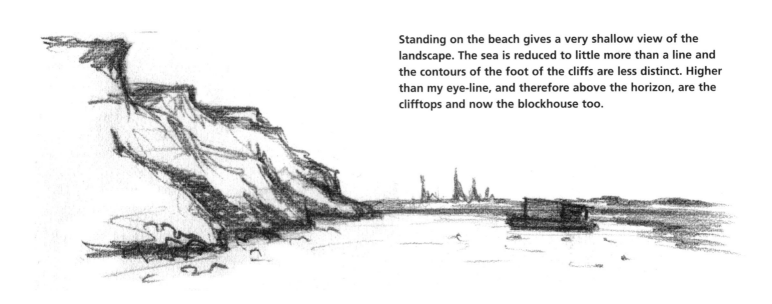

Aerial perspective

Though it is barely perceptible close-up, air has a certain density. So when you look at a distant object, you must look through a greater mass of air than when you look at something nearby. This phenomenon has the effect of reducing tonal contrasts over distance. For example, in the picture below, the wooden groynes of the foreground are nearly black but get progressively paler the further away they are.

Aerial perspective can be subtle or quite exaggerated according to weather and lighting conditions, but it is always present, even over short distances. The rule of thumb is to apply less shade and weaker highlights to distant objects and increase the contrasts as objects get closer to your viewpoint. A sensible approach for a picture of depth is to work from background to foreground.

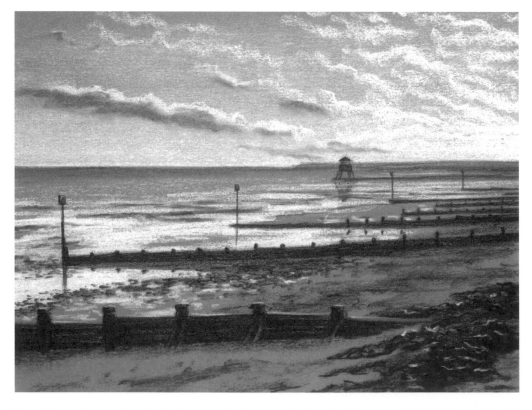

The effect of atmospheric density can also be seen in the sky, the tone of which is considerably paler at the horizon than it is overhead. But, just to keep us on our toes, the sea often appears to be exempt from this rule. Due to the curvature of the earth and reflections of the sky, it often seems to darken slightly at the horizon.

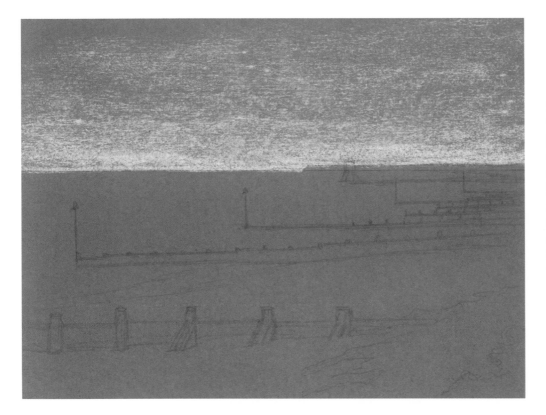

STEP 1

To complement the bleakness of this scene I worked on grey paper to establish the overall tone immediately. I kept the rough pencil drawing very simple. Using the side of a short length of white chalk, I laid on the basic tone of the sky.

STEP 2

I smudged and blended the sky tone with my fingertip to produce a fairly smooth gradient, then drew the clouds on top with more white chalk. Clouds often follow a similar direction or seem to radiate from a common point.

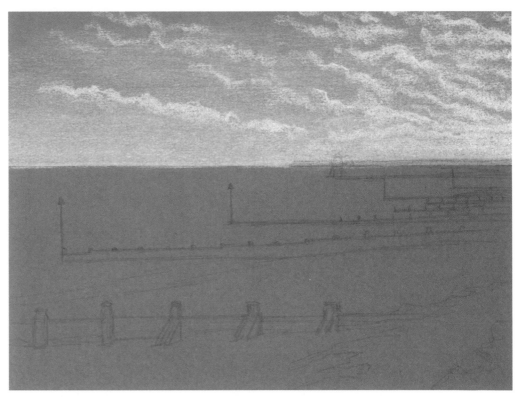

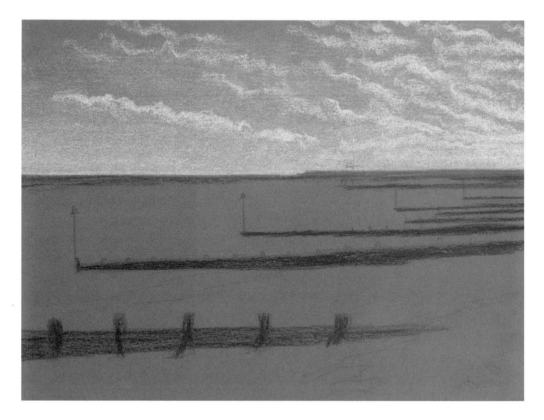

STEP 3

I applied the first strokes of charcoal, taking care not to press too hard. Subtlety is everything with an atmospheric picture and it's easier to strengthen tones later than it is to weaken them.

STEP 4

I added the white of the water around the groynes; at low tide water collects in shallows that reflect the light of the sky. I also smudged the charcoal of the sea for a smooth transition towards the horizon.

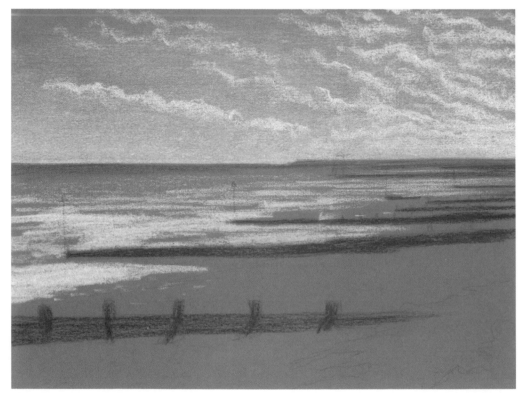

STEP 5

With the highlights of the water in place I could properly establish the charcoal drawing and control the tones.

Smudges of charcoal in the bigger clouds gives them solidity. Happy with the general background, I added the detail of the posts and lighthouse as well as their reflections. The lighthouse is classically placed at horizontal and vertical thirds in the picture. Getting the reflections right was important; they are directly vertical and not too heavily stated.

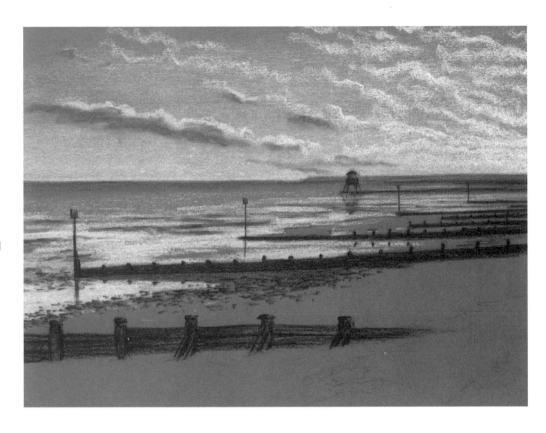

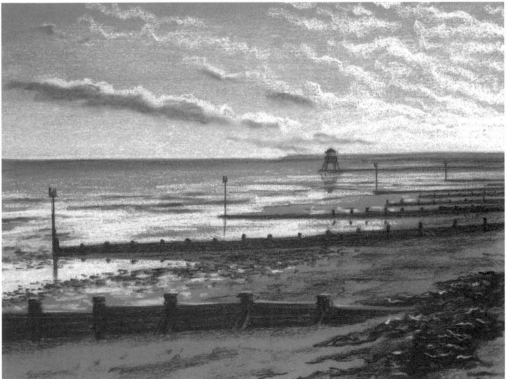

STEP 6

Here I strengthened the tones of the foreground details to bring them forward in the picture. To enhance the depth, I added a few bright highlights to the piles of seaweed at the very front. Aerial perspective is not simply about the darkness or lightness of things, but their relative contrast.

Texture and effect

Although the principles of drawing outdoor subjects are no different from those of still-life subjects, the range of textures in the natural world is greater. The shapes that are found in landscapes are often subtle and form alone cannot be relied upon to describe the subject.

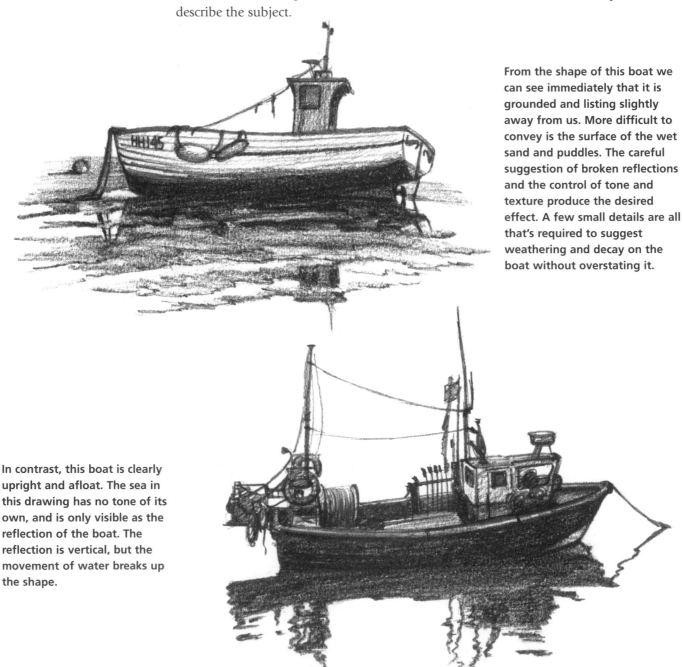

From the shape of this boat we can see immediately that it is grounded and listing slightly away from us. More difficult to convey is the surface of the wet sand and puddles. The careful suggestion of broken reflections and the control of tone and texture produce the desired effect. A few small details are all that's required to suggest weathering and decay on the boat without overstating it.

In contrast, this boat is clearly upright and afloat. The sea in this drawing has no tone of its own, and is only visible as the reflection of the boat. The reflection is vertical, but the movement of water breaks up the shape.

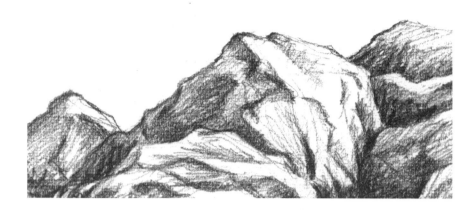

Given no context on which to base an understanding of scale, the viewer might read this as a mountain range.

The general form and texture of rock is the same regardless of its scale. In this complete version of the drawing, the scale is dictated by the seaweed clinging around the high tide mark on the rock. Precisely measured drawing is not required in organic shapes; instead you should explore ways of using the pencil to describe differences in texture and form.

Tree forms

If you can draw a rock, you can draw a mountain; if you can draw a tree, you can draw a forest. By far the most common motif in landscape art, trees offer interesting challenges and variations for the draughtsman.

Recalling our doodling exercise on page 16, there is a generally accepted shape that stands for a tree, but real trees are much more varied and interesting. For your tree drawings to look convincing, try to forget any preconceptions you may have.

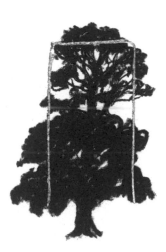

CRAB APPLE LARCH POPLAR ELM

Some trees follow the cartoon idea of a tree: basically ball-shaped, though still incorporating knobbly limbs and protruding tendrils. Some trees are quite neatly triangular, while others follow other uniform geometric shapes. There are even trees that naturally form vaguely rectangular outlines. Generally, trees have shapes all of their own, identifiable by species.

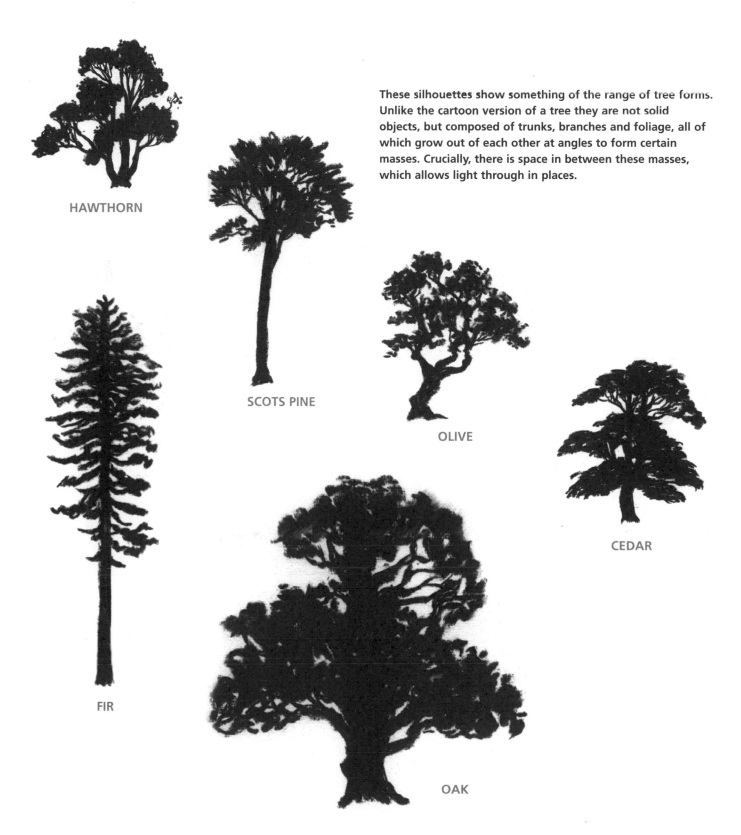

HAWTHORN

SCOTS PINE

These silhouettes show something of the range of tree forms. Unlike the cartoon version of a tree they are not solid objects, but composed of trunks, branches and foliage, all of which grow out of each other at angles to form certain masses. Crucially, there is space in between these masses, which allows light through in places.

OLIVE

CEDAR

FIR

OAK

Drawing trees

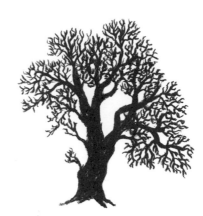

The best way to understand how trees are constructed is to start with the silhouette of a generic winter tree, with no leaves to hide the structure. The trunk is clearly the main solid chunk of a tree, from which grow a few heavy branches, or limbs, which sprout smaller branches. You may see a pattern developing: the trunk divides into two main limbs, each of which is half as thick as the trunk. Each of those limbs divides into two branches, each of which is half as thick as the limbs. And so it goes out to the bustling network of tiny twigs, from which the leaves grow in the spring.

Drawing foliage

Drawing trees in leaf saves you the hassle of all those fiddly twigs, but brings its own issues. Let's go back to the most basic form of a tree: a sphere on top of a cylinder.

With your experience of still life, shading such a form will present no problem, but it doesn't look much like a tree.

By simply employing different pencil marks the shape takes on a more tree-like appearance, but still has none of the natural form that we have discussed.

Think of the tree as a series of spheres supported by a number of cylinders. Mentally simplifying the form makes the job of rendering the foliage more approachable.

STEP 1

To draw the real thing,
sketch the trunk and visible
bits of branch and outline
the general masses of
foliage.

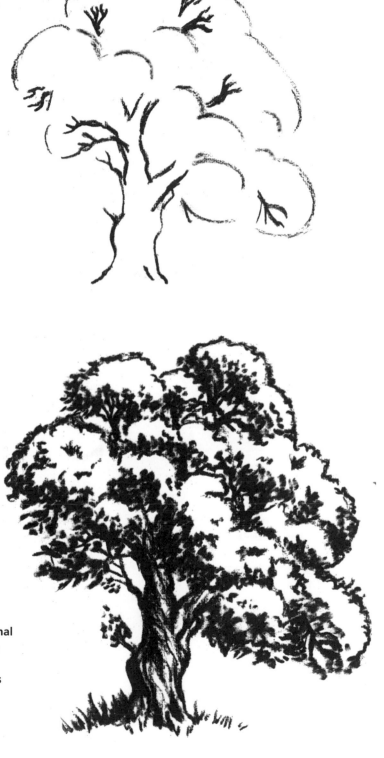

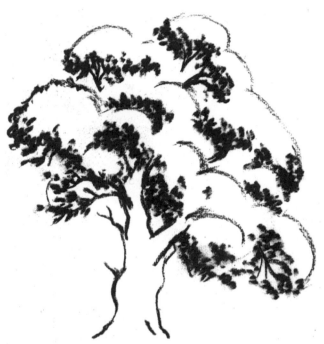

STEP 2

Apply shading to the
underside of the foliage
masses. Note that following
my example is no substitute
for looking at a real tree to
see where the shade falls.

STEP 3

Having established the
general three-dimensional
form, it only remains to
work on the detail and
textures until the tree is
finished.

Sketching materials

As much as is possible, landscape drawing should be done outdoors, directly from life. With that in mind, your choice of materials may be a practical consideration as much as an artistic choice. Artists working on location commonly use the following media.

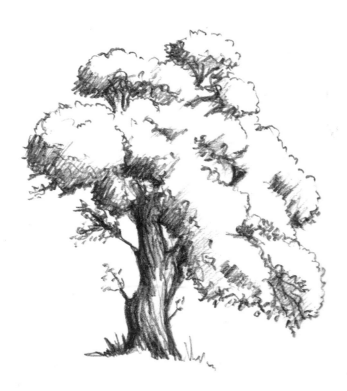

PENCIL

Pencils are cheap, simple, lightweight, and can be both sensitive and robust in use. Here I've used the pencil quickly and sparingly, allowing a lot of the paper to show through. I shaded with quick diagonal strokes and then deepened the tone with textural marks.

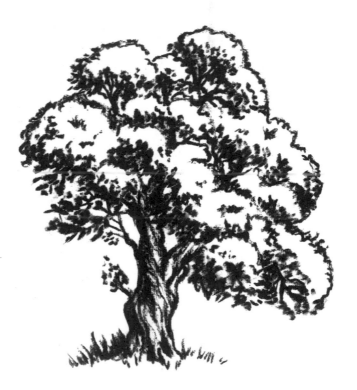

CHARCOAL

Charcoal, with its dark line, encourages boldness, though it can easily be softened or corrected. The smudginess that makes charcoal so versatile also means that it is unstable. Finished charcoal and chalk drawings can be protected against smudging with an artists' fixative spray, although hair spray is nearly as good and much cheaper.

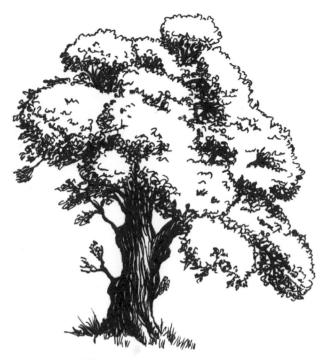

FELT-TIPPED PEN

Using ink encourages you to be positive in your mark-
making. There are no shades of grey and the mid tones are
built up from textural marks and hatching. Good-quality felt-
tipped drawing pens are inexpensive and handy to use in
the field. They can be used on their own or to define detail
in other media.

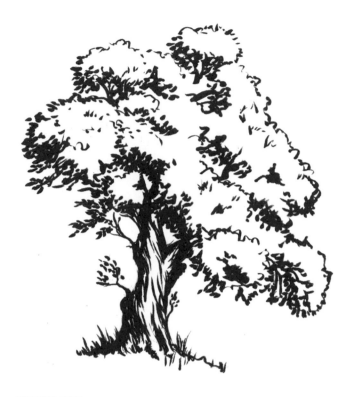

BRUSH-PEN

The felt-tip I used here has a brush-shaped nib, allowing for
broad, varied marks and fine detail. I find brush-pens very
useful and expressive sketching tools.

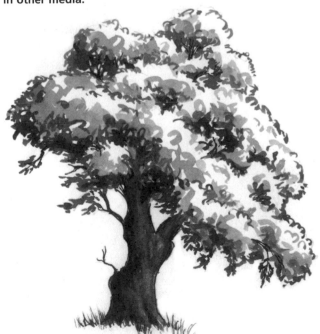

WATERCOLOUR

After some sketchy outlines in pen, I shaded this tree in
a couple of tones of black watercolour wash. It is not the
most practical medium for sketching outdoors, requiring
water, brushes, a palette and drying time, but is popular
for the blending and textural effects that can be achieved.

Sketching outdoors

When sketching outdoors remember that you can get quite cold and uncomfortable sitting still, particularly on the ground. Wrap up warm and take a small stool. It's also advisable to avoid public thoroughfares where you can be jostled and interrupted. Keep an eye on the weather as well as passing wildlife and be prepared to make a quick exit. During the preparation of this book I was moved on by a couple of downpours, one angry swan, many inquisitive cows and an interfering old gentleman.

A typical way of working is to make sketches from life and then use them to inform more finished pictures at home. However, if you have the stamina, there's no reason why full-scale finished pictures can't be done in the wilds. Whatever approach you take, it's a good idea to ease yourself into the activity by spending a day or more filling some pages with quick sketches or careful studies of landscape details.

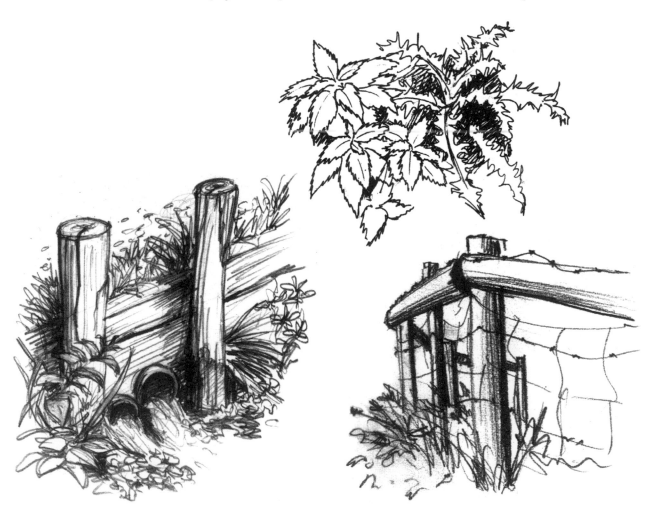

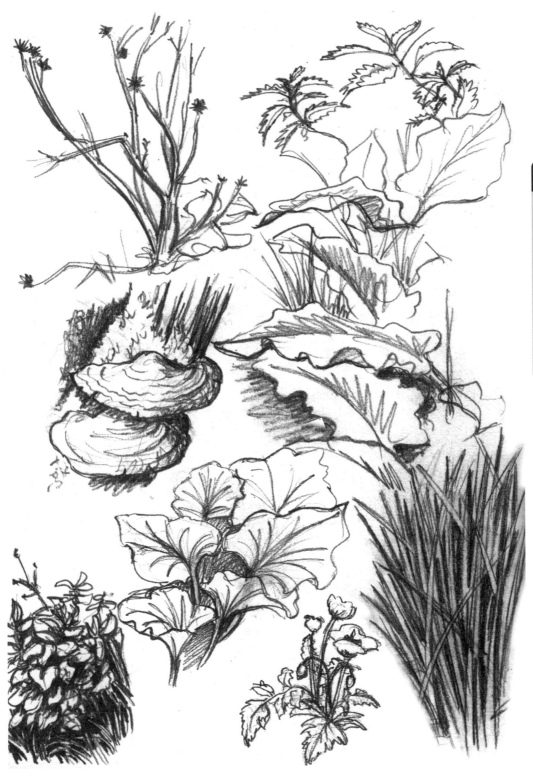

TIP

A robust, inflexible sketchbook is invaluable to the roving artist. Its size and paper quality is up to your own taste or requirements. I have worked in sketch-books from A6 (10 x 14cm / 4 x 51/2in) up to A1 (60 x 84cm / 24 x 33in) but I generally use the more practical A4 or A3 sizes.

A detailed study

I couldn't resist drawing these gnarled and twisted trunks when I came upon them. This study is all about texture and really getting to understand the form of the wood wrapping around itself. I used a soft pencil in an A4 sketchbook and spent about an hour on it. As with most of the pictures in this section, it was done on location.

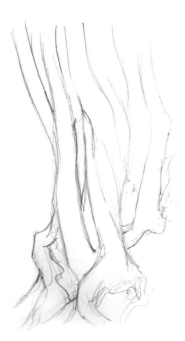

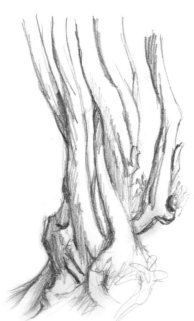

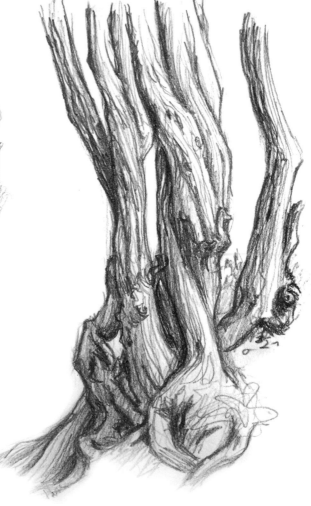

STEP 1
First I wanted to isolate each trunk and root and capture the directions of the twists in their form.

STEP 2
Some rough shading helped me to make sense of the individual masses within the subject.

STEP 3
I really enjoyed this stage, using the textural marks of the bark to build up the tone and describe the form. I added some knots, knobs and nodules along the way. As it was only a sketch, I could almost have finished at this stage, but I was having too much fun to stop.

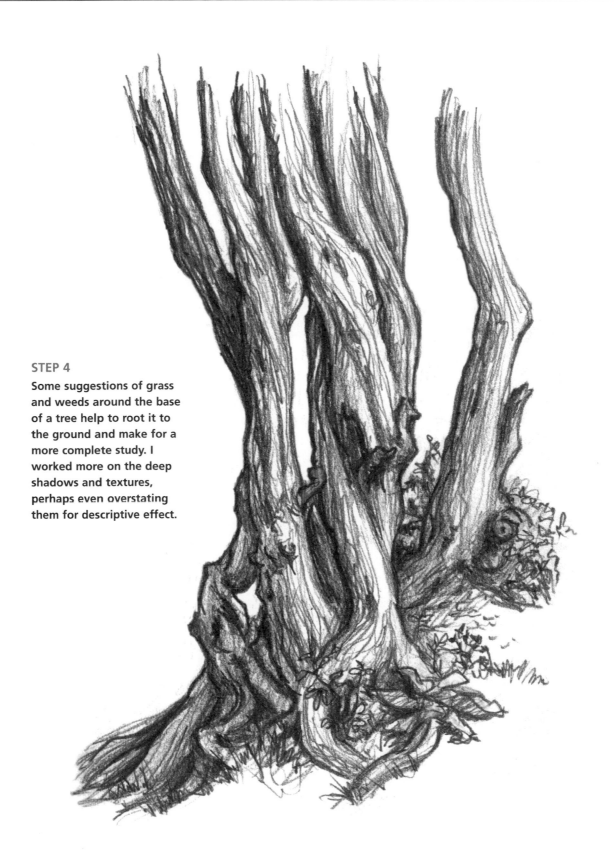

STEP 4

Some suggestions of grass
and weeds around the base
of a tree help to root it to
the ground and make for a
more complete study. I
worked more on the deep
shadows and textures,
perhaps even overstating
them for descriptive effect.

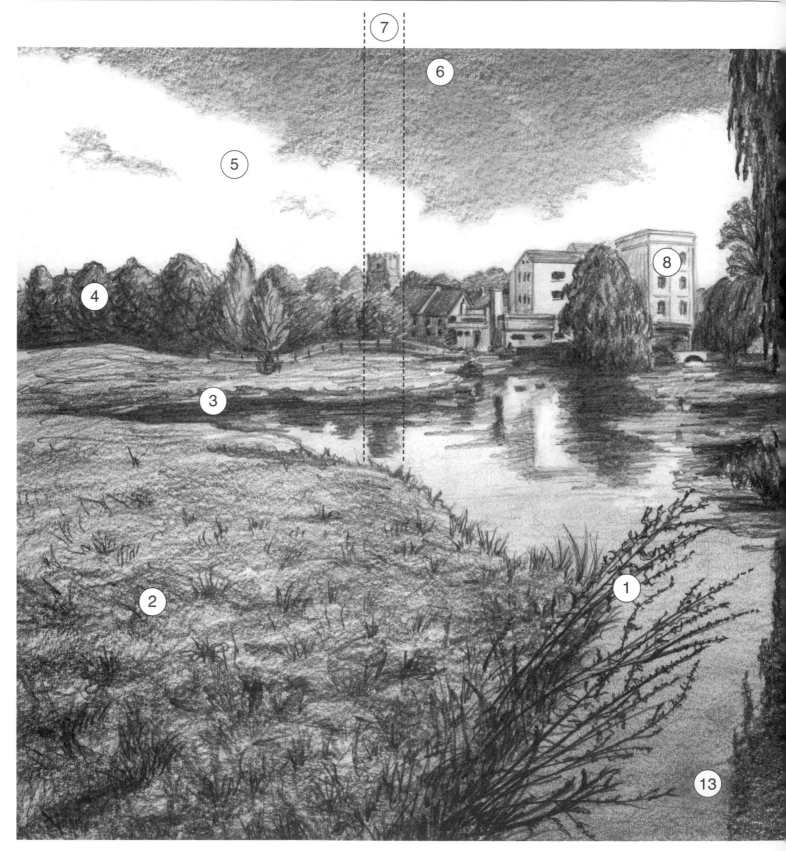

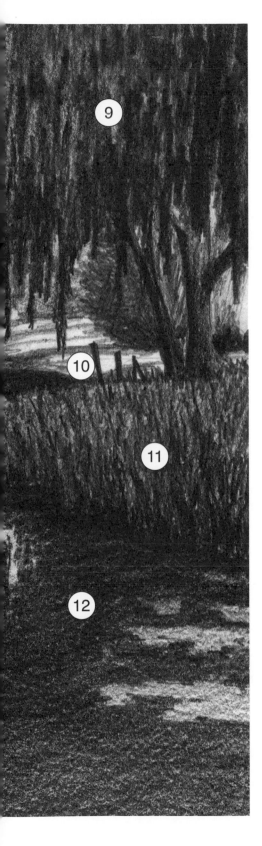

The big picture

When you approach making a full-scale landscape drawing there are a great many things to juggle. At first, the complexity of a large scene might be quite daunting, but some basic rules and hints, many of which we've touched on already, should make the subject easier to confront.

1
Reserve the richest tones and greatest tonal contrasts for elements in the foreground.

2
For larger featureless areas, find a texture to break up the monotony of the mass. The texture, like the tone should get bolder towards the viewer.

3
Water is usually dark where it meets the land.

4
Distant objects appear progressively weaker in tonal contrast, relative to those close up: The effect of 'aerial perspective'.

5
Try to leave the pure white of the paper for some areas of the drawing.

6
A clear sky gets progressively paler towards the horizon.

7
Reflections run directly vertical from source objects.

8
A focal point should not be rendered in significantly greater detail than its surroundings.

9
The quality of the marks you use help describe the character of trees and foliage.

10
Some simple silhouetting can be effective.

11
Long grass should be treated with different marks to short grass.

12
Reflections are at least as dark and normally darker than source objects, but diminish in intensity with steep angles of view to the reflective surface.

13
Reflections of sky are darker further down from the horizon.

Composition – selection

When you are deciding upon a scene to draw, the first step is to find a location that interests you. Beyond that, you'll need to consider a multitude of options about what parts of the scene to include and how to place them within the 'frame' of your picture area. Here are some croppings of my millpond scene to show the different kinds of pictures that can be selected from the same scene.

This is dull. The buildings and horizon are right in the middle of the picture and the overhanging foliage upsets the tonal balance. The scrappy detail around the edges is distracting.

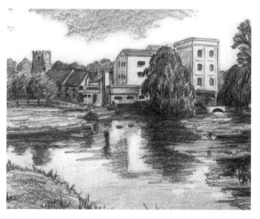

This selection zooms closer in on the buildings yet allows space for their reflections to play an active part in the composition. The higher horizon makes for a more decisive and effective use of space.

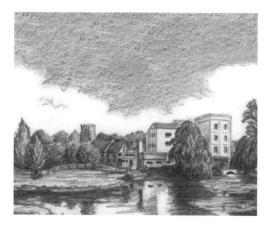

With a lower horizon, the water is largely cropped off and the sky is allowed space to be a main feature.

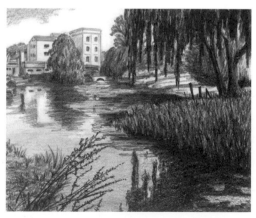

Here the sweep of the river leads the eye into the scene in a graceful curve. The darker tones bring a different feel to the picture.

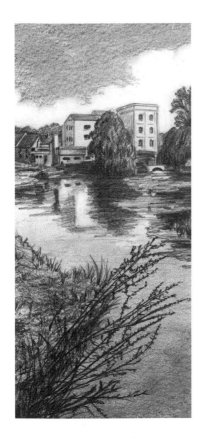

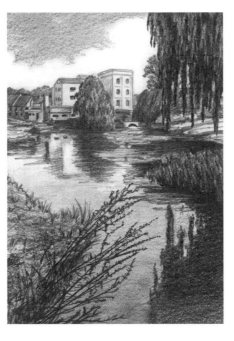

Just because your subject is a landscape, it does not have to follow a landscape format. This portrait format enhances the meander of the river to reveal a pleasing 'S' shape curve. The cropping is carefully considered for tonal balance.

This more extreme vertical framing reduces the scene to three layers of depth. Excluding peripheral detail can give a picture intrigue and impact.

An extreme horizontal format is similarly effective, lending the scene a cinematic quality.

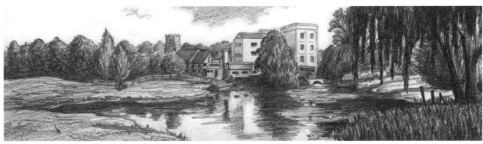

There's nothing to say you have to draw the dominant feature of a scene. This sedate composition focuses on the church tower and trees.

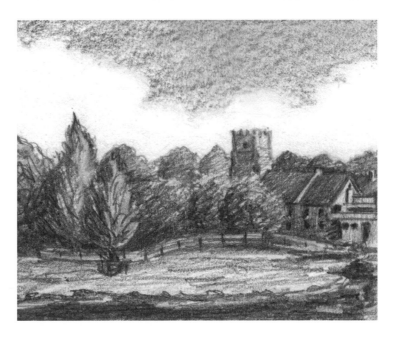

A landscape in pencil

Over the new few pages you can see the stages that I went through to make some landscape sketches in various media. I try to think afresh about each new subject and the appropriate medium and method. You're probably developing your own methods by now, so take the following examples as nothing more than suggestions for material, techniques and processes. The first example is a different view of the millpond we have just been studying. It is executed in soft pencil in an A4 sketchbook and took about half an hour to complete.

STEP 1

As usual, I started with a rough outline of the main shapes and dimensions. The composition is based around the large willow, placed off centre.

STEP 2

The initial shading was deliberately unfussy, roughing in all the main areas of shade with the same motion. The point here was to cover a lot of the white paper quickly, which moves the drawing along rapidly.

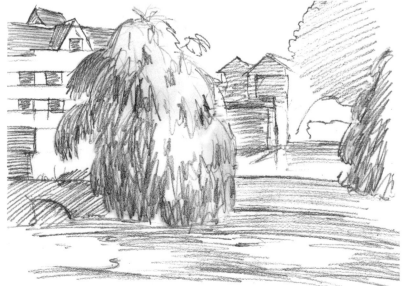

STEP 3

Next I made a closer analysis of the tones, applying heavier shading where it was needed and stating some of the details along the way. I adjusted the direction of the pencil strokes to suit the surface I was trying to describe.

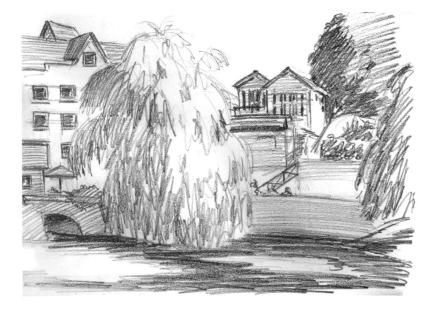

STEP 4

Working over the whole drawing, I honed the details, squinting my eyes to discern the tones. A few minimal bits of erasing were all that was needed to clean up and finish off, as most of the underdrawing is lost amid the shading.

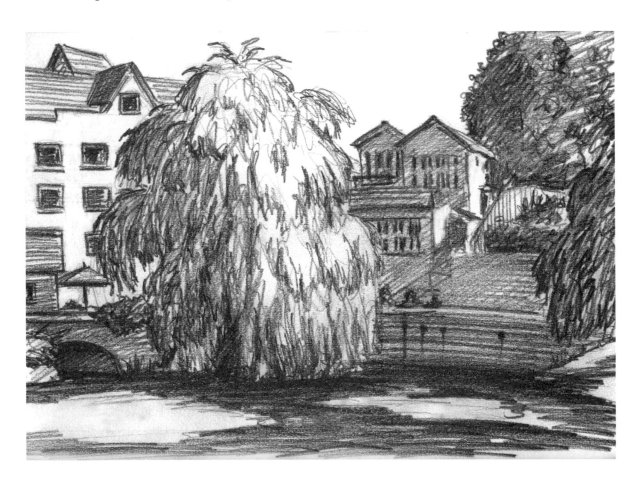

A landscape in charcoal

I chose charcoal for this sketch to render the dark and fairly flat tones. Again I did it in an A4 sketch pad and spent just under an hour on it.

STEP 1

In my initial pencil drawing,
I was aiming to place the reflections
accurately from the very start.

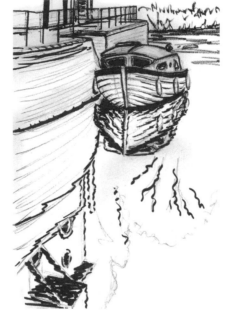

STEP 2

Charcoal being so unstable, I pinned
down the important dark outlines of
the picture with a black brush-pen so
that whatever smudging might occur
the drawing would remain in place.
I drew the outlines of the reflections
with a wavering broken line to
suggest the movement of water.
The tree branches would be useful
later to retain the character of those
parts of the reflections.

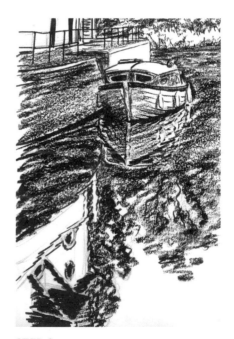

STEP 3

With a short length of charcoal,
I roughed in the areas of tone.

STEP 4

I used my fingertip to smooth over the charcoal to work it into the grain of the paper. I then applied charcoal again to deepen the tones where necessary.

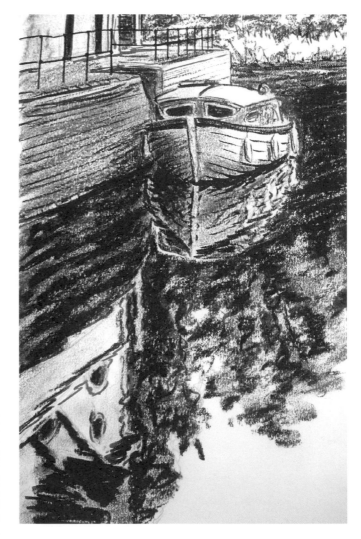

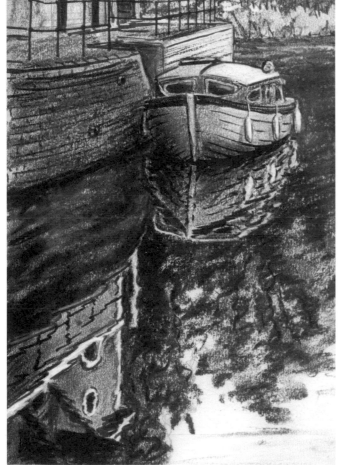

STEP 5

To finish the picture I gave it a general tidy up, smoothing out some shading here, adding touches of detail there and also pulling out some highlights with an eraser.

A landscape in pastels

Inspiration often strikes at inconvenient times and you may spot great subjects when you are busy or without materials. As long as you can jot down the essentials of a scene, you can work it up into a picture later. The great thing about landscapes is that once you are conversant with natural forms, textures and lighting, you can make up those details that circumstances prevent you from recording accurately.

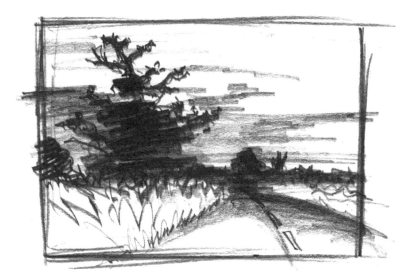

Driving in the late summer evening, I was struck by the silhouette of a dead tree and the verges illuminated by my headlights. I stopped the car, drew this rapid sketch and tried to commit as much detail as possible to memory. Once home I set about this pastel study, which took about an hour.

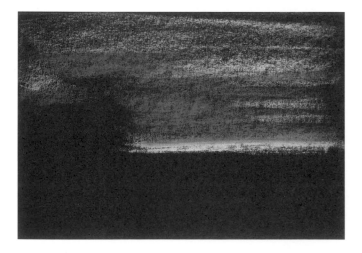

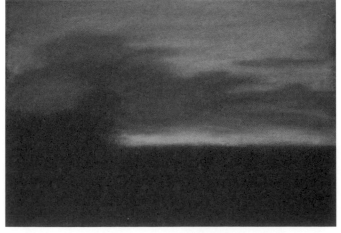

STEP 1

On some cheap, black craft paper I applied some sky tones in horizontal strokes using the sides of short sticks of white and grey pastel.

STEP 2

I smudged the pastels with a fingertip then added more layers of pastel to build up a smoothly blended night sky.

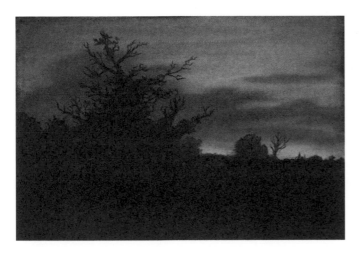

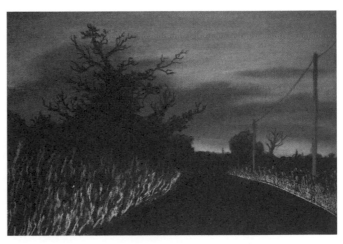

STEP 3

On top of the sky I added the next layer of the picture with charcoal, largely inventing the details of the branches and skyline.

STEP 4

Using artistic licence, I added some telegraph poles in charcoal and grey pastel and then mapped out the areas of illuminated grasses.

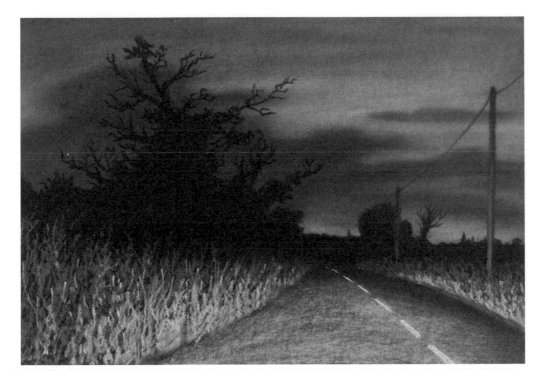

STEP 5

I worked on the details and mass of the verges in grey pastel and then in white on top for an extra layer of depth. The road surface was stroked on with the side of the white pastel stick and smoothed over with my finger. I added the white lines and some highlight on the nearest telegraph pole.

A landscape in scraperboard

Scraperboard can be bought in sheets of various sizes or in packs that come with a scraping tool. It's an enjoyable medium that allows you to draw with pure white on solid black, the tool scraping away the black surface to reveal a chalky layer underneath. It's portable enough to be a sketching material, but is more commonly used for detailed pictures of carefully considered tonal contrasts.

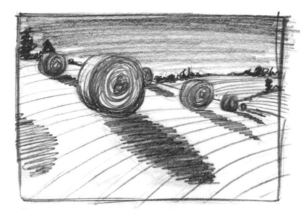

Some time ago, this scene caught my eye and I made a pencil sketch for possible future use. It's a good scraperboard subject because of the deep shadows and the texture of stubble in a harvested field.

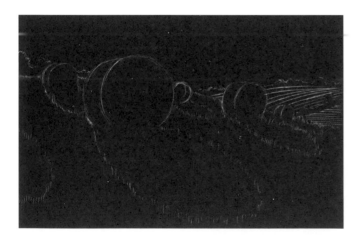

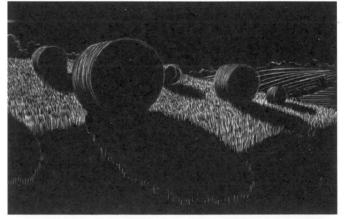

STEP 1

With the fine point of the tool, I established the outlines of the main shapes.

STEP 2

Starting to scrape away the detail, I was careful to make the marks follow direction and describe texture. I worked on the stubble from the distance forwards.

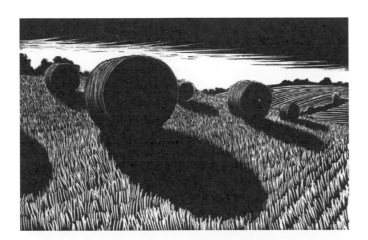

STEP 3

From the middle ground forwards, the stubble had to be set down in rows to convey the feel of a harvested field. Using the broader edge of the tool, I made the marks bolder as I worked down the picture. I started on the sky, intending to make it completely white, but at this point I liked the effect and decide to leave it with a suggestion of dramatic cloud.

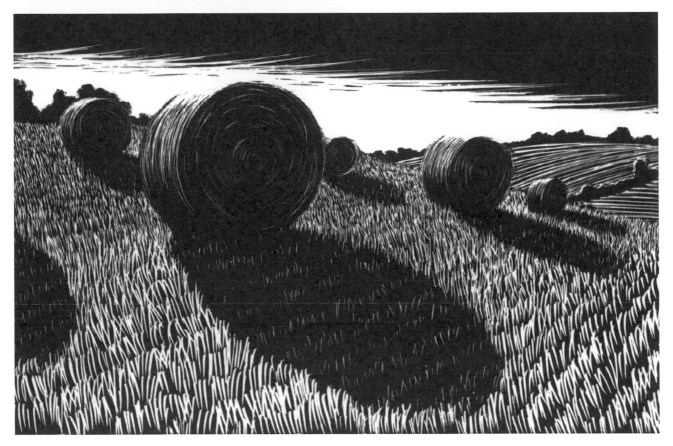

STEP 4

To finish, I brightened the highlights on the bales and scratched in some broken detail in the shadow areas to break up the masses of solid black.

Liberties with landscape

Up until now, the landscapes that we have worked on have been drawn from directly observable locations. As you have seen, it is important to consider your selection of subject, viewpoint and framing to bring the best out of a view. With the last two examples though, I worked from a mere impression of the scene and effectively invented the details. Rather than faithfully reproducing what exists in reality, you can apply a similarly creative approach to any picture you draw. For as long as people have been drawing, artists have meddled with the visible world to suit their needs. Remember that as an artist you do not have to be a slave to nature.

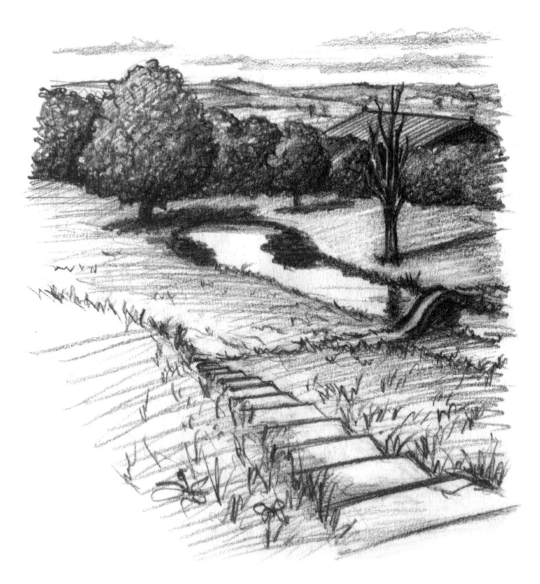

This is a scene I drew from life. Despite some interesting elements, it is not a particularly pleasing view. The roof of an industrial unit spoils it somewhat, as does the dead tree. Compositionally, the direction of the steps and the placement of other details could be improved.

Lines of trees varied

Tree removed

Bridge moved to
more prominent
focal point

Shadow added to
balance the tones in
the composition

Steps enlarged and
curved to lead the
eye gracefully into
the picture

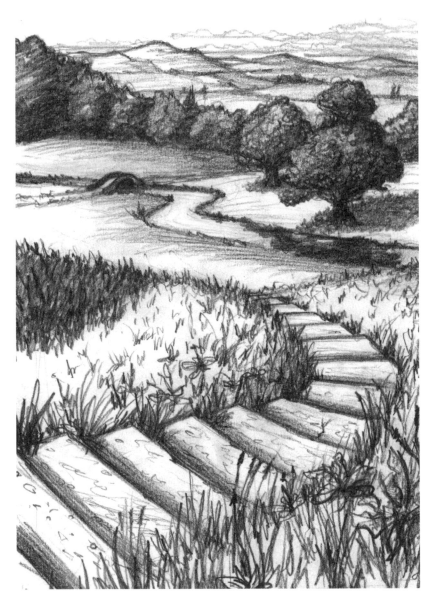

Height of hills
exaggerated

Factory removed

Tree restored to life

Odd shaped lake
changed to a
meandering river

Strong plant forms
in foreground for
pictorial depth

Here is a reworking of the scene, done at home. When you make such changes, remember to adjust shadows and reflections as appropriate. In practice it's unlikely that you would want to change so many elements – if it's that unsatisfactory, you would do better to look elsewhere for inspiration! My changes are merely a demonstration of what kinds of creative alterations can be made.

Inventing landscape

From selection, omission and manipulation of natural scenes it is only a short step to making up landscapes to your own specifications. With experience of sketching natural forms and textures and with reference drawings and photographs to work from, there are no limits to the worlds you can create on paper. Here's a breakdown of my procedures for creating a spooky landscape scene, with a distinctly illustrative feel.

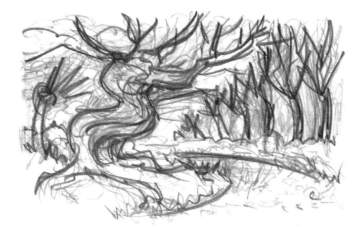

A scruffy sketching manner is good for exploring possibilities. I produce many of these before I settle on a composition to work up.

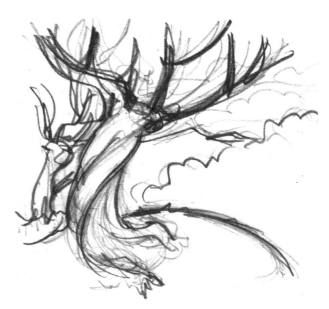

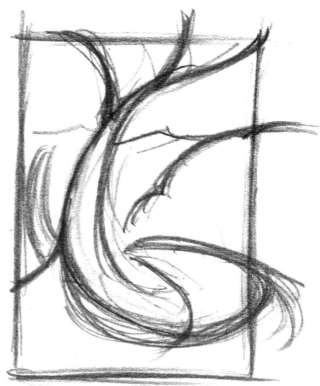

Honing down the sketch, I could see that it might work well in a narrower format.

After stripping the design down to its elementary compositional elements, I settled on a framing that I was happy with.

STEP 1

I expected to work in detail, so I used a fairly robust sheet of drawing paper and drew the main elements of the composition and shapes with an HB pencil. The tree shapes are based loosely on sketchbook pieces.

STEP 2

As the foreground tree is by far the most dominant element, I made sure it was convincingly formed.

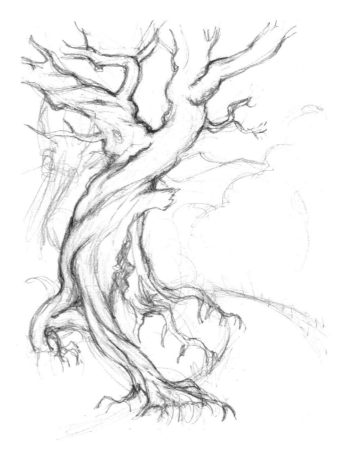

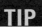

TIP

If something doesn't seem to work, it's best to change it immediately you realize this, rather than continue and hope it will come together in the end.

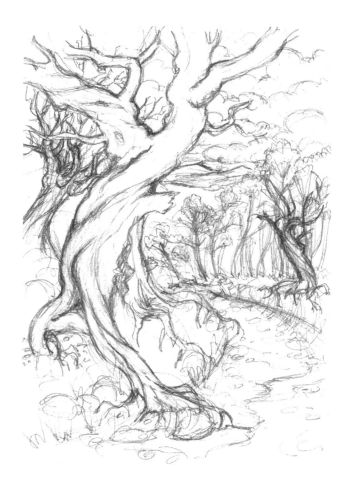

STEP 3

I designed the other tree shapes and details, working from the foreground backwards towards the horizon. The sky is not based on any real observation of clouds – I treated it as a textural element to break up the white of the paper.

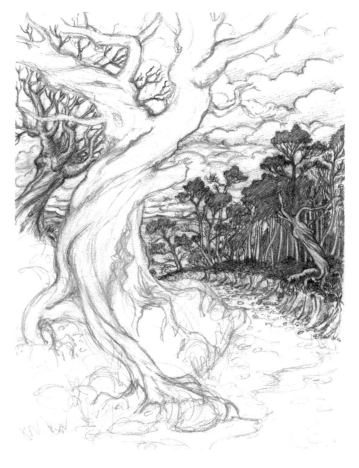

STEP 4

With the underdrawing in place, I sharpened my HB and started on the final pencil work. I now worked from the background forwards, paying particular attention to the trees of the middle ground. It became apparent that the high horizon looked odd, so I erased the distant hills and redrew them lower down the page. Filling in further clouds, I could consider the background finished for now. The sky is not based on any real observation of clouds – I treated it as a textural element to break up the white of the paper.

STEP 5

Switching to a 4B pencil, I rendered the foreground tree. The change of tone given by the soft pencil had the immediate aerial perspective effect of pulling this part of the picture forward in space.

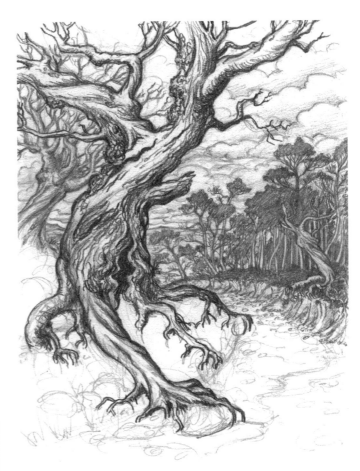

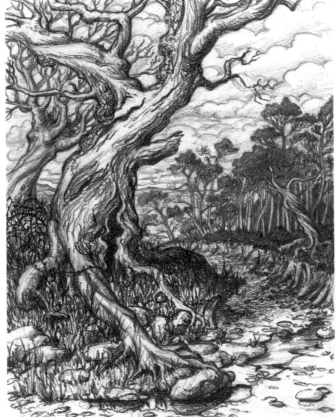

STEP 6

Further details and textures drawn from my head completed the foreground. With my soft pencil, I worked into the tones of the middle ground to darken the shading and smooth the tonal transitions from foreground to background. Although this landscape is invented, the usual rules of aerial perspective are needed to make it believable.

Landscape as design

Once you free your mind from wanting to set down things exactly as nature presents them, you will gain even more enjoyment from drawing and also move closer to developing your own unique style. It's a valuable experience to try drawing pictures with great economy. Through self-imposed restrictions you will be forced to invent solutions that may feed into other areas of your work. One interesting approach is to restrict yourself to working in only solid black and white.

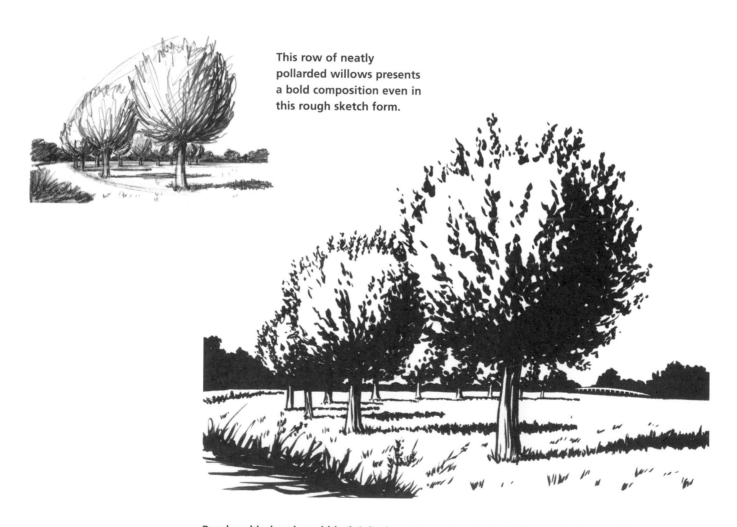

This row of neatly pollarded willows presents a bold composition even in this rough sketch form.

Rendered in brush and black ink, the picture adopts a bold illustrative feel. With no shading or mid-tones to fall back on, you are forced to make the stark decision between either black or white for each part of the picture, while maintaining clarity of design.

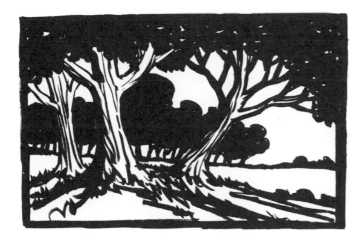

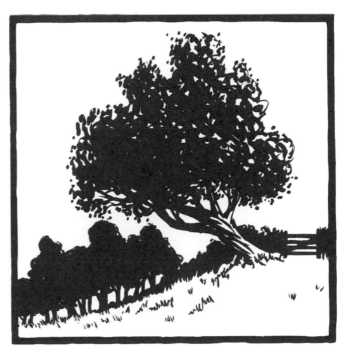

Landscape forms lend themselves well to strong, simple designs, which can be based on observed scenes or conjured from the imagination. Try to create some of your own as exercises in simplification and planning.

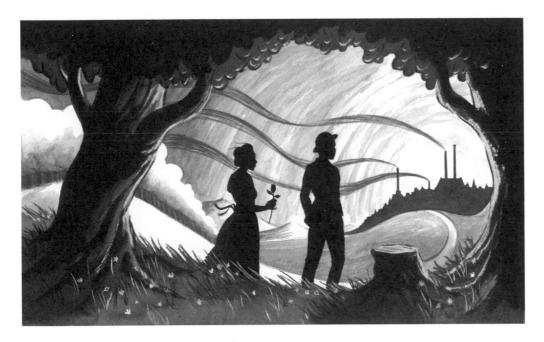

Setting naturalism aside, landscape features can be used purely as design elements. For this book illustration the foreground trees and grass form a kind of frame. The undulating background is heavily stylized and serves to lead the eye to the distant town.

GOING TO TOWN

Wherever humans have lived, they have made their mark on the landscape. Old and new, rustic and urban, every building is in some way unique and offers its own challenge to the draughtsman. Tell-tale details convey a building's character, purpose, prestige and period, yet for all their variety and complexity, structures of any size can be reduced to common forms that facilitate our drawing of them. Complicated angles of perspective can be ordered into demystifying diagrams.

Where there are buildings, there are cars, clutter, ruin and rubbish, which the artist can choose to overlook or embrace as worthy subjects. With experience you may take all manner of liberties with the built environment, through selection and distortion. You can even create images of buildings that do not exist in the observable landscape.

We have all spent much of our lives surrounded by walls. Perhaps this is why buildings can provoke in us certain feelings and associations. Using appropriate techniques and materials, we may convey something of those moods or atmospheres that words may not easily describe.

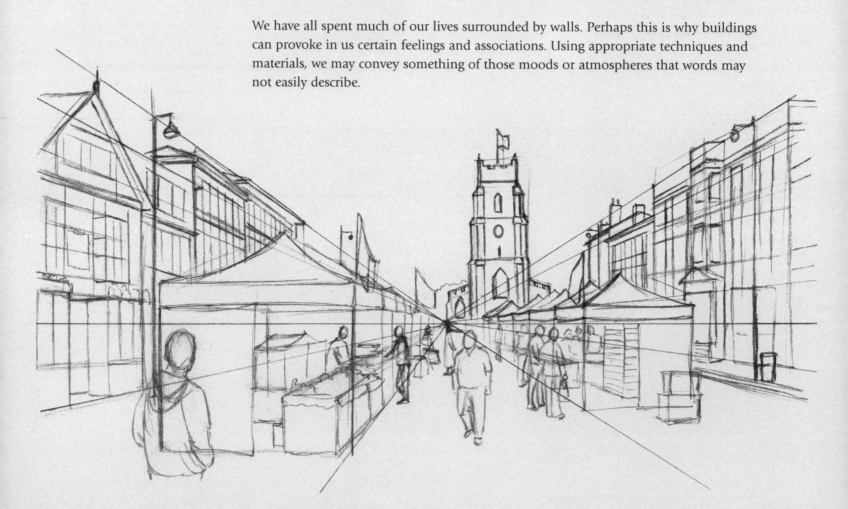

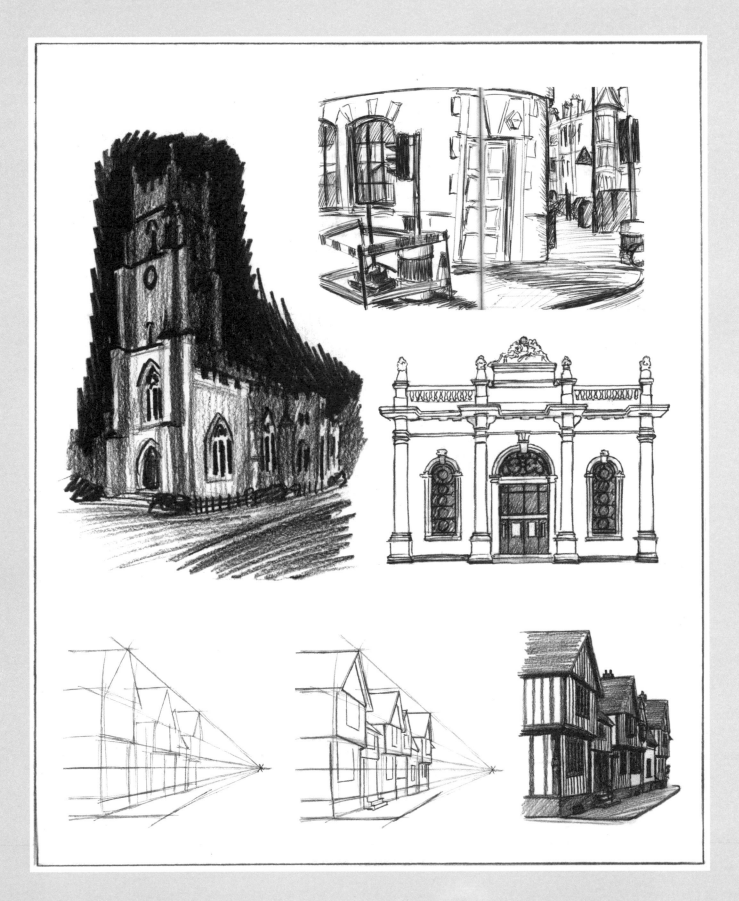

Going to town

When it comes to drawing architecture, it's easy to feel overwhelmed by the complexity of structure and detail. But drawing buildings is no more difficult than many still life or landscape subjects – you only have to recognize that they are composed of essentially simple shapes.

As you discovered on page 17, an elementary three-dimensional house is an easy shape to draw.

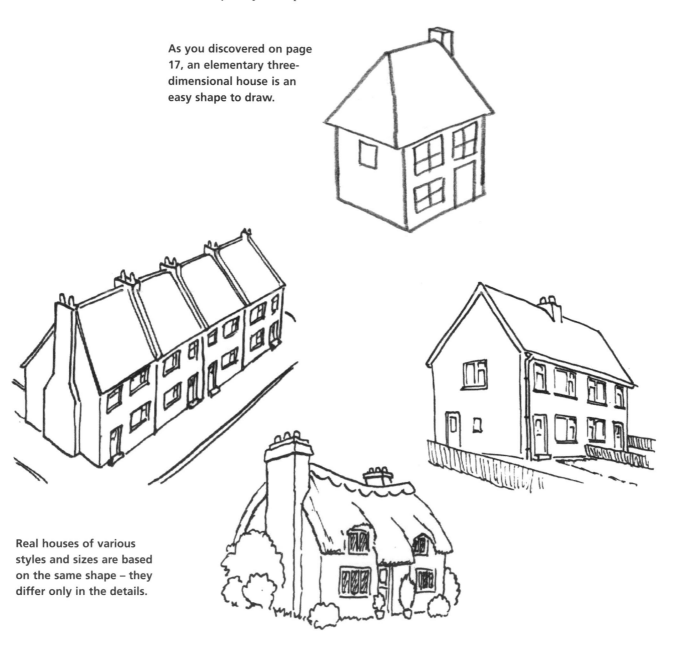

Real houses of various styles and sizes are based on the same shape – they differ only in the details.

112

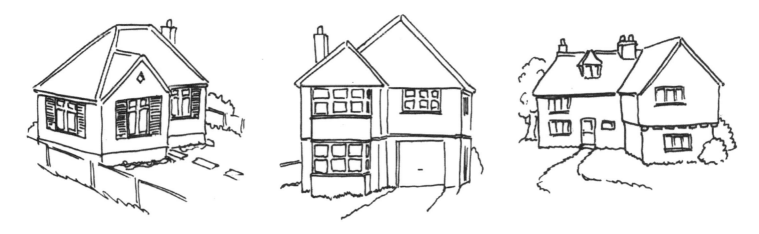

Where houses depart from the basic box shape, they are often composed of two or more of the same shapes attached to each other. However, the differences between buildings are as important as their inherent similarities. A mere glimpse of these houses, simply drawn as they are, is enough to inform the viewer of their age, size and prestige. It is all in the detail, styling and proportions.

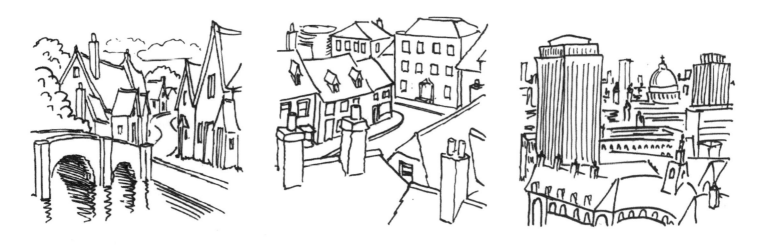

If you can draw one house, you can draw another one next to it and one opposite that and so on, until a street scene emerges. Again, very little drawing is required to distinguish between a sleepy village, market town and bustling metropolis.

The grid

Because there is order and design in buildings, you can use structural guidelines to help you make sense of even complex architectural schemes.

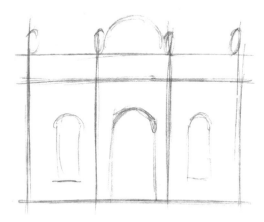

STEP 1

As with any drawing, start by lightly sketching the rough shapes.

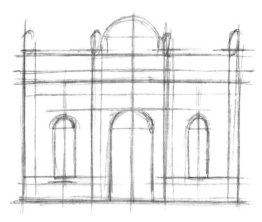

STEP 2

Looking carefully, it's clear that all sorts of details line up with others, vertically and horizontally, so it's quite simple to build up a grid of guidelines to help place things.

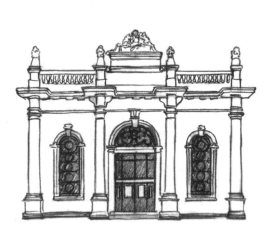

STEP 3

The grid breaks the drawing down into clearly marked sections. Details can then be drawn onto the relevant lines with confidence and even a touch of spontaneity. Well-drawn guidelines make this possible.

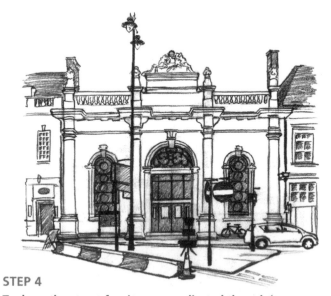

STEP 4

To draw the street furniture, complicated though it may look, is quite simple if you think of the building as a grid on which to place the various objects. Remember, you are at liberty to include or omit whatever you choose.

I did this large-scale drawing in felt-tipped pen and charcoal over a couple of hours. I used the buckled fencing as a feature; it also served as a convenient grid to help me place the architectural details. I was happy to let the grime and crookedness of the foreground influence my handling of the buildings.

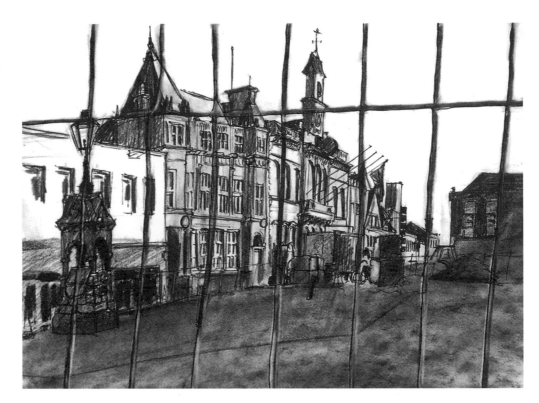

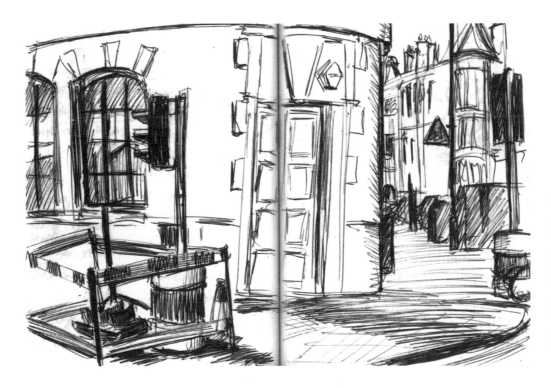

I rather enjoy drawing the clutter of the streets. It's as worthy a subject as any other and it can be liberating to draw something messy. Here's a drawing across two pages of my sketch-book, executed in ball-point pen in about 20 minutes.

One-point perspective

Newcomers to drawing often become over-anxious about perspective, but there's really no need. In fact, you will have already used perspective. In drawing the most rudimentary box you will have judged the angles by eye or by holding up your pencil. Consequently, studying perspective only brings greater clarity and order to what you do already.

The simplest form of perspective is for objects that are facing towards you on a level surface. All verticals, as you'll expect by now, remain strictly vertical and all horizontal lines on front-facing planes are drawn strictly horizontal. But those lines that recede from your view do so at angles that are easy to identify. This is known as one-point perspective.

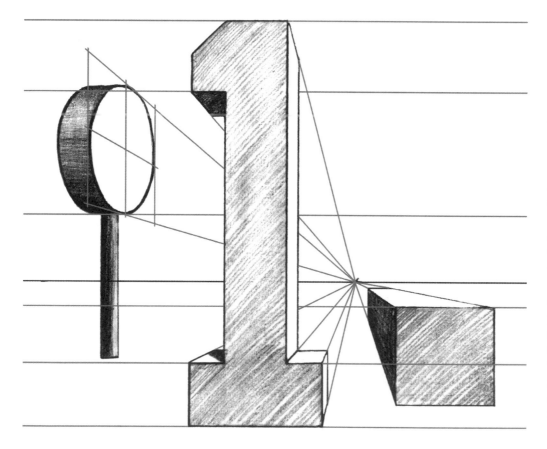

The secret to getting perspective correct is in identifying the horizon, that is, the level of your eye in relation to the objects. Imagine you are standing in this diagram, in front of enormous blocks. Your eyes are level with the black horizon line. That means you can look down on the top of the rectangular block but look up at the ellipse opposite. Your position along the horizon determines the 'vanishing point', that is, the point at which receding angles meet. So here you are positioned between the number 1 and the rectangular block. From the vanishing point, a ruler will clearly indicate the receding angles, including those you need to draw an ellipse.

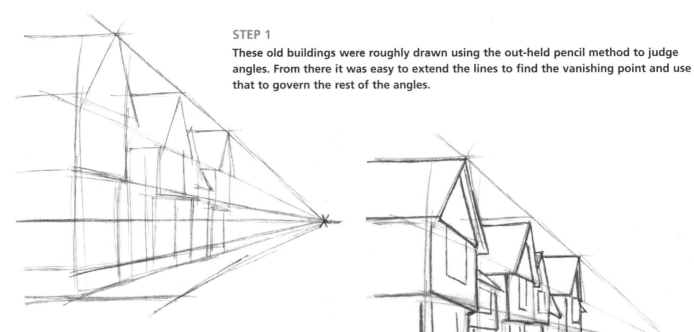

STEP 1

These old buildings were roughly drawn using the out-held pencil method to judge angles. From there it was easy to extend the lines to find the vanishing point and use that to govern the rest of the angles.

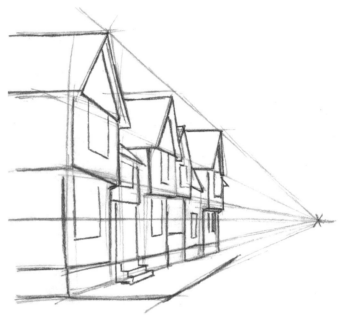

STEP 2

The perspective lines and the vertical lines form a grid to guide my drawing of the buildings, windows and details. I deliberately skewed some lines to show the buckling of the old structure, and also to demonstrate how divergences from the perspective grid are quite noticeable in a drawing.

STEP 3

With strong outlines in place, the guidelines can be erased and detail added, for a bold, unhesitant finished picture.

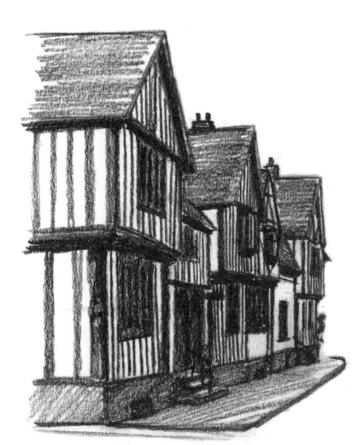

One-point perspective in practice

In this more formal drawing I have used one-point perspective to order a quite complex scene of a market place.

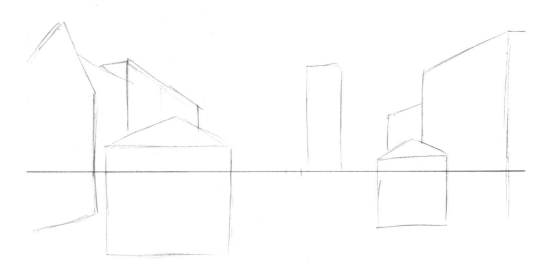

STEP 1

After settling on a horizon, I roughly placed the main blocks of the scene relative to my eye-line.

STEP 2

Next I established the vanishing point and used a ruler to set down the main guidelines.

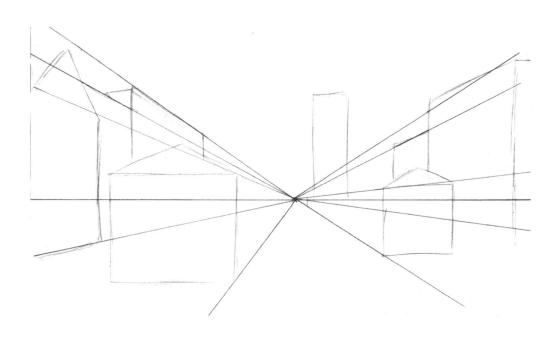

STEP 3
Following my guidelines,
I could draw the main
blocks of the buildings and
market stalls accurately.

STEP 4
As I gradually honed the
details, I placed windows
and other features among
the guidelines, always
keeping that vanishing
point in mind.

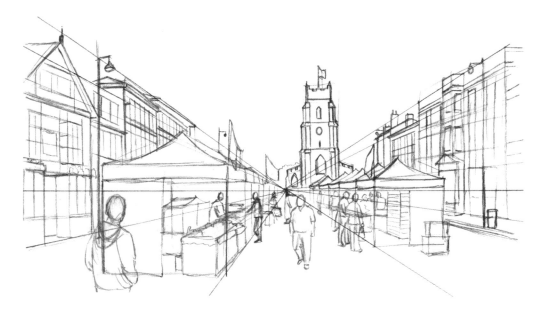

STEP 5

More details brought the scene to life. People are easy to put in place using the horizon. From my viewpoint, standing on a step, my eye-line was slightly above the heads of the people on the ground, so their heads sit just below the horizon.

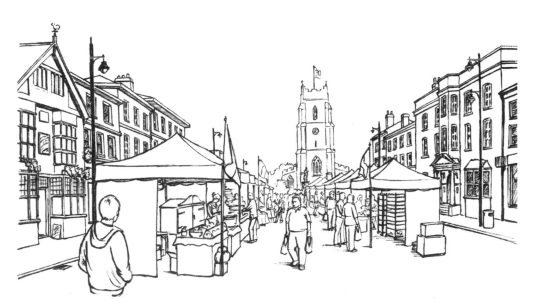

STEP 6

This being a complicated scene with lots of fiddly guidelines, I chose to do the good linework in ink, with a fine-tipped drawing pen. This meant that I could erase all the guidelines in one easy action without harming the drawing. It took a lot of time and patience to ink so many windows and details. I used a slightly broader pen to strengthen the lines of the foreground and thereby establish a sense of aerial perspective. A few strokes of shade at the feet of the people plant them firmly on the ground.

STEP 7

To add some tone I used some black watercolour paint applied with a medium (No. 6) round watercolour brush. It takes a bit of practice to use watercolour, so do some trials on scrap paper first. The secret is to keep the brush well loaded with paint, apply it in broad strokes and then let it dry. Watercolour can tend to make your paper buckle, so a heavy grade of paper is advisable.

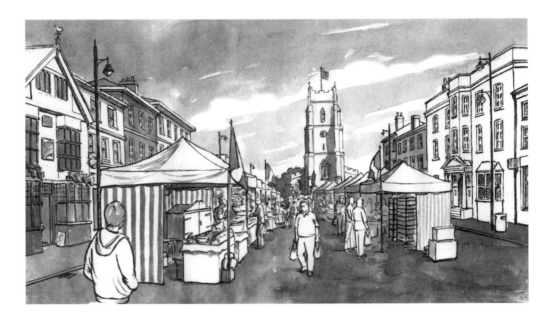

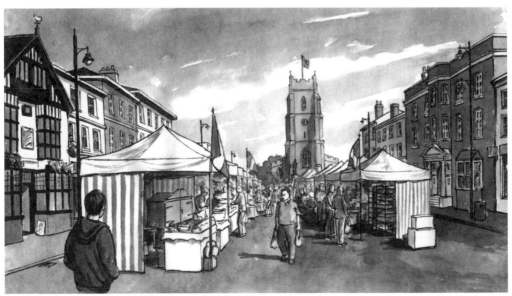

STEP 8

Going over selective details with less diluted watercolour gave me an adequate range of tone to finish the picture. I could have carried on refining the tone, but that would have made the picture heavy and overworked. I was happy with quite a loose rendering.

Two-point perspective

As you may have guessed, one-point perspective does not address all potential perspective problems. More commonly seen and used is two-point perspective, which comes into play when objects are viewed from an angle.

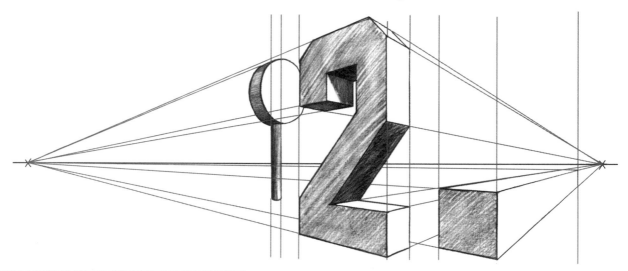

Here the diagram is viewed from such an angle that none of the blocks is seen straight on. That means that both front and side faces recede from view and so therefore do the angles of their construction. Vertical lines are still drawn the same, but all horizontals, except the horizon, are angled upwards or downwards towards either of two vanishing points.

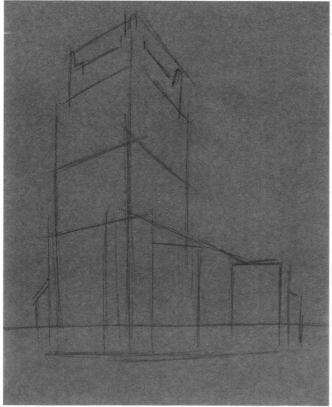

STEP 1

The church in my market square, when seen closer up and at an angle, provides a good exercise. A rough drawing, judged by holding the pencil out, sets up a reasonable approximation of the proportions and angles of perspective.

STEP 2

Extending the lines of my rough drawing, I could set down some vanishing points on the horizon and then use these to draw a perspective grid. I had to attach extra bits of paper to accommodate the vanishing points and ruled guidelines.

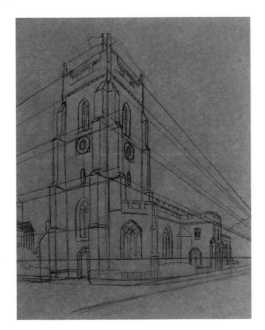

STEP 3

I could now correct the misjudged angles of my rough sketch. The details of the church were relatively easy to place within the framework of guidelines, though they did take a bit of analysis.

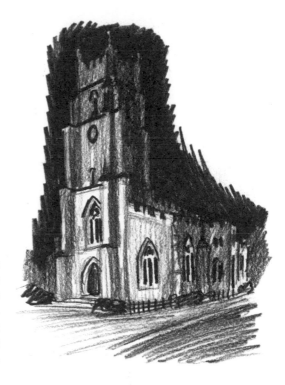

Here's why I was working on toned paper; I wanted to show the church as it is when illuminated at night. This hastily scribbled sketch provided all the lighting information I needed.

STEP 4

So that I could erase all the guidelines, I firmed up the drawing with a felt-tipped drawing pen. I also used the pen to shade some of the details that I knew would be solid black in the finished picture.

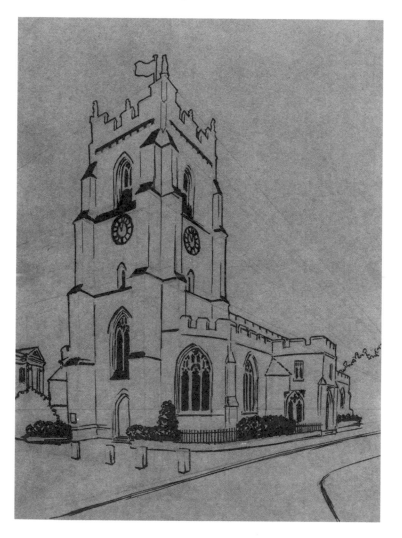

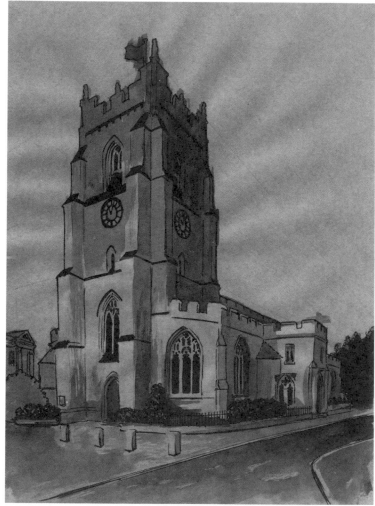

STEP 5

With some diluted black watercolour I roughly added an extra layer of tone, referring to my sketch. I was not too worried about going over the lines. You can see how the watercolour has made my thin paper buckle.

STEP 6

Painting the sky in solid black ink brought instant atmosphere. I also darkened a few areas with more watercolour.

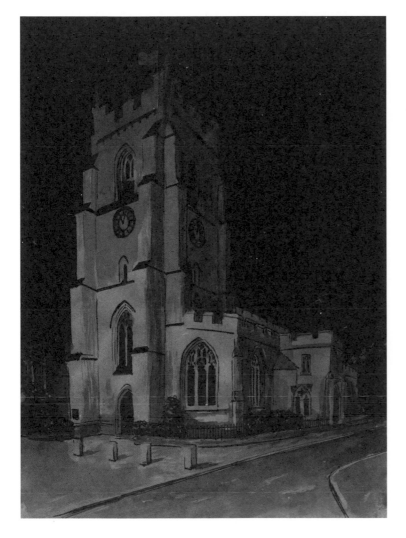

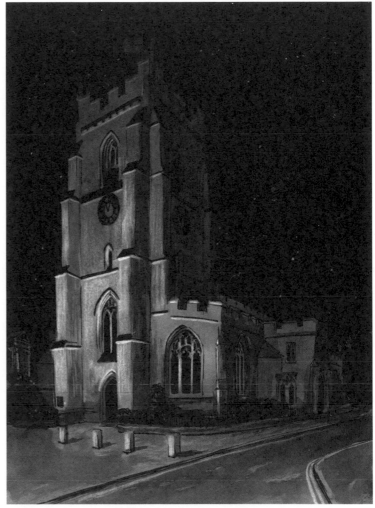

STEP 7

The final touches were added with strokes of white chalk, shaped with a flat edge for the stonework and sharpened to a point for the fine details. It's always enjoyable to add the highlights that bring a picture to life, but don't overdo it. Allow some of the original grey paper to show in places.

A working knowledge of perspective will prove invaluable for all manner of subjects and nearly every kind of architecture. When you have grasped the principles, it will be relatively easy for you to adjust perspective views or create new ones. I devised this scene from my imagination, based on some reference photographs. Perspective allowed me to construct a convincing drawing.

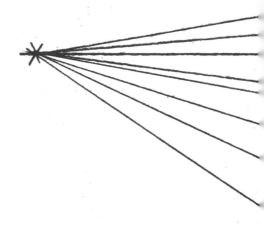

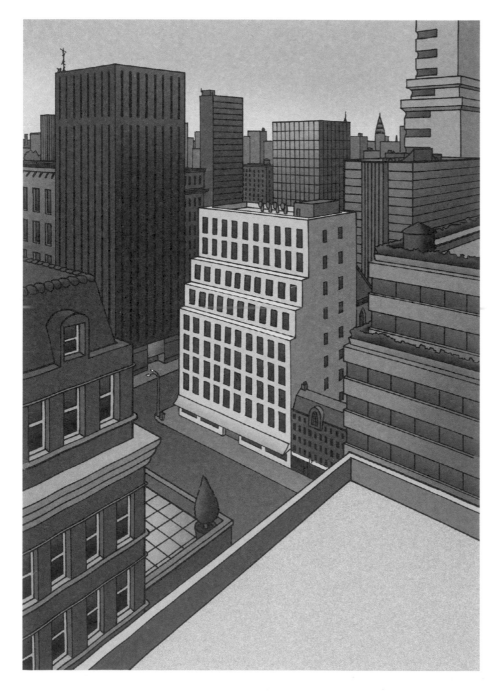

In this scene the eye is led into the picture rather than away from a central object, as in the picture of the church . But its construction follows exactly the same principle; every horizontal line goes to one of two vanishing points.

When the lines of perspective are included you can see that the distant buildings are clustered along the high horizon, or eye-line. You'll notice that these buildings, as a mass, meet or extend above the horizon. In the middle distance and foreground, every rooftop, ledge, balcony and pavement follow the same perspective scheme.

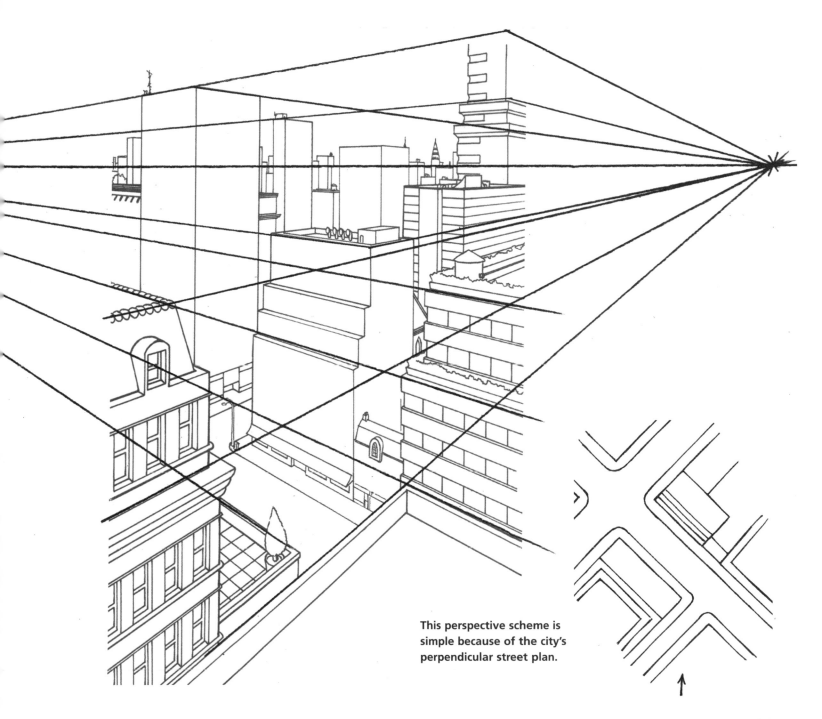

This perspective scheme is simple because of the city's perpendicular street plan.

Multiple vanishing points

Two-point perspective can get more complicated when buildings do not follow a perpendicular street pattern. In this street plan the structures are laid out at odd angles to each other. Constructing the perspective of such scenes requires you to think of each building individually and identify seperate vanishing points for each.

STEP 1

This bus shelter is easy to draw. It's virtually one-point perspective, the second vanishing point being so far away that its recessive effects are negligible. I inked this in black and grey marker pens to avoid confusion with later pencil work.

STEP 2

For the background block of buildings I found a new vanishing point, entirely distinct from that of the bus shelter. The buildings' other vanishing point is so far off the page that it's impractical to draw it, but its angles can be reasonably judged by sight.

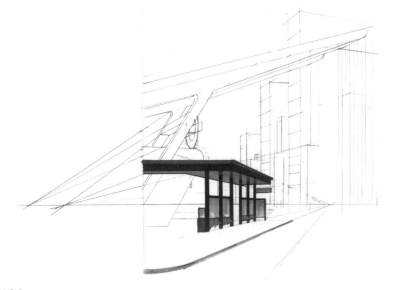

STEP 3

To further complicate matters, another structure in the middle ground is laid out at yet another angle and so another vanishing point is required.

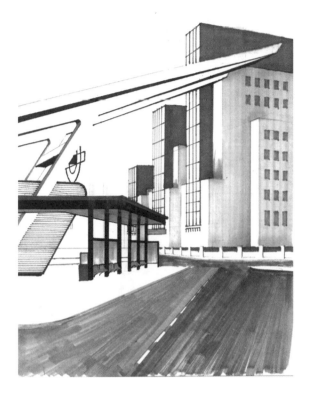

STEP 4

Once the drawing was established, I could start to introduce tone. To create depth, I refrained from outlining the distant buildings in black and instead used fine grey marker pen. After outlining I erased the network of pencil and laid in some flat tone with broad-tipped marker pens.

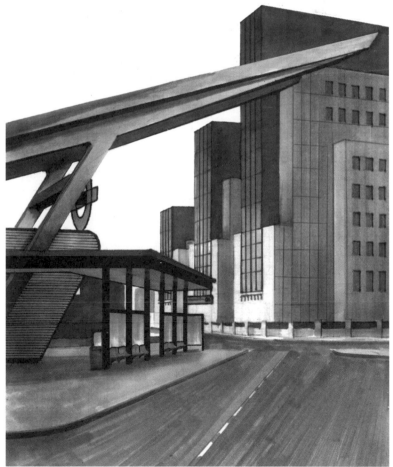

STEP 5

I finished the picture by building up the tones in layers. Marker pens are not easy to use, especially on intricate details. Their use is explained more fully on pages 132–3.

Cars

The modern town or landscape that escapes the intrusion of motorcars is rare indeed. Their shapes may be complicated but, as with buildings, a perspective grid is a very helpful drawing system.

This vehicle is drawn from quite close up with a low eye-line, making for a dramatic angle of view. Perspective lines guide the drawing of many elements of the bodywork and the ellipses of the wheels. However, unlike a building, there are few, if any, truly vertical lines, so the angles of uprights must be judged by eye.

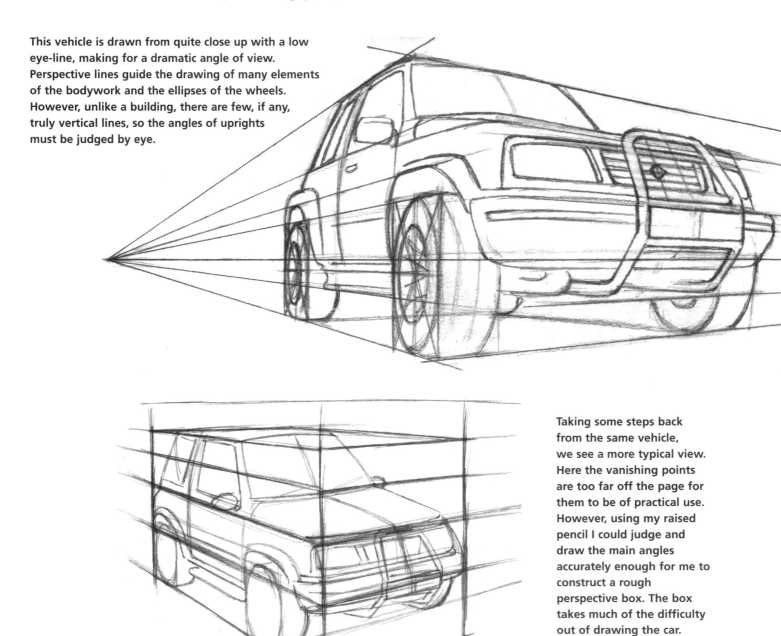

Taking some steps back from the same vehicle, we see a more typical view. Here the vanishing points are too far off the page for them to be of practical use. However, using my raised pencil I could judge and draw the main angles accurately enough for me to construct a rough perspective box. The box takes much of the difficulty out of drawing the car.

Not all vehicles are angular and suited to drawing with a perspective approach. This is the first stage of my sketching the curved and rounded lines of a sleek sports car.

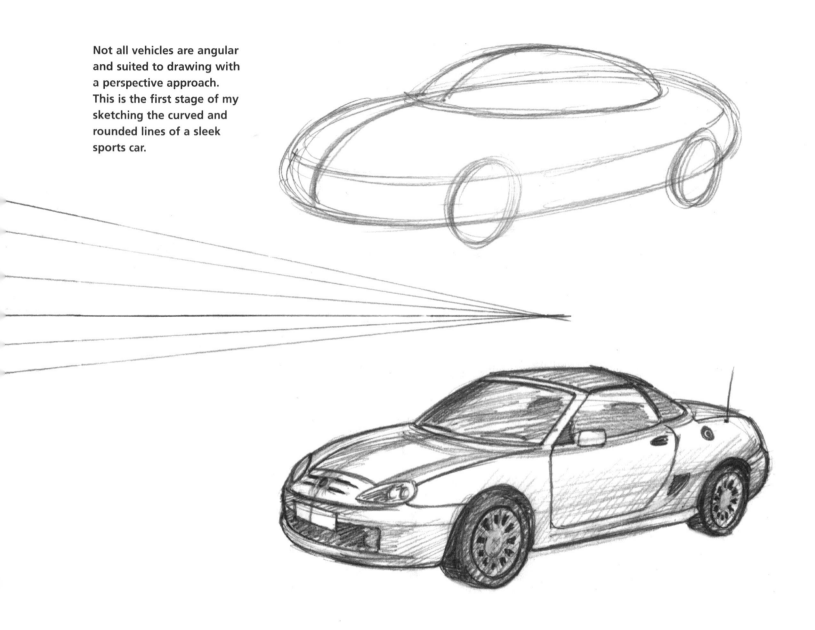

Given quick but well-proportioned under-drawing, cars like this can be sketched quite quickly. A lot of technical subjects can be drawn without the need for complicated perspective analysis. It's easy to get too hung-up on perspective. As you gain experience, perspective will become a matter of instinct and you will be able to sketch complicated structures quite freely from observation alone.

Shine and sparkle

One of the most striking features of a new car is the deep and reflective lustre of the bodywork, which requires some care and attention to render. For this exercise I used several shades of artist's marker pens. These are expensive and require some practice to master, so think carefully before investing in some. Similar effects can be achieved by supplementing black ink with pencil, charcoal or watercolour.

STEP 1

This is the second stage of the drawing, traced clearly from a scruffy original sketch. To trace, stick the original to a window with the fresh paper on top of it. The light passing through the paper will permit you to see the drawing clearly.

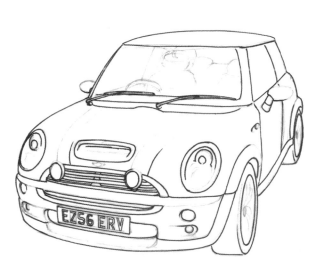

STEP 2

Outlines should be drawn in confident, fluid actions. Turn the paper to allow your hand to follow its natural arc for each new line. Resist outlining everything; some outlines are best left to be delineated by tonal shift or highlights.

STEP 3

It's easy to over-ink this stage. Look closely to identify those areas that reflect no light at all and paint them with solid black ink. Like the polished metal on pages 56–57, the shine on glass and paintwork is formed by reflections of surrounding objects. On the side a distorted car is visible and you can see a shop front in the windows.

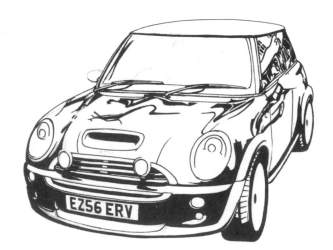

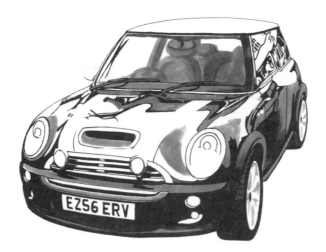

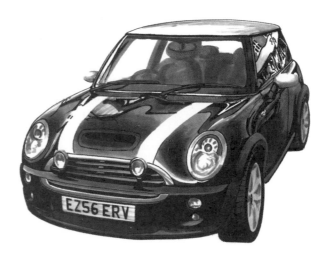

STEP 4

Start the shading with bold blocks of the most obvious tones. Work systematically across the picture so that you can keep track of what goes where.

STEP 5

Build up the tones until you achieve the desired finish. Try to leave some parts of the car pure white for the full tonal range. Blending the tones takes some skill with markers, so practise blending effects on scrap paper.

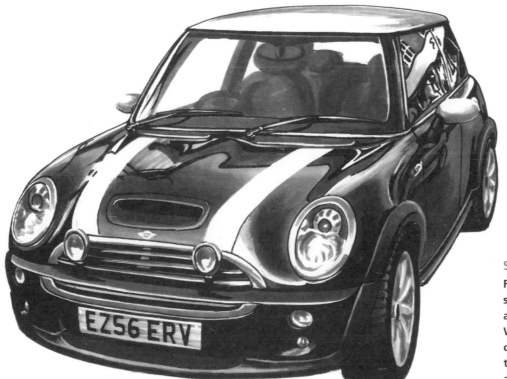

STEP 6

For the last stage I used a fine sable brush to paint highlights and trimmings in white ink. Watered down, white ink can also add muted accents to dull surfaces such as rubber and plastic.

Ruin and decay

Drawing man-made structures with a vigorous approach can be as rewarding as lavishing time and application on them. A good exercise is to draw things that have character through age and neglect. Such themes release you from any innate need to make your drawings clean or precise and are usually all the more enjoyable for it.

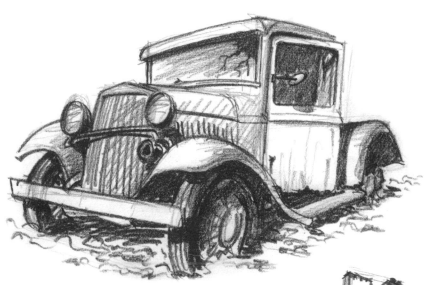

Despite the twisted frame of this old car there's perspective at work here, even though I was hardly aware of it as I drew. It takes a little sketching experience before these things become instinctive, leaving you free to enjoy other elements of a subject.

Sometimes you need to work hard to make something look rough. Crumbling walls, cracks, fallen timbers all needed to be drawn with distinctive marks to describe this condemned building. As is the nature of masonry, the perspective remains rigid despite the decay.

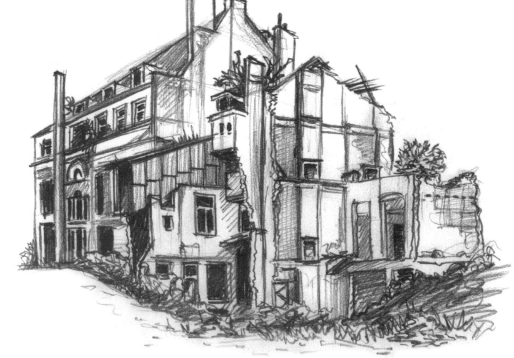

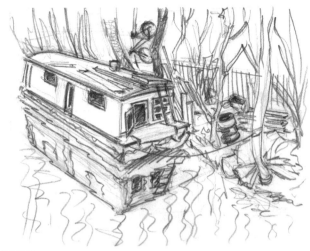

STEP 1

Scenes of neglect can start with the roughest of underdrawings. Notice how the perspective of the barge's reflection runs to the same vanishing points, as if an identical barge is glued to the underside.

STEP 2

In firming up the outlines, my lines were scratchy and carefree. I kept the marks for the barge, trees, reflections and debris distinct from each other. There really was a bicycle stuck in a tree!

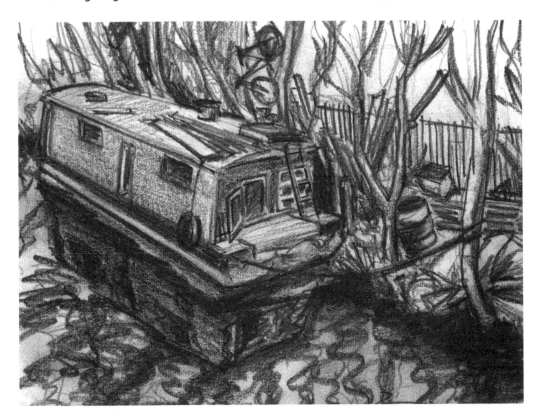

STEP 3

With a heavy graphite stick, I enjoyed pushing tone around, smudging and virtually attacking the paper. When working with heavy tone it is important to keep the picture legible, even if you have to invent outlines, highlights or areas of deep tone for details to stand out against.

Three-point perspective

This final perspective scheme uses three vanishing points. Although it is easily observable, its effect on everyday scenes is subtle and it tends to be largely ignored by many artists – but it can be used to dramatic effect, especially in illustrations and comic books.

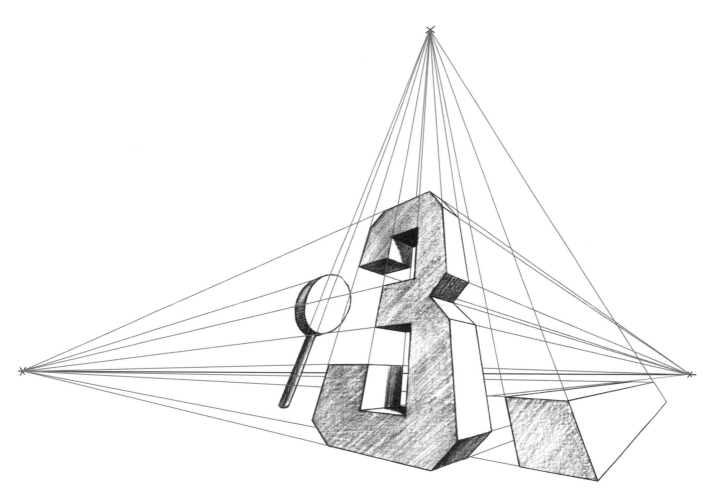

The third vanishing point is located high above an object and governs the vertical recession of scale. Often that point is so high that its effect is minimal, but we can see it clearly in this exaggerated diagram. For a third vanishing point to be so low, one would have to be extremely close to the objects, close enough that the perspective scheme actually distorts the shapes of the objects to the left and right. In practice you would rarely include features as low as the horizon when drawing objects high overhead, since they would be outside your natural field of vision.

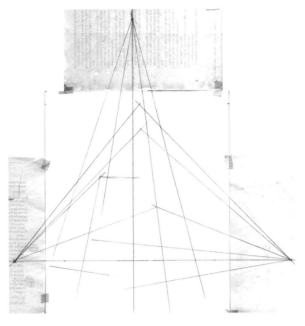

STEP 1

Going back to the church and standing very close to it, I did some sketches and took some photographs on which to base the following perspective exercise. To make this extreme close-up work, I had to draw it with a rigid perspective structure, which again meant attaching extra paper to my drawing to accommodate the vanishing points.

STEP 2

Referring to my sketches and photographs, I transferred the church's shape onto the perspective grid. Some of the angles are unnervingly distorted, but so much the better for an interesting picture. I worked on heavy, textured watercolour paper to help achieve the effect I intended for the rendering.

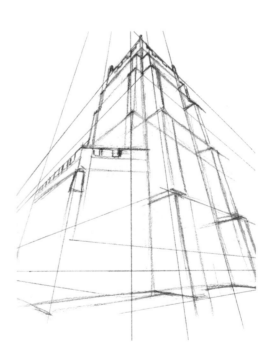

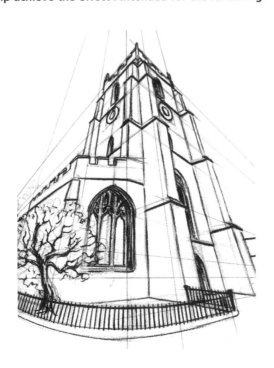

STEP 3

With a No. 6 round sable brush and ink, I drew over the outlines and details. Though this drawing was rigidly planned, I didn't want it to look too precise, hence the loose brush line.

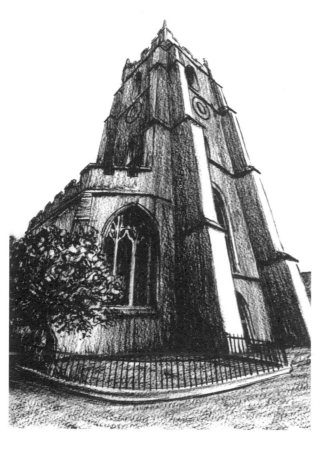

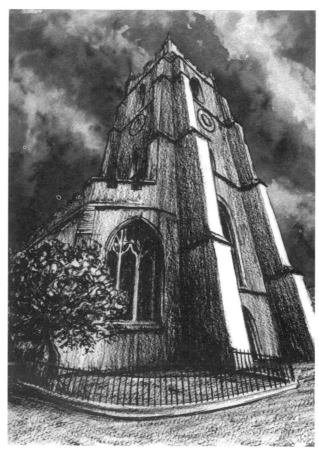

STEP 4

After erasing the pencil marks,
I applied tone and texture, referring again to my photographs. With the brush only partially loaded with black ink, I held it side on to the paper and dragged it. The heavy texture of the paper received broken shading, which is suitable for the rough stonework. I built up the tone in layers, taking care to leave some highlights unshaded.

STEP 5

With the brush well loaded with clean water, I wetted the sky area, being careful to leave the church dry. While the paper was wet, I dabbed on black watercolour of various degrees of dilution and allowed the pigment to spread naturally and dry in the air.

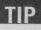

TIP

Another benefit of heavy-grade paper is that it can stand getting very wet without the buckling that thinner paper suffers from. For a dramatic sky, I used a technique called 'wet-on-wet', which allows paint or ink to spread in random cloud-like textures.

STEP 6

To unify the parts of the picture, I used some watercolour to wash over the stonework and foreground. That done, I decided to further darken parts of the sky, so I soaked it again and dropped more paint on selectively. Against all the heavy textures, the highlights on the church looked unfinished, so I carefully drew on some detail by brush. Then, to finish off, I only needed to add a few touches of highlight. Using a fine brush (No. 3 round sable) and white ink, I picked out some details on the tower, tree and railings, making sure that the direction of light was consistent. I also used the white ink to touch up the break in the cloud and give the cloud some form.

Sketching structures

By now you should have some understanding of how perspective can allow you to sketch structures with understanding and confidence. There is much to be learnt from sketching that no amount of theory in books can ever teach you. When you get the chance, look at other artists' sketchbooks and see how they may have arrived at solutions to problems you may have encountered. Here are a few pages from mine.

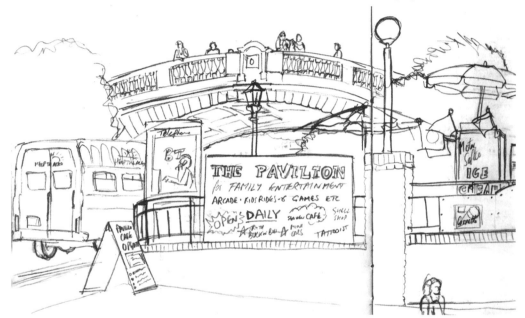

This quick study displays little perspective, but aims to include lots of detail. Drawing details, however sketchy, increases your stock of visual memories.

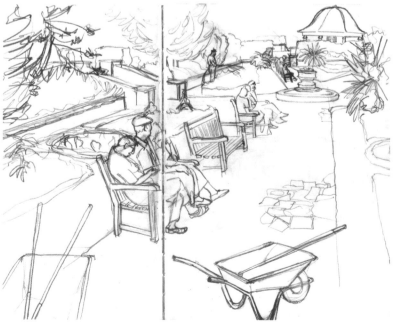

This sketch employs simple one-point perspective. One aim of sketching is to record information for later use, so there's little need to draw whole surfaces (such as the paving here) when a small area will suffice as a reminder.

Even a tiny sketchbook allows scope for worthwhile studies. This sketch is only a few centimetres high.

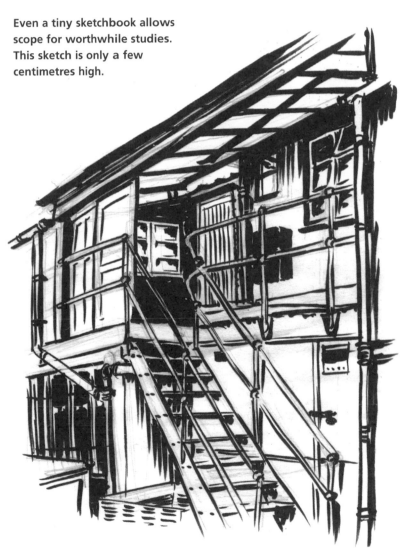

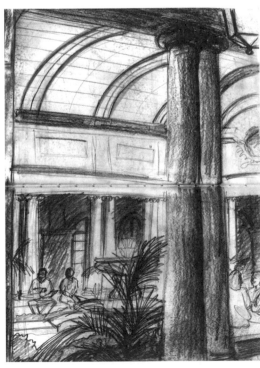

Slightly more ambitious, this sketch aims to capture something of the light coming through the glass roof by contrasting it with the tones behind the columns.

The logistics of sketching outdoors often prohibit precision and fussiness of detail, thus helping to encourage spontaneous mark-making. This brush pen study over rough pencil captures the structural feeling of the scene rather than accurate perspective and proportion. The minimal tone is for clarity and character.

From sketch to artwork

I sketched this medieval crypt on holiday; the closeness of the arches and the unusual under-lighting interested me. Rediscovering the sketch, I was inspired to make a more polished drawing of a similar scene and add some embellishments of my own.

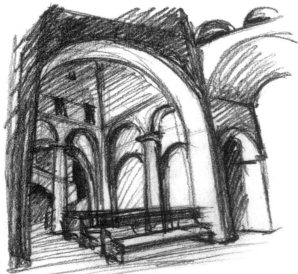

My original sketch.

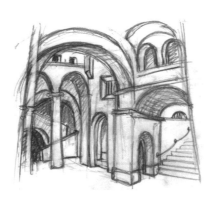

I redrew the scene with less dramatic perspective but more details for a slightly fantastical design.

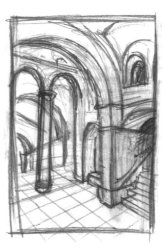

I decided to change the shape of the picture and roughly redraw the composition within a tighter framing.

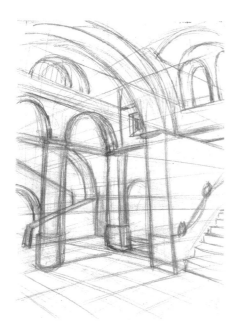

STEP 1

Using my sketches for reference I lightly drew the main columns and arches on good paper with a hard pencil, using perspective lines to guide the angles.

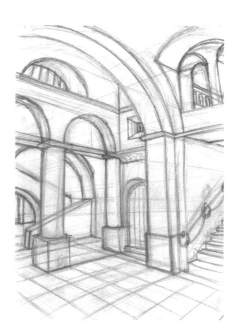
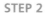

STEP 2

Switching to an HB pencil, I firmed up the drawing and added further detail.

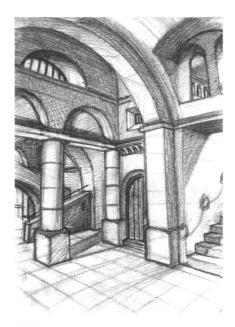

STEP 3

Crucially, I had to decide where to put the light sources and work out the resulting shadows and shade. The lighting had to make the picture easy to read, lend a sense of atmosphere and disperse the tone sufficiently to balance the composition. Still using an HB pencil, I lightly shaded the areas of tone that I had decided upon. Along the way, I viewed the picture in a mirror, which allowed me to identify areas of inconsistency.

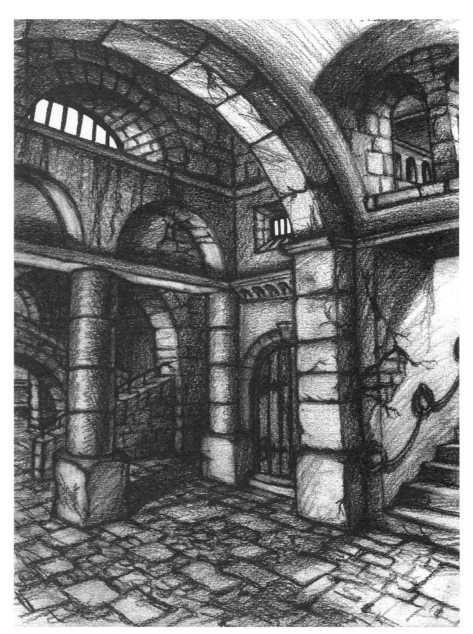

STEP 4

With the hard work done, I took up a soft pencil and further built up tone, texture and detail. Working on a lightly grained paper lent the shading a pleasing stone-like surface. I did not use an eraser until the very end, picking out only the brightest light through the windows. All other stray marks and smudges are lost among the heavy shading.

143

Buildings as illustrations

As we have seen, there is no rule that demands that all your drawings are slavishly copied from the real world. An observed building may be exaggerated in different ways for the sake of drama, composition or interest, or buildings may be purely dreamt up. In my work as an illustrator, I have been called upon to create buildings and scenes for various purposes. Here are some examples.

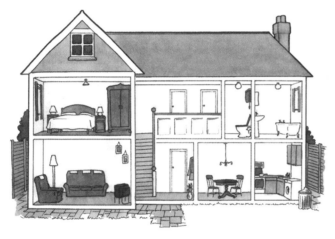

A drawing may be stripped of any artistic statement for the sake of communication. This diagrammatic illustration was done in fine-tipped pen and watercolour wash.

I drew this ancient Greek villa from the angle that best suited the purposes of the book it was commissioned for. Here I used pen and watercolour wash.

Though the theme is silly and the drawing style very simple, this scene needed a lot of thought to include all the required activities in a satisfying composition. The characters are alien, but the setting is drawn from our own world.

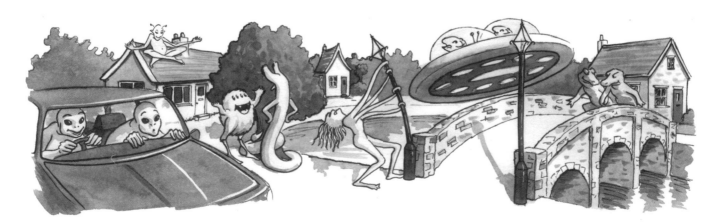

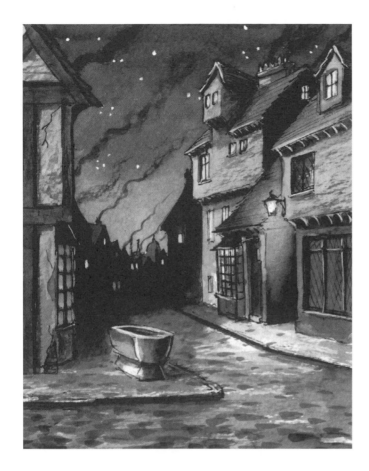

There is little detail in this depiction of a Victorian street, heavily shaded with solid black ink and watercolour. Its strength is in its simple composition and lighting.

The diminished scale of this building reduces it to a symbol. The elements of grime and cleanliness are exaggerated to support the message of the article the drawing illustrated.

It was fun to design this spooky castle straight from my head without the need for historical or pictorial accuracy. This was drawn with a steel drawing pen and ink.

This whimsical illustration catches the eye because it shows a normally upright and rigid building as unnaturally flexible. In real life it would topple, but then in real life, it would not have a mouth!

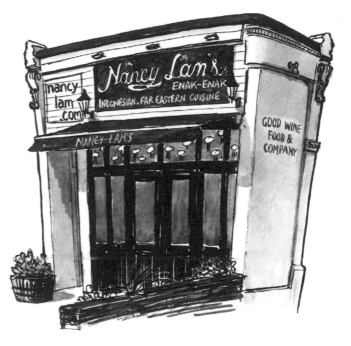

I did this loose illustration with a couple of felt tip pens and a very light watercolour wash. I distorted the vertical lines for a playful effect.

I employed an impossibly exaggerated perspective scheme to add dynamic impact for this illustration. Over a careful pencil drawing I inked it loosely with a medium watercolour brush and ink. The application of some rough watercolour washes and a few highlights in white ink made the various parts of the picture stand out clearly against each other.

Alien cities can be created quite easily. Start with the bigger elements and overall shapes and then add bits on, working towards smaller details and accents. Repeating and combining forms suggests unified architectural design.

This more sophisticated attempt at a futuristic city sets the viewer amid a seemingly erratic jumble of outlandish buildings. But there is method in the construction; once again perspective helped me to create the scene.

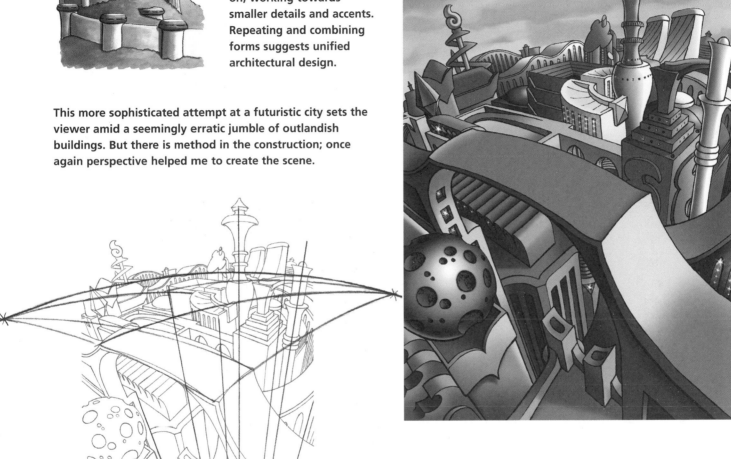

The three-point perspective at work here differs from my earlier demonstration (page 136) in that the third vanishing point is below the horizon rather than overhead. I wanted to suggest the curvature of a small, overcrowded planet and so the horizon line is curved. Therefore, the perspective lines radiating from it had to be curved too. It was a bit of a challenge, but satisfying to resolve.

MAKING FACES

Meeting strangers, we look to their faces for clues to character; in relationships, faces send out signals of acceptance or displeasure; we remember our loved ones with images of their faces. The human face is the first thing that children draw and, given its infinite variety and facility for expression, drawing portraits offers scope for a lifetime of study and interpretation.

When you embark on this subject, try to enjoy the stages of becoming familiar with the many aspects involved. Be satisfied at first if you can draw faces with a glimmer of life and believability and don't be disheartened when true likenesses elude you. With every drawing you increase your understanding of portraiture and move closer to surmounting the intriguing challenge of drawing a portrait that reflects the very essence of a person.

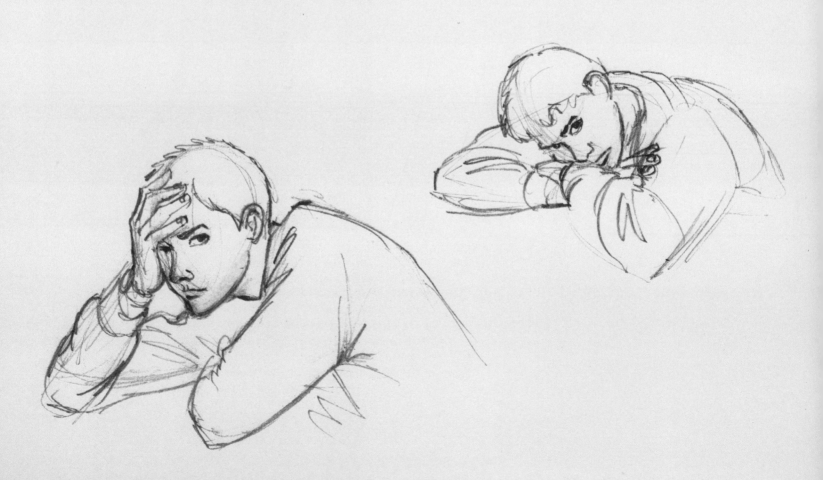

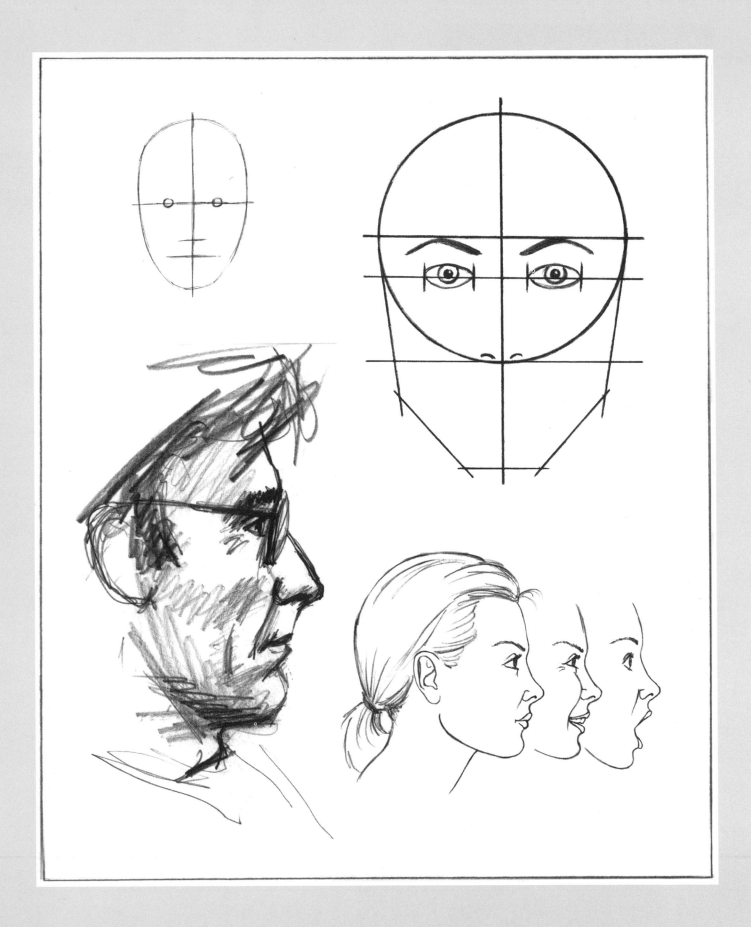

The construction of the head

The wide variation in people's features is one of the reasons why faces are so fascinating to study and draw. However, there are enough similarities in the way the human head is constructed to make some generalizations.

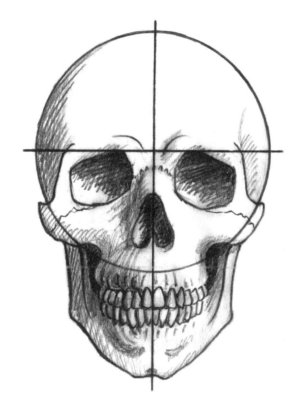

Most skulls are remarkably similar regardless of gender or race. Here is a mature adult skull; some simple guidelines can help you to visualize its construction. Study this drawing alongside your own face and familiarize yourself with the points where the bone is visible under the skin of the face: brows, cheekbones, chin, nasal bridge and so forth.

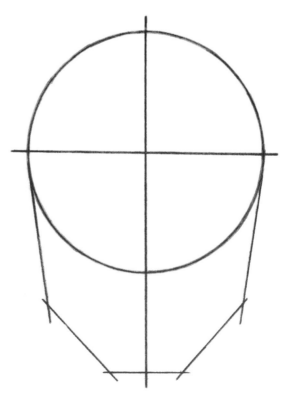

STEP 1

With some simple foundations, it's easy to draw a head and place the features accurately upon it. Start with the same cross and circle as the skull, then add a rough framework for the jaw line. An angular jaw immediately defines this as a man's face.

STEP 2

Eyebrows are easily placed just under a horizontal line drawn at the mid-point of the circle. The nostrils fit at about the bottom of the circle. The eyes sit along a line that is about halfway between the top and bottom of the whole head. To space the eyes, divide the width of the head into five equal units, with a whole eye's width between the eyes.

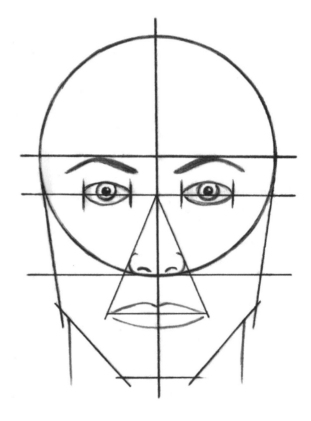

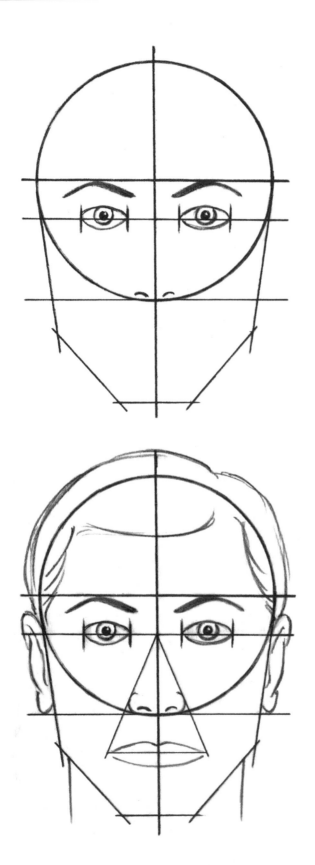

STEP 3

A triangle drawn down from the eye line will indicate the width of the nose and mouth. The neck is slightly narrower than the jaw.

STEP 4

The ears can be placed easily in relation to the nose and eyes. Even short hair sits quite high above the scalp.

Facial features

Cleaned up and refined, our diagrammatic head can become a reasonably realistic man. Angular lines and bold features clearly identify him as male, but exactly the same proportions can be used for a woman's head. Here the jaw is more rounded, the nose and brows smaller and the lips fuller. These are only guides to average facial proportions so it's no surprise that they look a bit bland. Real faces are more interesting, with wildly varying features.

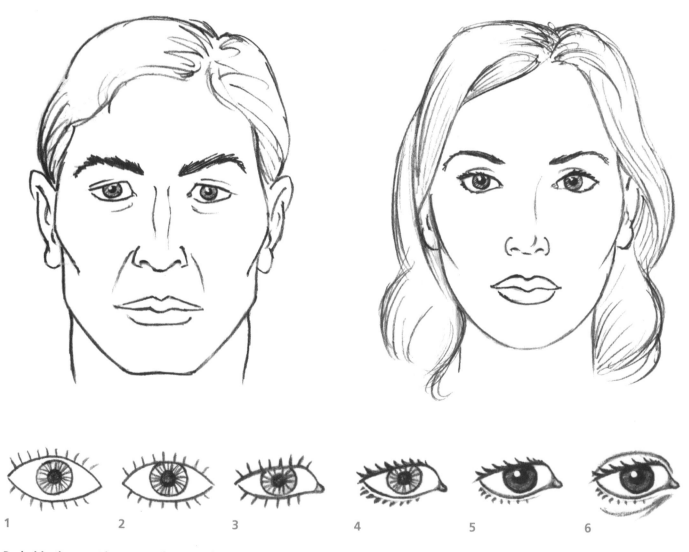

1 2 3 4 5 6

Probably the most important feature of portrait drawing is the eyes. The first of these drawings is from my childish icon on page 16. I'm going to correct it in steps: (2) Usually the iris is partially covered by the upper lid (and often by the lower lid too). (3) The shape of the eye opening is more interesting than bland curves. (4) Lashes are thicker on the upper lid and follow a uniform angle. (5) The iris is best rendered as a smooth tone, rather than the over-fussy radiating lines. (6) Much of an eye's character is in the shape of the lids and creases that surround it.

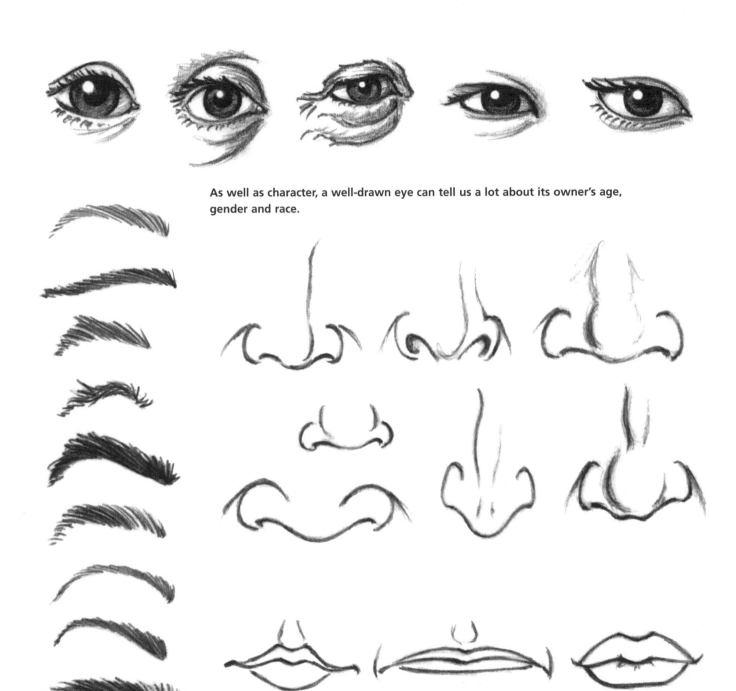

As well as character, a well-drawn eye can tell us a lot about its owner's age, gender and race.

Similarly, eyebrows, noses and lips are infinitely varied and must be studied carefully to capture their idiosyncrasies.

153

A simple self-portrait

To draw a real face, you'll need a model, and you won't find anyone more patient than yourself. Use a mirror that's large enough to fit your whole head in and position yourself so that you don't need to move anything other than your eyes to flit between mirror and paper.

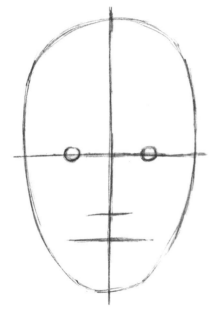

STEP 1

My head and face are quite long, so I started with a long oval. The important thing here is to correctly measure the relative height and width. Sight-size with your pencil to place the lines of your nose, mouth and eyes. Accurately spacing your features will determine the success of the final likeness.

STEP 2

With the spacings marked, the features can be sketched in quickly. Work on the shape of your jaw too.

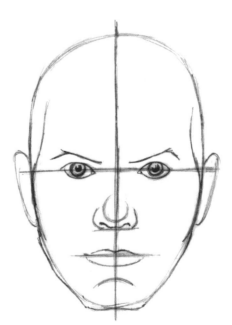

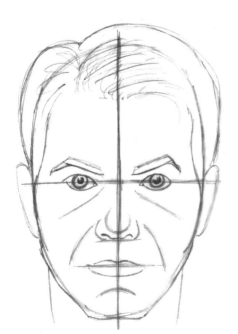

STEP 3

Add more details as you go. Treat the hair as a broad mass. Your drawing might already bear a passing resemblance.

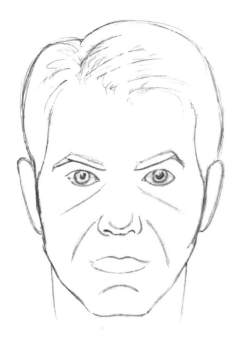

STEP 4

Erase all the guidelines before getting into too much detail.

STEP 5

Now look very closely at yourself and refine your features. The hair can be worked on, but it's not too important beyond its overall shape and size. Pay special attention to your eyebrows; they hold a lot of character.

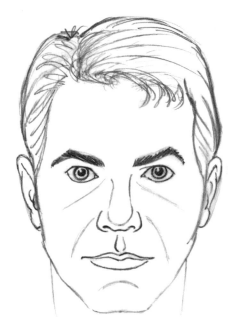

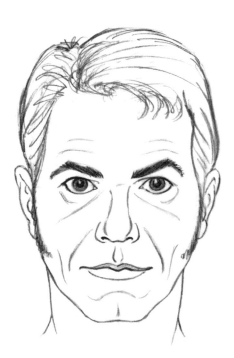

STEP 6

The weight of line is important in these final stages – darker around the eyes, nostrils and between the lips and fainter for creases and age lines. Does your self-portrait look as serious as mine? That's because of the formal angle of view and lack of expression. We'll cover these elements later.

The head in profile

When the head is seen from the side, the same vertical proportions apply as to the front view. But, with the turn of the head, the horizontal proportions shift. Again, I've broken down the drawing into steps to help you get to grips with the form.

STEPS 1 & 2

This time the circle is a guide to nearly the whole head's depth, the skull being deeper than it is wide. A straight line down from the front of the circle will form the face and chin; note that it slopes inwards. Halfway down that line we can draw the nose line.

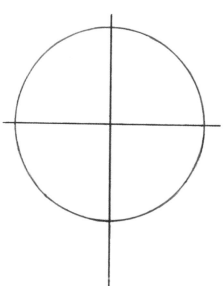

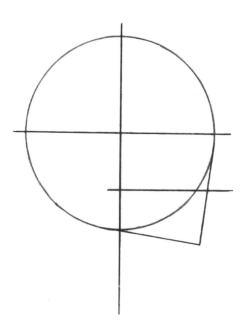

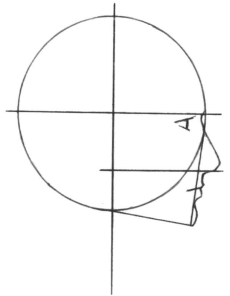

STEP 3

All the facial features sit forward on the head, taking up little of the profile's overall surface area.

STEP 4

The neck is not upright, as you may imagine, but has a natural slope forward. The back of the skull is quite high and cuts into the guide circle. Place the ear more than halfway back on the head, taking its height from the nose and brow line.

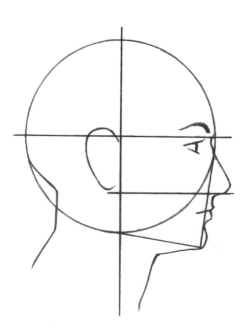

STEP 5
Once placed, the features can be refined.

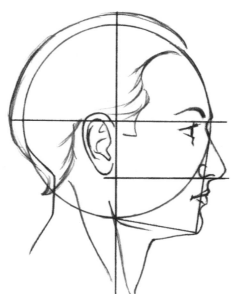

STEP 6

Even short hair sits quite high above the top of the head. The hairline grows from the forehead and neck in a definite shape.

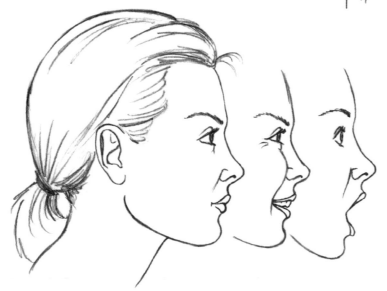

As with the front view, the same proportions apply to the female head. The extra expressions here demonstrate different forms that the eye and mouth can take when seen from the side.

Different angles

Drawing the head from front and side views is good preparation for the more complicated angles from which you will more commonly draw people. To do this you need to think three-dimensionally.

When an object is turned to show both its front and side this is known as a three-quarter view. Such a view throws the placement of facial features into confusion, but some guidelines will help enormously. The guidelines are the same as those shown on the previous spread, except that the verticals bend to follow the three-dimensional form of the head. The principle is no different to the cat all the way back on page 9.

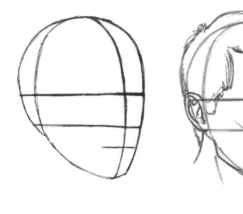

Following the guidelines, you can place the features with confidence.

A rear three-quarter view follows a very similar framework. Note the slope of the neck.

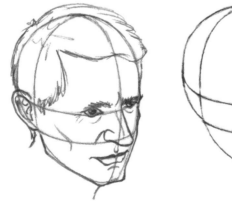
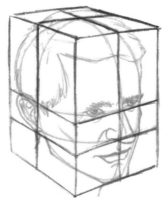
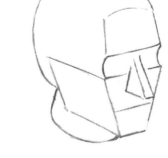

Things get a little more complicated when looking at the head from above. Here the horizontal guidelines need to curve too.

It might help you to think of it in terms of perspective. The principles of two-point perspective (see page 122) apply here. Alternatively, you might be better able to visualize the head's angles by breaking it down into its planes.

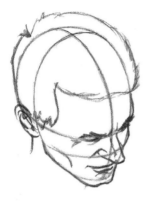 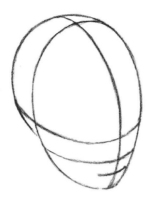

Here's the same head seen from a steeper angle above.
The curve of the horizontals is more pronounced and the
face gets smaller as the upper head gets bigger.

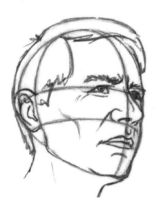 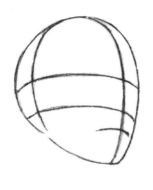 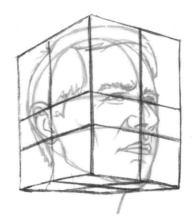 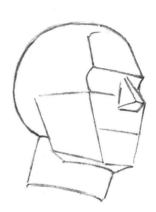

Seen from below, the horizontal guides run the other way.
The lower face is more visible and the hair recedes.

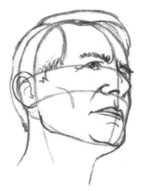 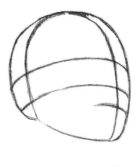

With an even lower viewpoint, the hair recedes more and the
furthest eye becomes obscured by the nose. The undersides of
the nose, upper lip and jaw come well into view.

Self-portrait (three-quarter view)

It's time again to employ your ever-willing model and put all the theory into practice. Sit square at your desk and place your mirror at an angle to get your three-quarter view. Either tip your head down to see yourself from above or slant your mirror to see yourself from below. Think about the lighting possibilities, because you will be using tone in this drawing.

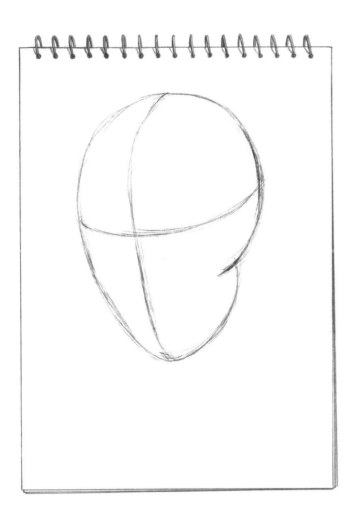

STEP 1

Construct a rough head shape, based on the sight-sized proportions. If you want to include your shoulders in the picture, be sure to leave sufficient space on the paper.

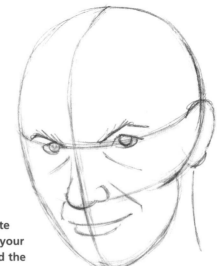

STEP 2

Rough in the approximate shapes and positions of your features, bearing in mind the curves of your head.

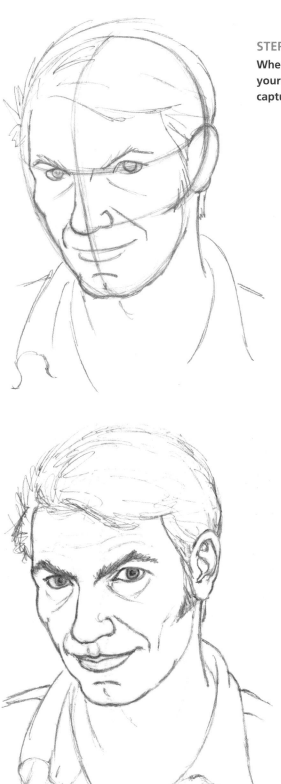

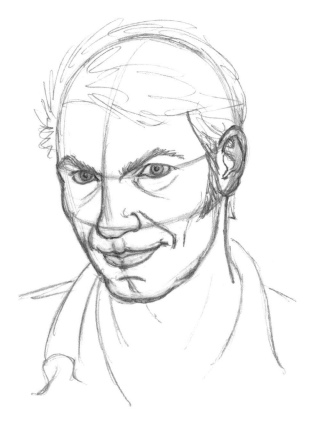

STEP 3

When your face is largely correct, continue to draw the rough shapes of your hair and neck. Don't move on until you're satisfied that you have captured a passing resemblance.

STEP 4

Scrutinize yourself carefully and work on the details of your face. Try to get your eyes to look directly out of the page. Be prepared to redraw any elements that seem to be badly placed; the spaces between are as important as the features themselves.

STEP 5

Erase rough marks and guidelines. Don't worry about neatness too much at this stage; you're only halfway through this drawing.

Adding tone

Shading a portrait need not be thought of as very much different from any other tonal drawing, except that perhaps more care needs to be taken. Ill-considered shading can subtly alter the form of the features and change a portrait's likeness of character. However, good shading cannot salvage a badly drawn outline; if you're unhappy with your drawing, work on it further before you start the next step.

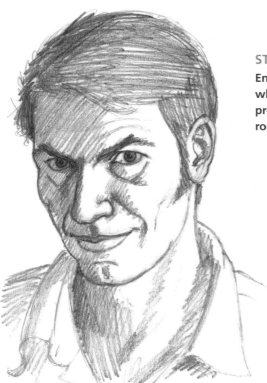

STEP 6

Ensure that your light source, whether artificial or natural, is constant while you work. I have the benefit of a large north-facing window to provide even, diffuse light throughout the day. With a soft pencil, roughly shade all the surfaces that are not lit directly.

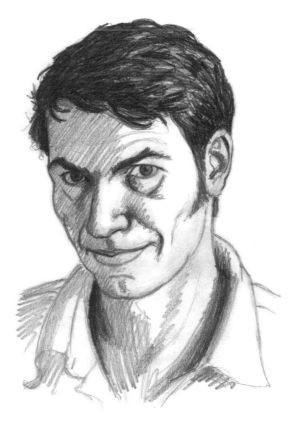

STEP 7

Identify and shade the darkest darks so that you have the picture's full tonal range from white paper to the blackest mark your pencil can make. Don't get carried away, though – only the very darkest areas should be so heavily wrought. Think of your hair and eyebrows as individual textures rather than dark blobs.

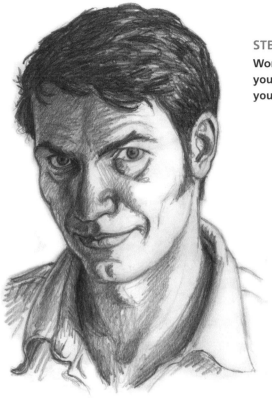

STEP 8

Work over the shadow areas again, varying the direction and weight of your pencil marks as appropriate. Try to mould and shape the contours of your face. Observe reflected light, too – there will always be some present.

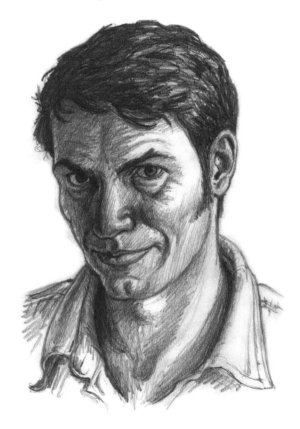

STEP 9

Now work on the more gentle tones in the lighter parts of your face. In my picture, there are essentially four tones: white, black, dark grey and, at this stage, lighter grey.

STEP 10

To finish off, lift out some highlights with your eraser and clean up around the edges. Squint your eyes to even out any stray tones and even them out. A few final textural marks around the hair, lips, wrinkles and collar can go a long way towards an accomplished finish. This drawing is intentionally over-wrought to demonstrate a very intense approach to identifying and describing tone. Over the following pages I'll demonstrate some more sensitive tonal applications.

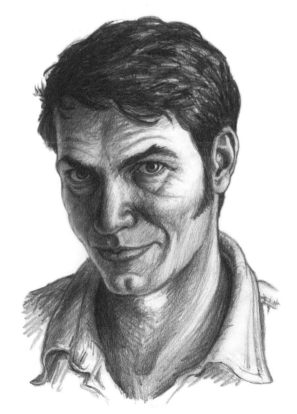

Youth and age – *Babies*

The proportions discussed so far have related to adults, fully grown and prior to the onset of old age. Heads of different ages are not only proportioned differently, but also display varied muscle and fat distribution as well as skin texture.

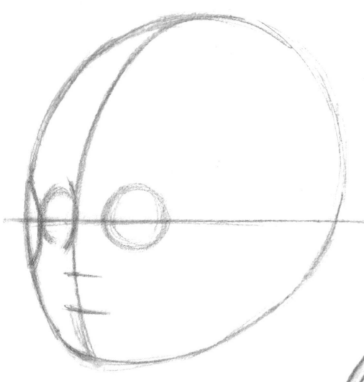

STEP 1

A baby's head is much more rounded than an adult's, almost spherical in its general shape. The eye sockets are relatively large and sit low on the head, well below the halfway line.

STEP 2

Drawing a baby is all about smooth and rounded curves. The forehead bulges pronouncedly, as do the cheeks. The nose, mouth and ears are small compared to the large, expressive eyes.

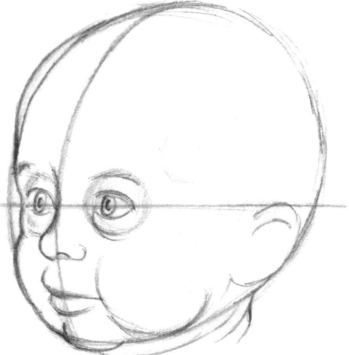

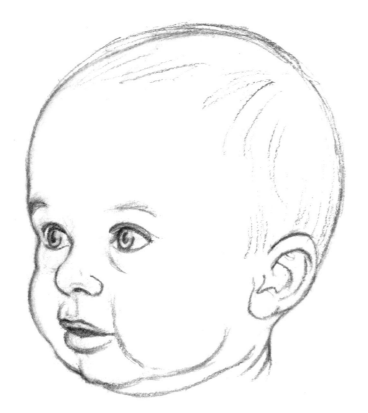

STEP 3

Because babies are so soft and clear-skinned, it is appropriate to strive for cleanness of line and tone in your drawings of them. Before the final treatment, try to make your drawings as clean as possible. (For clarity, this example is printed darker than I would normally work.)

STEP 4

I used the side of a soft pencil for shading, merely accentuating the curves that model the baby's face and leaving broad areas for the viewer to imagine the curvature. I further softened the edges with light dabs of an eraser. The eyes are more heavily worked, with fine strokes for the lashes and bright highlights. Some gentle wispy marks describe the fine texture of the baby's hair. This baby is a girl, but the differences between sexes are not normally noticeable at this age.

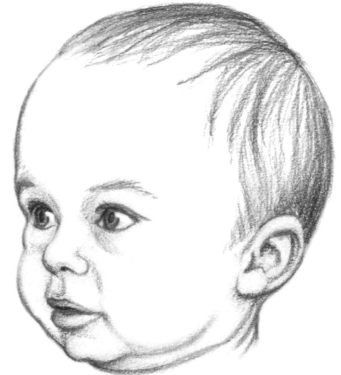

Children and teenagers

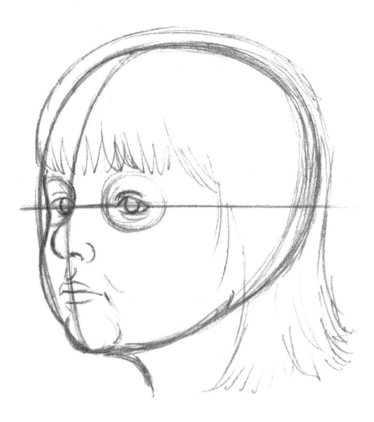

Here's a girl aged about seven. Her face is clearly longer than a baby's, but her eyes are still more than halfway down her head and her eyes are large. The cheeks and forehead are soft and round, but less so than a baby's.

The treatment here is similar to that of the baby, though I have not been so cautious over the softness of the modelling. As well as the skin, I've left some areas of the hair white. This suggests shine, but also keeps the drawing fresh; it's very easy to over-work hair and make a drawing heavy. The important things are to draw the overall shape, describe the direction of flow and use appropriate textural marks.

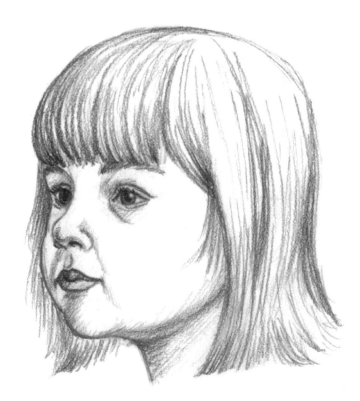

By the age of 13, the head is developed to more adult proportions, though the eyes are still relatively large. The cheeks and forehead are more rounded but there are also some angular lines, particularly around the jaw. The neck becomes stronger and broader.

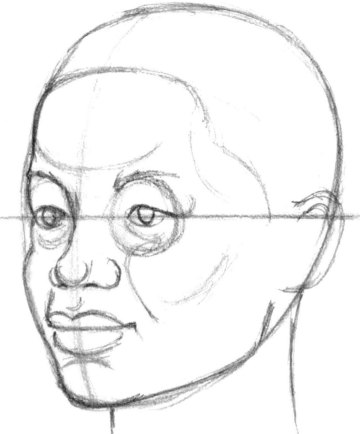

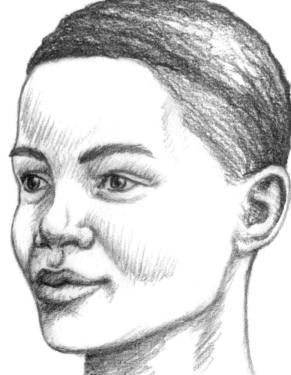

With heavy brows and defined cheekbones I've done slightly more comprehensive shading on this boy. The hair, though very dark, is still allowed to fade into highlight and the tightly cropped curls are rendered as a solid textural surface.

Middle and old age

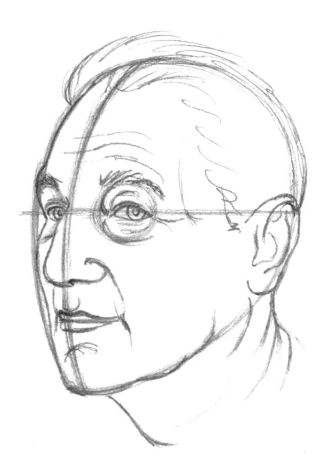

In middle age the forehead slopes away and the jaw slackens so the eyes should be drawn further up the head, above the halfway line. The nose and ears, particularly those of men, continue to grow, but the lips thin and the eyes shrink into the skull, making them proportionately smaller than those of the younger adult. Jowls form and the muscles of the neck loosen and sag.

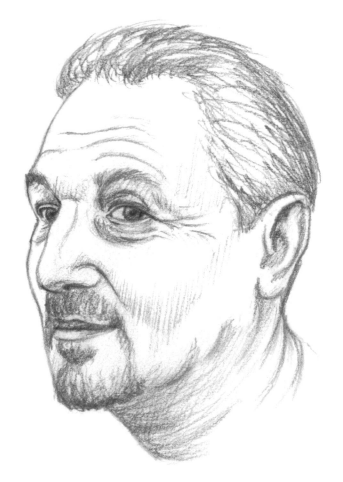

I've paid attention here to the wrinkles around the eyes and the heavy skin of the eyelids. Eyes, which are essential features of character, also carry the most obvious signs of age-related wrinkling around them. I've made little attempt here to soften the outlines and shading, but have still kept them restrained.

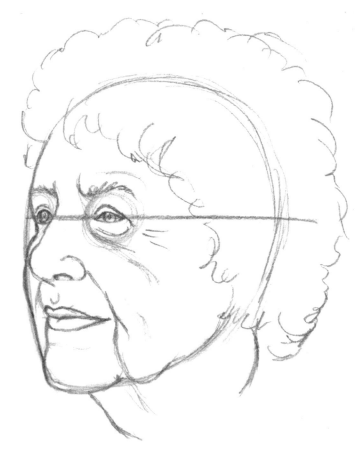

In old age the skin and muscles slacken further, forming pronounced jowls and deep furrows around the mouth. The eye openings close up considerably.

The older a person is, the more their face displays traits of their character. The lines around this lady's eyes and cheeks suggest that she has laughed and smiled a lot.
Nearly all the shading of this face follows the wrinkles. Drawing a few curls and roughly scribbling the shape of the mass is sufficient to describe a full head of hair without overwhelming the more detailed drawing on the face.

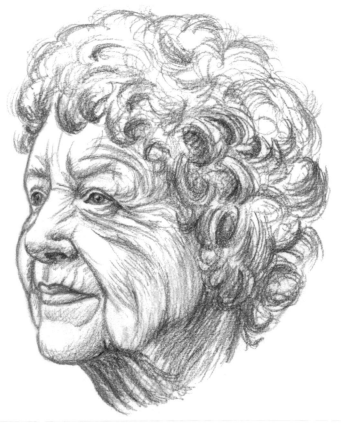

Drawing from live models

If you've ever sat for a portrait, you'll know how tedious it is to hold a pose for any length of time. People are less reluctant to sit still when they are otherwise occupied. Television is a good way of keeping people rooted to the spot. With this selection of sketches I was trying out different media and drawing methods. Some of the pictures are quite rapid and in other cases the sitters were patient enough to let me make quite detailed studies.

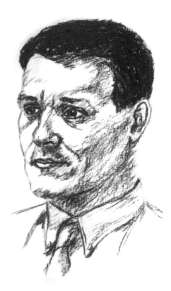

Here charcoal was used very lightly with no smudging or blending.

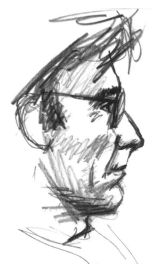

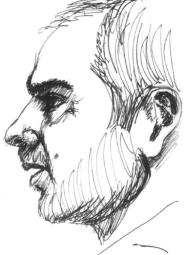

A couple of small, quick pencil studies with rough shading.

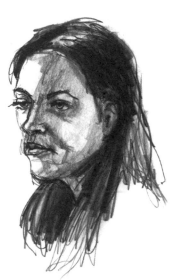

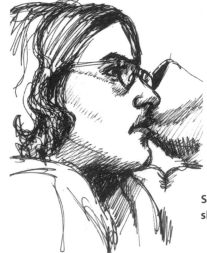

Some rapidly executed sketches using a felt-tip pen

170

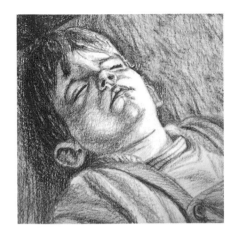

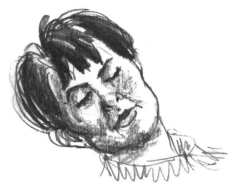

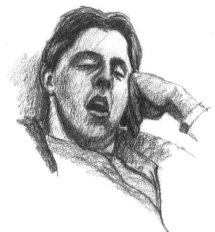

Another way of ensuring that people don't move is to catch them when they are snoozing. This may afford you the time for more detailed studies.

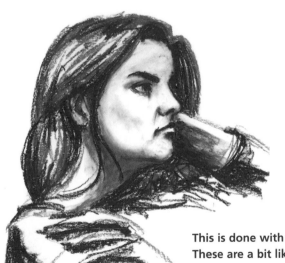

Here I was allowed time to make a more detailed study of the planes of the face and the effect of light upon them, using charcoal and three shades of grey chalk.

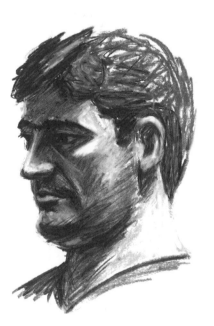

This is done with black and grey conté crayons. These are a bit like chalk, but have a more waxy quality and are less prone to smudging.

Doing studies like these will give you a good grounding in the structure of the face and a range of varying features. Hopefully you'll achieve some pretty good likenesses as you improve. You can experiment with media and drawing styles too. However, each of these pictures has one thing in common: they are dull! Absorbed in television or their dreams, the faces are slack and entirely without emotion. They make no connection with artist or viewer. If you want to make portraits rather than merely draw people's heads, you'll need to push yourself and your subjects further.

Expression

Capturing expressions is one of the most difficult elements of portraiture, mainly because they are so fleeting. Photographs, however, will freeze them forever, so they are very useful tools for familiarizing yourself with the facial contortions that display emotions. Each of these examples was drawn from a photograph.

Sharp, jagged lines from a chisel-tipped pen enhance the feeling of pain and distress. The upper face is fully tensed while the mouth is quite relaxed.

TIP

Strange though it may seem, if you mimic an expression with your own face as you draw, it really helps the drawing progress. Subconsciously you isolate the muscles that go into forming the expressions.

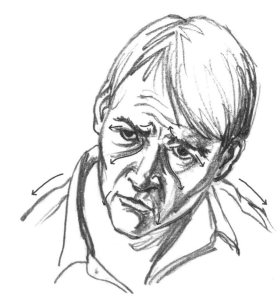

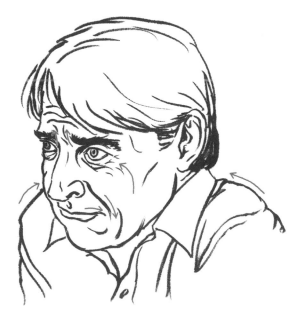

This dejected face is largely at rest. The lines slope away from the middle and the shoulders follow the same directions. Only the brow is tensed.

The worry lines of the forehead are joined by tension in the cheeks and around the mouth in this anxious expression. The shoulders hunch and the head sinks into the neck.

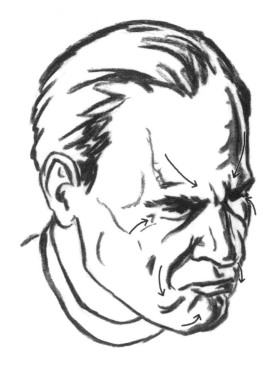

The jaw is set, the chin comes up and the brow comes down to show anger. The face seems to close in on itself, rendering the eyes as mere slits. I tried to draw this face with the vigour and directness that the attitude suggests.

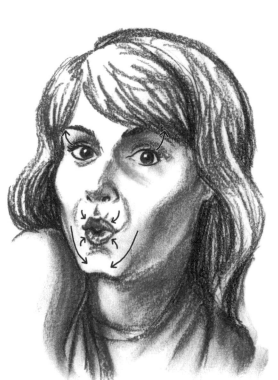

In contrast to anger, in flirtation the face is pulled outwards and open except for the pursing of the lips.

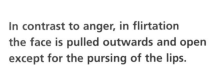

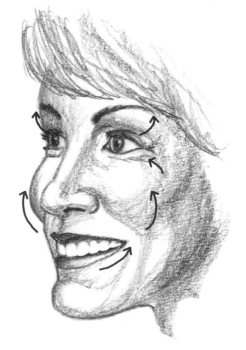

Although a number of muscles are employed to spread the mouth and raise the cheeks, a genuine smile should look effortless and involuntary.

Rapid sketching

The best way to improve your skill at drawing any subject is to practise as much as you can – and drawing is rarely more rewarding than when you capture, in a few lines, a spark of life or personality in someone's face.

Persuade friends, family and neighbours to spare you five minutes. Most people's patience can run to this length of time and it's just long enough to bash out a rough sketch. Ask them to display some kind of emotion (though many will naturally only smile). Don't worry too much about capturing likenesses, as these will come with time and practice.

Importantly, keep in mind the confident line of our earliest icon drawings, making each mark direct and decisive. That is the secret of successful rapid sketching. Here are some of my better efforts at this exercise. Compare all these sketches with those of the television viewers on pages 170–1: though less carefully rendered, they are much more lively and interesting. They are also more varied in age and background. Try to draw all kinds of people; every face is unique and fascinating in its own way.

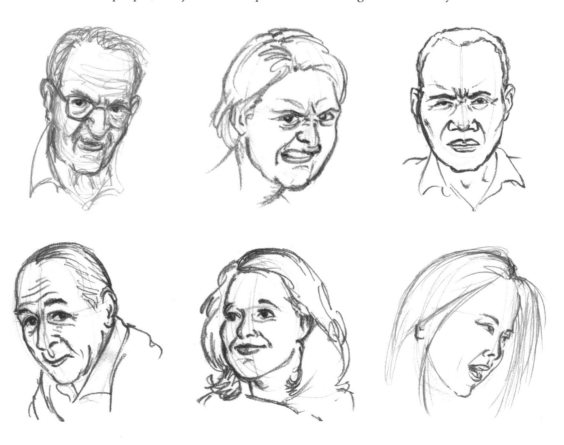

Glasses can be a defining element of some people's faces. They are often surprisingly tricky to draw, but it's worth the effort to get them right. Remember that they tend to sit just below the eyebrows and the eyes appear near the top of the lenses.

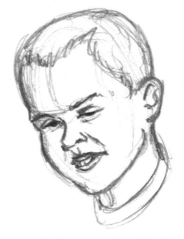 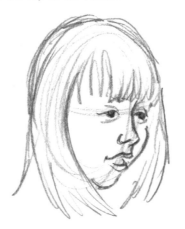 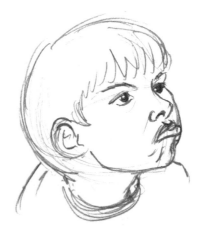

Children find it especially difficult to keep still; five minutes is an eternity to them. Out of over a dozen attempts these are my only presentable drawings, so don't be disheartened by a high failure rate.

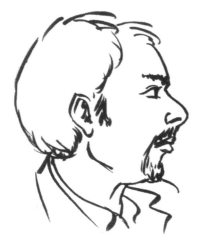

Profiles are relatively easy; there's half as much to draw! I did these using a felt-tipped brush pen without pencil guidelines.

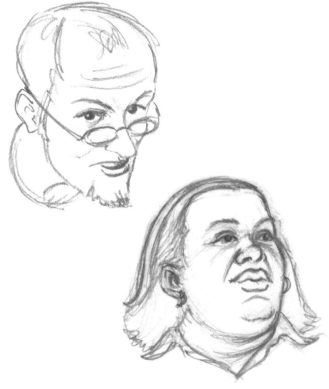

Try some drawings from different angles, above and below.

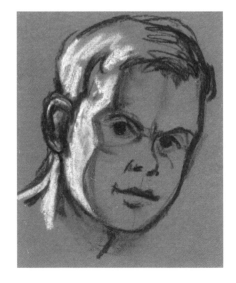

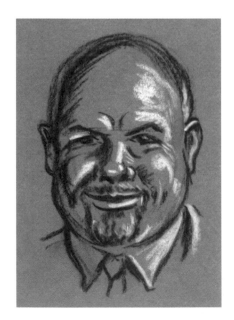

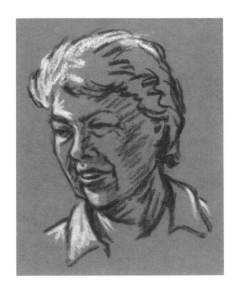

With a little practice, charcoal can be an effective sketching tool. When you are using toned paper, white chalk highlights are a very quick short cut to light and shade in your sketches.

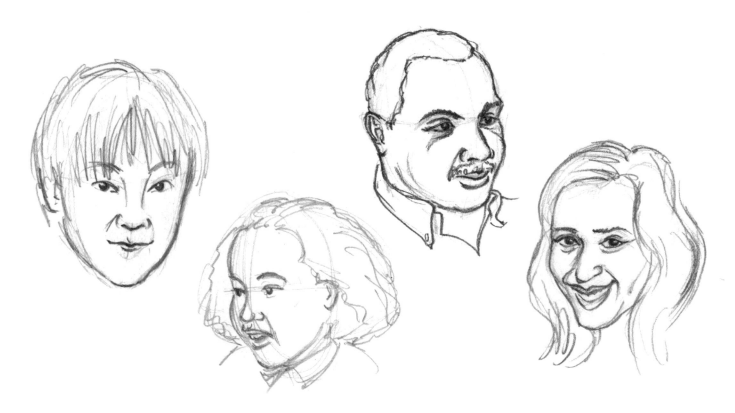

Drawing people of different ethnic backgrounds need not present any particular challenge. Racial characteristics will come through if you draw what you see. The character and expression are what matters to your drawing. I have not shaded the hair of any of these heads, though it is understood that that of the Japanese, Indian and African people would be very dark. In the same way I generally would not render the local tone of skin.

TIP

Facial features are sufficient to describe racial characteristics. Heavy shading only masks character and makes for muddy pictures, as these two versions of a teenage African boy demonstrate.

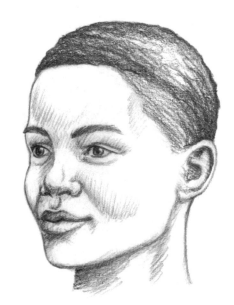

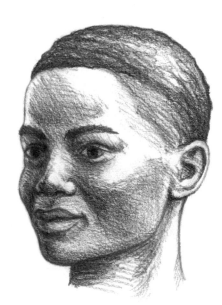

Lighting

As you get further into the realm of tone, you'll become aware of how carefully controlled lighting can add impact and character to your drawings. It can take quite some time and experimentation to arrange the lighting for a portrait. Here I show the same woman drawn in different lighting set-ups each of which creates a distinctive mood.

I used charcoal and white chalk on mid-grey paper and spent about an hour on each.

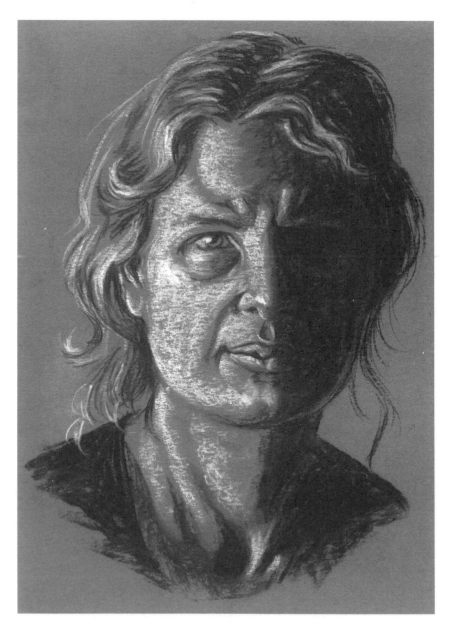

In a semi-darkened room I set up a single table lamp and placed it to the side of the sitter. This angle of light throws the features into high relief and brings dramatic impact to what would otherwise be a pretty dull front view.

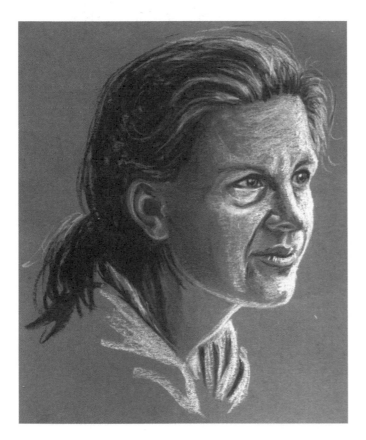

Here the sitter was looking out of a window in diffused daylight, which lit her face from the front. If you use natural light, it's usually best to avoid direct sunlight, which can be very harsh and create extremely deep shadows. The sun also has a habit of going behind a cloud, just when it's least convenient and its angle will change while you work.

With the window behind the sitter, I directed the table lamp on the other side of her face as a secondary and much weaker light source. This arrangement leaves areas of the face that neither light source reaches in shade and enhances the bright halo effect of the rear lighting.

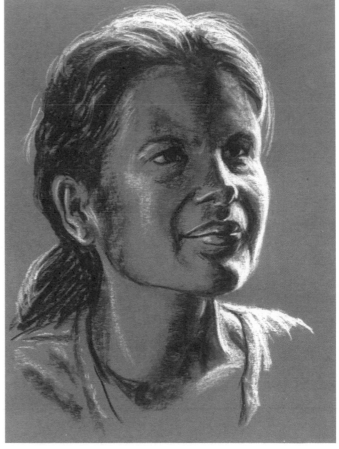

Experimentation

Using yourself as a model, you can let your hair down and spend some time experimenting. With a lamp and a mirror and whatever materials you can gather together, make a series of drawings. Your guiding principle should be to make each of them distinctly different, so play around with materials and lighting and have a go at tackling facial expressions as well. Don't worry about achieving likenesses; just try to enjoy the processes.

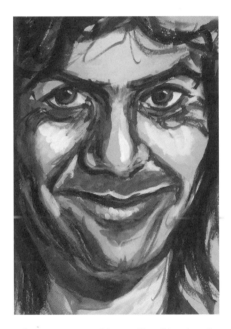

After a very rapid pencil guide sketch, I drew this with a stiff bristle brush in black poster paint on grey paper. Once dry, I added the rough highlights in white poster paint. I had to work quickly because my face doesn't naturally hold a smile for long.

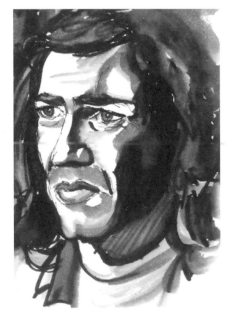

Using two mirrors, you can see yourself from other angles and avoid the eyes always staring out of the page. Here I used a fine drawing pen to scratch the drawing, then a broad felt-tipped pen to very loosely shade the main shadows. I lifted and blended the ink with a wet brush.

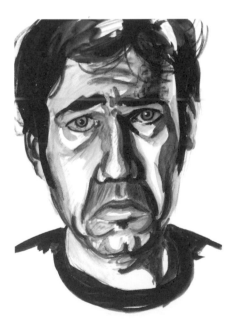

This miserable wretch began with water-soluble crayons, in two shades of grey, roughly scribbled on a large sheet of paper. With a soft, wet brush I painted over the crayon, pushing it around the paper like paint. Some watered-down ink then took care of the deep shadows and details.

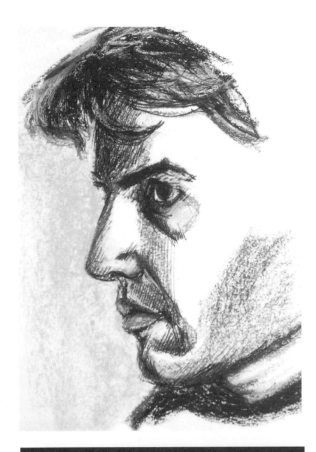

Again using two mirrors, here I supplemented fine pen line with some grey chalks.

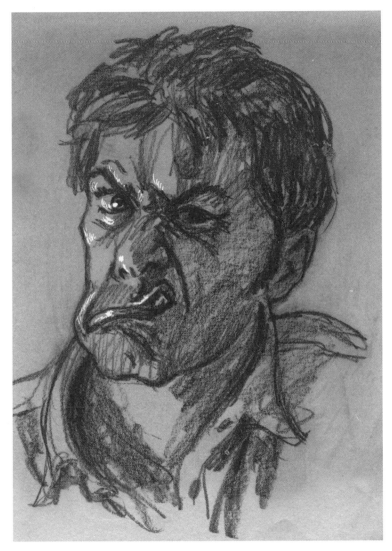

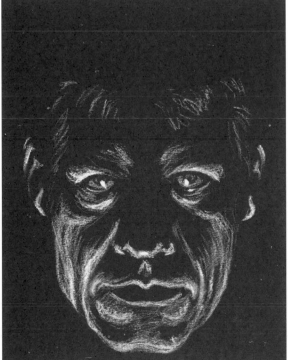

If this picture looks hurried, that's because my face hurt! I attacked the grey paper with a big graphite stick then added the minimal highlights with a white gel-pen.

Harsh underlighting produces some interesting and eerie effects. This is simply white chalk on black paper. It's a bit counter-intuitive to work light on dark, but an interesting challenge.

Composition – portraits

When you want to develop a portrait into a finished artwork you'll need to consider such variables as angle of view, lighting, media, mark-making and expression. As with other drawing disciplines, composition is also a vitally important factor. Looking at portrait paintings and photographs will reveal plenty of conventions and ideas for composing a picture around the motif of a single head. Here are some pointers.

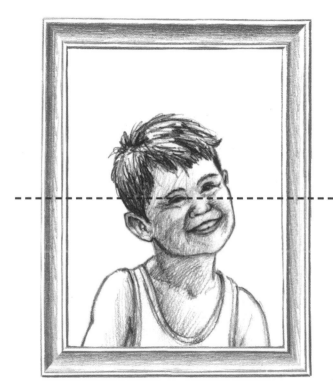

You may have observed in thousands of amateur photographs that a common instinct is to place the head precisely in the middle of the frame. This usually leaves an area of empty, wasted space above the head, and has the effect of making the subject appear to be dropping out of the frame.

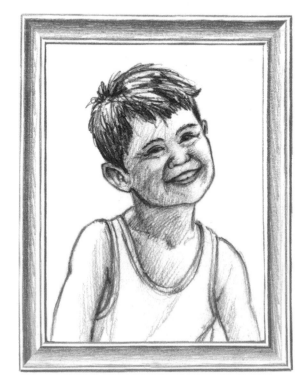

Placing the head higher up fills the frame more pleasingly. Regarding lateral positioning, this boy looks about right with his head in the centre, considering the lack of background and the amount of space that he occupies

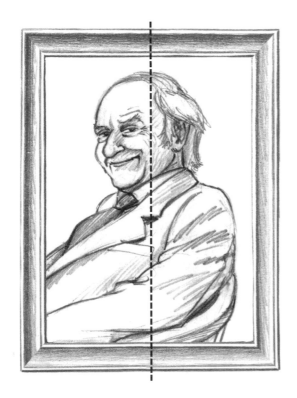

A head placed centrally on a vertical axis will not always work so well. There's a distinct imbalance to this composition with unnecessary space behind the chair.

With the picture moved to the right, the man's body meets both edges of the frame and his head is placed at a more generally satisfying third section. A balanced composition can often be achieved by placing one of the eyes precisely on the mid-way line, which works very well in this case.

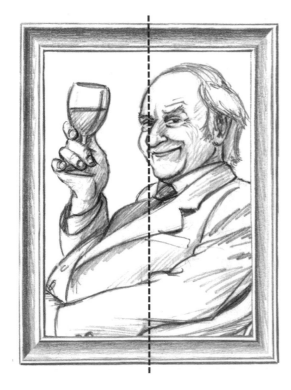

Here I've placed the other eye on the centre line, pushing the head to the edge of the frame. The composition still works, especially with the introduction of a wine glass as a secondary motif.

Portraits do not always have to be drawn in a 'portrait' format. Landscape formats allow space for backgrounds that can set a scene or say something about the person. They can also be compositional features in their own right, adding tone, depth and texture as a complement or contrast to the person.

Here the man's head and shoulders form a diagonal division of the picture area. The face positioned towards the edge of the frame is intriguing, suggesting that he is leaning to inspect something we cannot see. The background, a mere texture, lends tonal balance to the composition: dark around the highlights of the face and pale against the dark tones of hair and clothing.

A portrait need not always feature a face. This rear three-quarter view makes a feature of the woman's long neck and elaborate hair.

Artists often use the phrase 'less is more'. Close cropping excludes much of this man's head, but the impact is undeniable as his fine moustache fills the width of the frame.

Rules are made to be broken. The low placement of this head draws attention to the cigarette smoke, which makes a clear statement about the man as well as an eye-catching composition.

Likewise, this framing is dictated not by the woman's head but by her hat.

185

A portrait in felt-tips

Even the most accurate likeness, drawn with the greatest skill, is little more satisfying than a passport photograph if it fails to capture something of the sitter's spirit. Alongside proportion, lighting, expression and composition, a successful portrait should have something to say.

One wet afternoon, my teenage son was visibly bored, so I pressed him into modelling for me. He showed little enthusiasm so I decided to sketch him in various poses that expressed how he was feeling. I wanted to draw the mood as much as the person.

 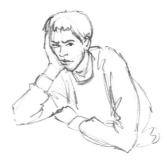 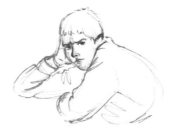 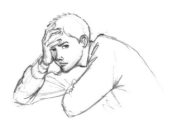

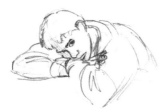

None of these rough sketches took more than five minutes and drawing them gave me a feel for the kind of poses that might work best. Through the sequence, the model gets more into role, his posture becoming progressively slumped.

I selected a pose to work up and thought about the lighting. I sat my model by a window and moved my position so that the background tones contrasted with the figure. Then I roughly shaded my sketch to see how it all worked compositionally.

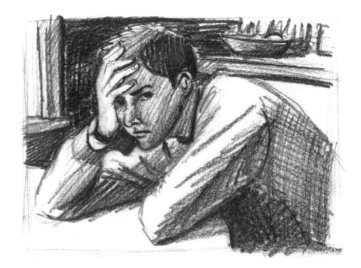

Arranging pose, lighting and composition is only part of the story – an artist must also consider the appropriate kind of treatment. I wanted a loose, unfussy, look to complement the mood and, working from a live model, I needed to work quite speedily. I settled on felt-tip pens to lay down the tones, softened and blended by water.

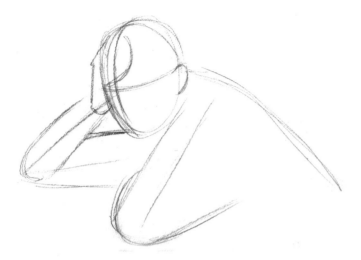

STEP 1

As I intended to use water on this picture, I used heavy-weight watercolour paper. As usual, the drawing started with rough shapes and angles.

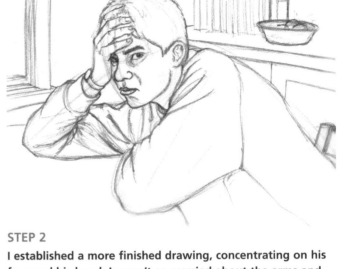

STEP 2

I established a more finished drawing, concentrating on his face and his hand. I wasn't so worried about the arms and background at this stage.

STEP 3

I outlined the eyes and some of the fine, dark details in permanent ink with a black drawing pen. For the remaining outlines I used an ordinary mid-grey felt-tip, then erased the pencil guidelines.

STEP 4

I used two shades of grey felt-tip to apply rough shading all over the picture, trying to follow the curves of the surfaces with my strokes. It looks a bit coarse, but there is a strong sense of light.

STEP 5

With a large brush, I painted water over the felt-tip marks to soften, blend and blur the surface. I worked quickly and stopped before the picture got too muddy. Notice the outlines remain unblurred where I used permanent ink, to retain those parts of the drawing.

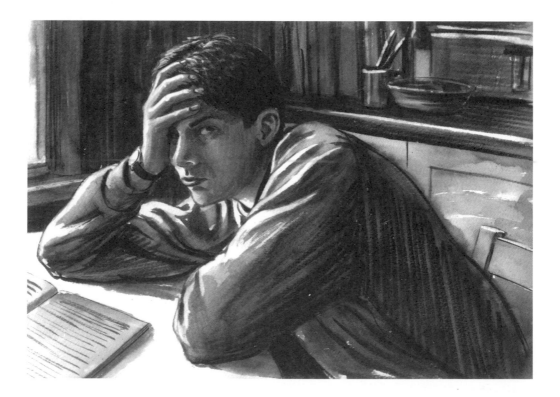

STEP 6

Once the paper had dried, I used the grey felt-tips again, along with a black one, to restate some details. For the final touches, I lifted out some highlights: using water on a small brush I remoistened areas and dabbed them with a dry tissue to pull the ink off the paper. For the brightest highlights, I painted on some neat household bleach with a fine brush. This picture has a loose feel, due to the almost accidental blurring and loose treatment of the shading and looks suitably sombre for a wet Sunday in December.

Ink wash and wax resist

Here's another technique for producing fully tonal pictures with rapidity and looseness. For this you'll need a white household candle. The idea is to draw highlights on the white paper prior to washing on the tones. The ink does not settle on the waxed areas, so they remain pale. I persuaded my son to sit for another picture and set a time limit of half an hour.

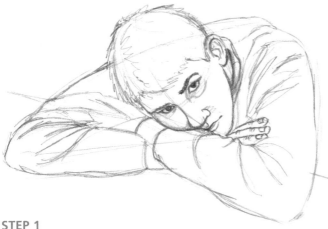

STEP 1

This drawing is quick and scrappy, but is sufficiently detailed to work on.

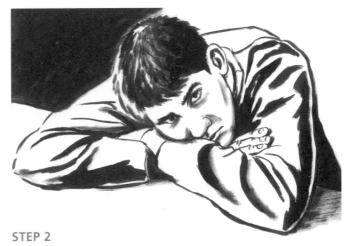

STEP 2

For the first stage of rendering, I used a stiff bristle brush (a No. 2 filbert) and neat black ink to draw the wrinkles of cloth and areas of solid black. When the ink ran dry on the brush I used it to scrub some slightly softer shading on the face and hair. The bristles were good for suggesting the texture of the hair. I used a fine brush for fine details and then erased the pencil lines.

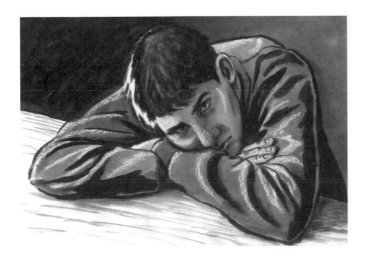

STEP 3

With the end of the candle, I added the highlights, drawing gently for pale areas and pressing harder for the bright white accents. I worked systematically from left to right so as to keep track of the invisible wax marks.

With watered-down ink and a broad brush, I washed over the boy and background in big sweeps revealing the highlights, like magic. Whilst the ink was wet, I dabbed some parts with a tissue for a bit of lightening and blending and then made myself stop before overworking the picture.

189

Spontaneous sketching

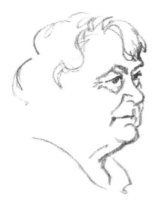

When you become engrossed in drawing people you may find yourself looking at every interesting face in the street with a view to how you would draw it. So why not try to translate that on to paper? I often carry a small sketchbook with me and sketch faces. On public transport, in cafés, pubs, parks, waiting rooms or anywhere people sit still for a few minutes, you can discreetly jot down their features. You will be forced to draw quickly from a few brief glimpses, sharpening up your visual memory and encouraging vigorous and economical sketches. They will not always work out well, but you will find you can often capture surprisingly accurate likenesses.

A very blunt, soft pencil is perhaps the easiest medium for rapid portrait sketches. Using soft lines somehow feels less committed than if you use hard lines, freeing you to make swift marks without fear of going wrong. You can always press harder to accentuate some details.

To be more ambitious, you can draw in tone with the flat edge of a pencil without doing line drawing first.

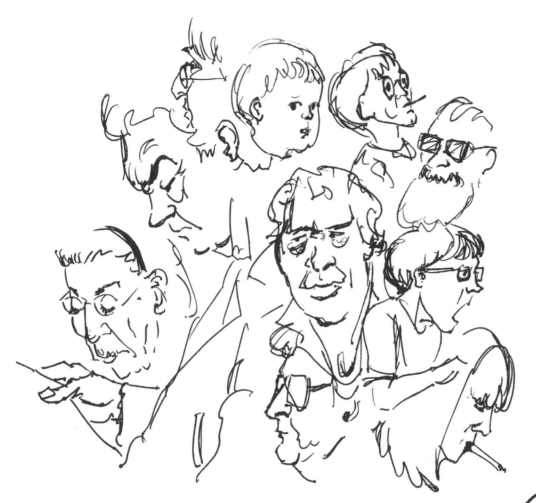

Here I used a fine felt-tip pen to fill a page with a montage of the people sitting around me on a train journey. In ink, every mark stands, so you must accept that some lines will go astray and not let your drawing be constricted by the fear of making mistakes.

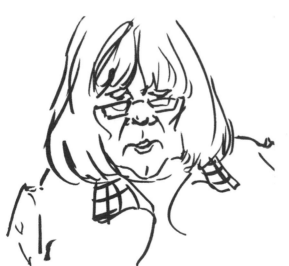

Though the brush pen is less easy to use, its varied line gives sketches a certain sophistication and allows for rapid suggestions of light and shade.

Working from photographs

Using photographs for reference gives you the opportunity to study faces with greater freedom than the patience of most sitters allows for.

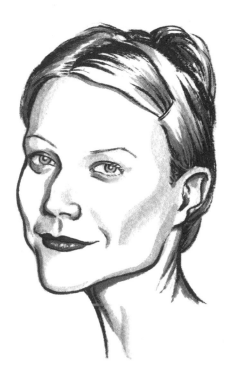

Photographs give you access to famous faces, which are excellent subjects for practice. I found Gwyneth Paltrow's delicate features hard to pin down and once I had established them in line I applied only a minimal wash so as not to risk losing the likeness with shading.

Because the expression, pose and lighting of photographed faces don't change, you have time to draw in great detail. Here I built up the shading with the side of a felt-tipped pen, grazed across a lightly textured paper.

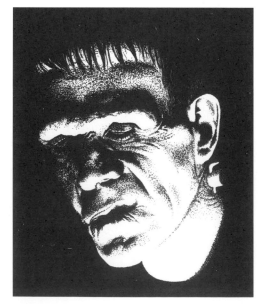

Apart from the solid black brush and ink areas, I did all the shading here in dots, using a felt-tipped pen.

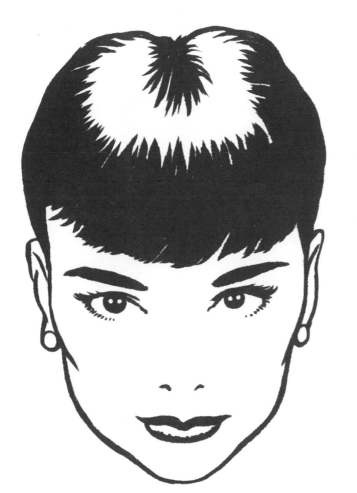

Following the adage 'less is more', a face can be distilled down to eliminate non-essential details. It takes time to produce a simple drawing like this, because each mark counts towards the likeness and must be accurate as well as graceful. I did this line drawing with brush and ink, using the shape of the brush's tip for the hair texture, similar to the rose design of page 43.

Interesting interpretations of faces can come out of tracing photographs. Without the struggle to capture likeness you can concentrate on pure design qualities. Here I've traced only the areas of deep shadow as a set of almost abstract shapes.

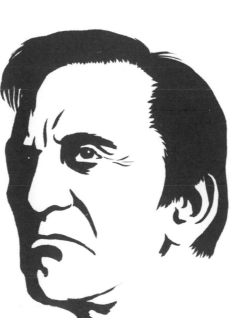

When filled in with brush and ink, the tracing becomes a bold and dramatic portrait.

Caricature

A logical progression from simplifying the features of a likeness is to exaggerate and manipulate them into caricature. It's a challenging discipline, but highly rewarding when successful.

Some faces are virtual caricatures already. Salvador Dali, with his moustache and wild eyes, needs little exaggeration to be turned into a cartoon sketch.

No careful study went into this sketch and it's not actually a good likeness at all, but Freddie Mercury's image is so strong that it's immediately identifiable.

Here I started with a distorted face shape, much broader around the jaw and cheeks, and then fitted the features into that shape. It has naturalistic qualities despite the distortions.

This is a much more subtle approach. Again, it's quite a naturalistic portrait except that I've enlarged the upper head and intensified the distinctive heavy brows as well as squaring the jaw line.

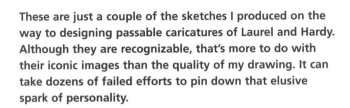

These are just a couple of the sketches I produced on the way to designing passable caricatures of Laurel and Hardy. Although they are recognizable, that's more to do with their iconic images than the quality of my drawing. It can take dozens of failed efforts to pin down that elusive spark of personality.

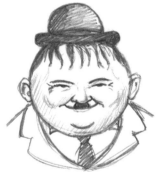

All of Cher's features are enlarged here and her face is elongated to make a grotesque caricature sketch.

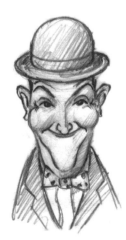

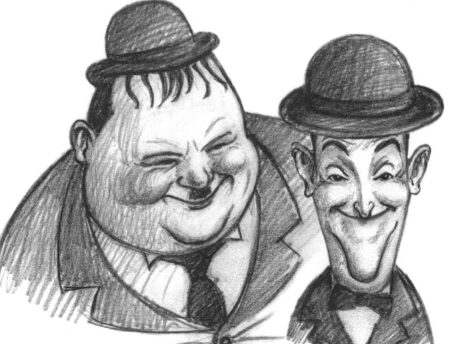

I think this version carries something of the spirit and warmth of the characters.

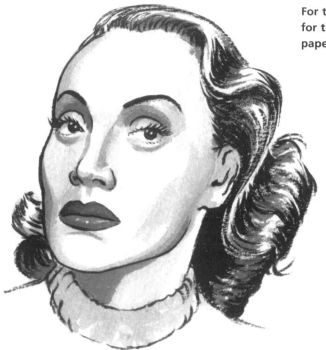

For this naturalistic illustration of Marlene Dietrich, I used brush and ink for the line and watercolour wash for the tone, working on textured paper. Her strong features and make-up lend themselves to caricature.

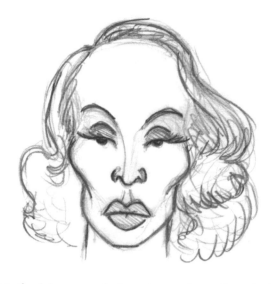

Overemphasizing every feature does not usually make for successful caricatures, but it's a good way to start the process of redesigning a face.

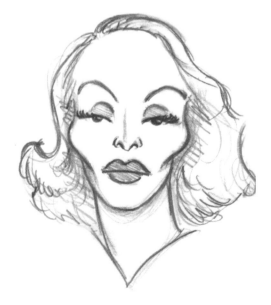

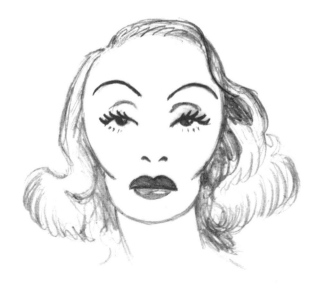

By enlarging the upper head, the eyes, eyebrows and hairline are featured strongly. The lips are still important, so I drew them large, but reduced the nose and jaw to give the other features the emphasis they need.

I continued to simplify the face shape and opened the eyes for the appropriately languorous look. The nose is now no more than two dots. I was sufficiently satisfied with this caricature to progress to a 'finished' version in ink.

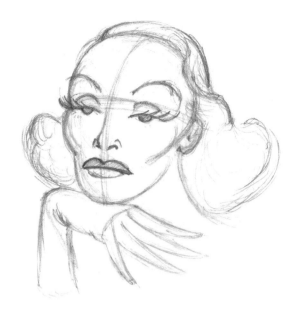

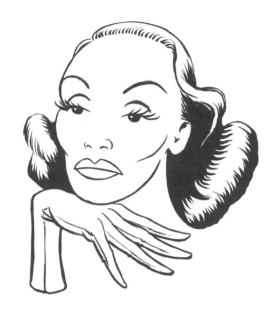

Drawing faces from the front is fine for a caricature, but to turn it into an artwork, I prefer a more sophisticated angle. Here, I reverted to the original view, but changed the line of the neck and added a gloved hand for a glamorous gesture.

With brush and ink, I followed the outlines, careful to make the lines fluid and smooth. Next I filled in the solid black areas and erased my guidelines.

Just a touch of tone, in grey felt-tip, added some make-up and shine to the eyes and lips and coloured the glove as a contrast to her porcelain skin. Although they don't represent shade, these simple touches of local tone, selectively applied, lend the line work a degree of slickness. While this picture looks much simpler than the naturalistic version, it took a lot more time to complete. Because it has undergone a selective and manipulative process, I consider it to be a more valid and interesting artistic statement than copying an existing photograph.

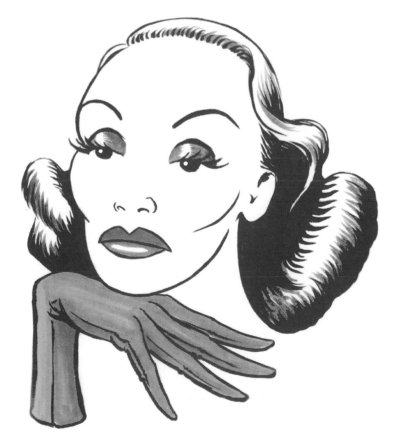

Fun with caricature

Caricature need not be restricted to famous faces. Playing around with faces and inventing characters can be a lot of fun. The caricatures shown here are merely examples of the genre. If you look at political cartoons, you'll see that each illustrator has a unique way of structuring and exaggerating faces and a personal take on each well-known face. Your own experience of people, your own drawing style and preferred media will naturally lead you to caricature in an individual way.

These two men are of similar age and build but they are distinctly different in personality and social class. The first could be an amiable shopkeeper whereas the second is clearly used to ordering people about – perhaps a lord or retired colonel.

These faces show similar differences, their characters and circumstances being quite distinct and discernible.

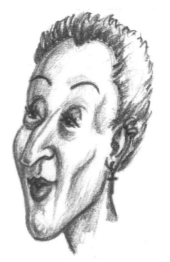

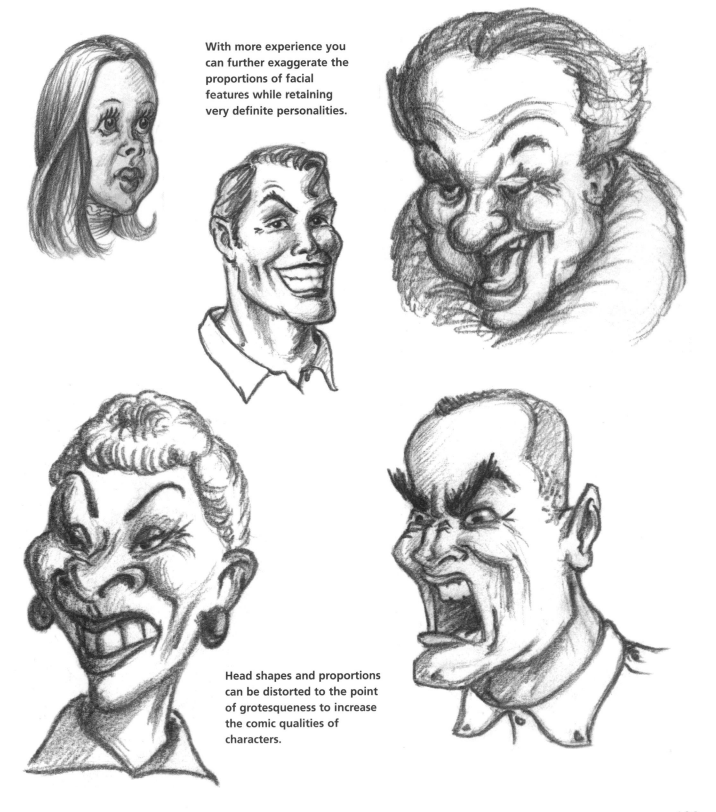

With more experience you can further exaggerate the proportions of facial features while retaining very definite personalities.

Head shapes and proportions can be distorted to the point of grotesqueness to increase the comic qualities of characters.

THE HUMAN FIGURE

Drawing human bodies, or 'figures', as artists call them, requires a bit more technical understanding than heads and faces, which don't have the complexity of structure, movement and gesture of the body as a whole.

There is a lot to take on, but it need not be too painful. The days of painstaking academic figure drawing have passed in favour of a more expressive and playful approach. Some preliminary explanations of the more important elements of theory cannot be avoided, but I've included only as much as you need to get started.

You may wonder why it is that artists seem obsessed with drawing nudes. There are very sound reasons: you will not get to understand how the motorcar works without lifting the bonnet and likewise, the artist must learn to draw the body, its knobbles, joints, muscles, sinews and fat, without the coverings of clothing. But we must look deeper still, beyond the skin and flesh to the skeleton, the key to proportion and articulation. Our investigation will be conducted from the inside out.

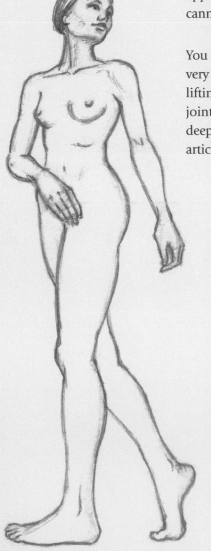

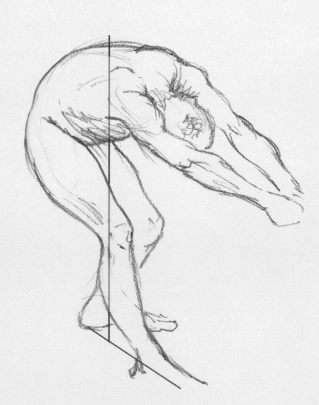

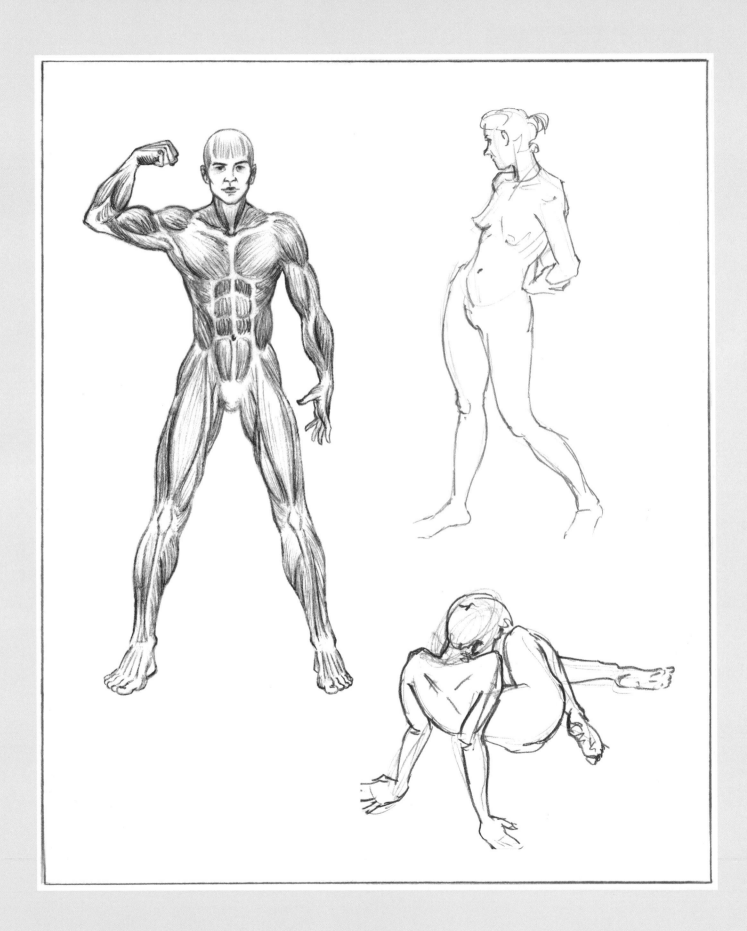

The skeleton

The skeleton provides the rigid framework for the musculature and it allows us to bend in the right places. Though the bones can't be seen in a drawing of a person, the proportions and articulation of the skeleton govern every pose. A basic working knowledge of the skeleton is therefore essential for successful figure drawing.

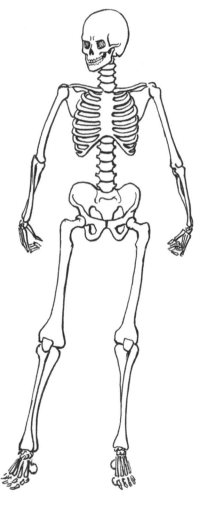

Made up of dozens of bones, the skeleton is a confusion of sticks and knobbles. For advanced academic figure drawing it would be important to know the individual bones, but for most drawing purposes such detailed knowledge is not necessary.

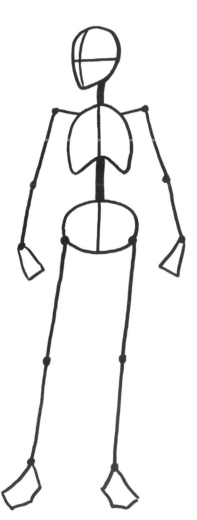

This is the skeletal framework that artists employ as the basis for drawing figures. Here we see all the important information: the relative sizes of head, chest and hips (and the spaces in between), the lengths of the limbs and the major joints and points of flexibility. Hands and feet are treated as general masses.

As well as the proportions, the basic skeleton establishes a figure's pose and posture. The skeleton on the left demonstrates a common misconception: that we stand bolt upright. Working from this model would result in a stiff and odd-looking figure.

This is a more natural posture. The differences are subtle, but important. The neck slopes forward, the back curves and the arms do not hang straight down, but are relaxed and supple. The vertical line in this diagram makes clear these divergences from the upright.

This fashion model's pose and her high-heeled shoes exaggerate the natural curves and angles of the standing posture.

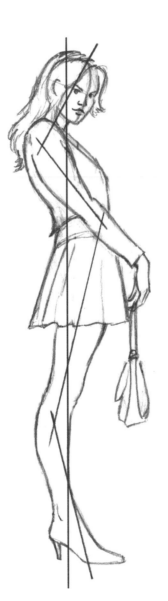

Seen from a three-quarter angle, the curve of the spine, the mass of the chest and hips and the general thrust of weight in the posture are clear in what is really little more than a stick man.

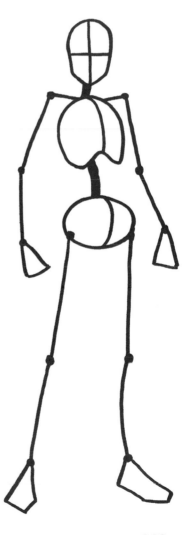

The musculature

Although the skeleton can be simplified for drawing, things are not quite so easy with muscles. They are responsible for the general contours of the body and so their relative shapes and sizes are more apparent under the skin's surface. The drawings below will help you to make sense of the confusing undulations of the body. They will be particularly useful when you come to draw figures without a model.

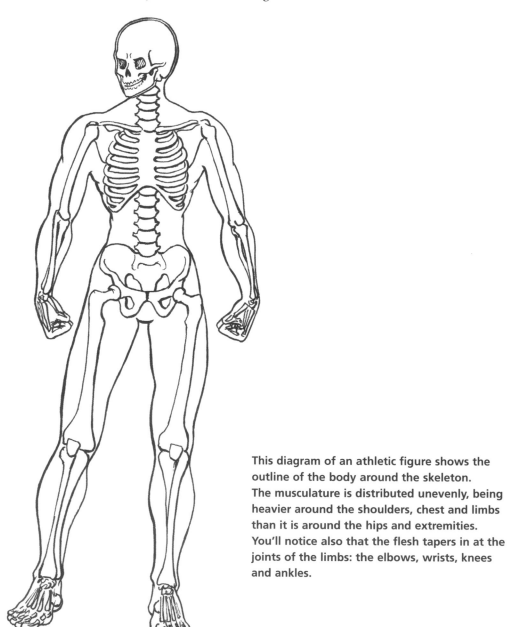

This diagram of an athletic figure shows the outline of the body around the skeleton. The musculature is distributed unevenly, being heavier around the shoulders, chest and limbs than it is around the hips and extremities. You'll notice also that the flesh tapers in at the joints of the limbs: the elbows, wrists, knees and ankles.

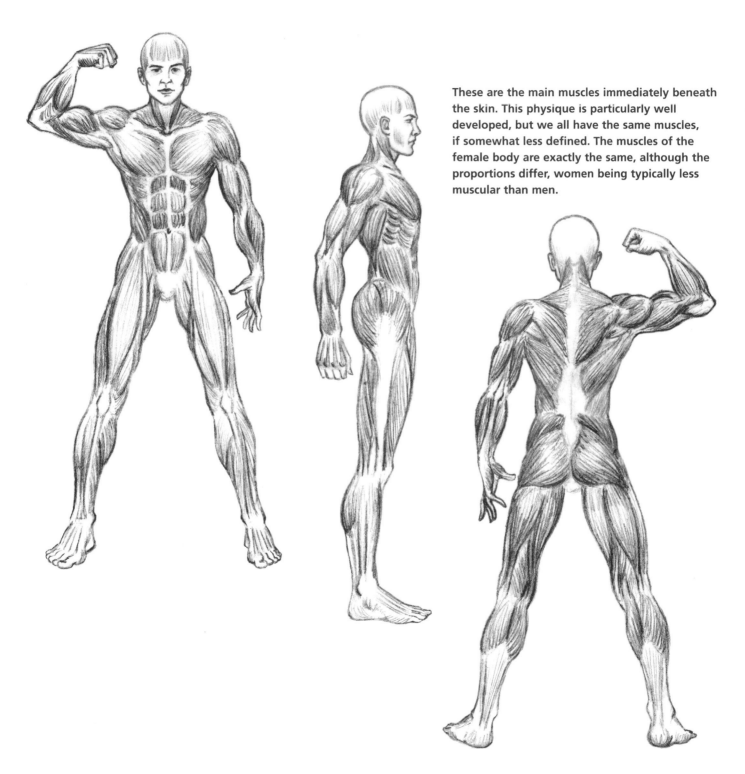

These are the main muscles immediately beneath the skin. This physique is particularly well developed, but we all have the same muscles, if somewhat less defined. The muscles of the female body are exactly the same, although the proportions differ, women being typically less muscular than men.

Proportion

Although heights and builds vary enormously, it's possible to establish some general guidelines about the relative proportions of the figure. Artists break down the body into head heights because whatever the size of the head, the rest of the body is generally in proportion with it.

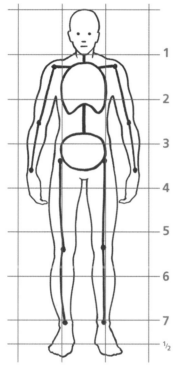

This fully grown adult male follows the average proportions of about seven and a half heads. Divisions can be imagined at the level of nipples, navel and so on, and the wrists and top of the legs fall at about half the overall height. The width is about two head lengths at the shoulders and one at the waist. Use this diagram as a rough guide only; proportions from six and a half to eight heads are not uncommon in adults.

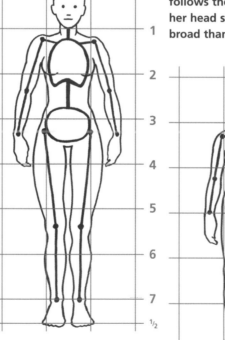

An adult woman, though generally shorter, follows the same vertical proportions relative to her head size. Her build will be generally less broad than a man's, though fuller at the hips.

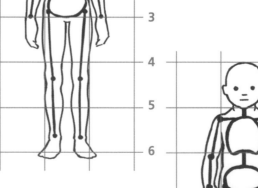

The head of an eight-year-old child is larger in proportion to its body, which is about six heads tall. The wrists and top of the legs still fall at about half the overall height.

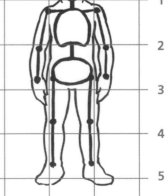

A toddler's head is about a fifth of its overall height. The head at this age is distinctly more squat in shape than an adult's and the legs are shorter relative to its body.

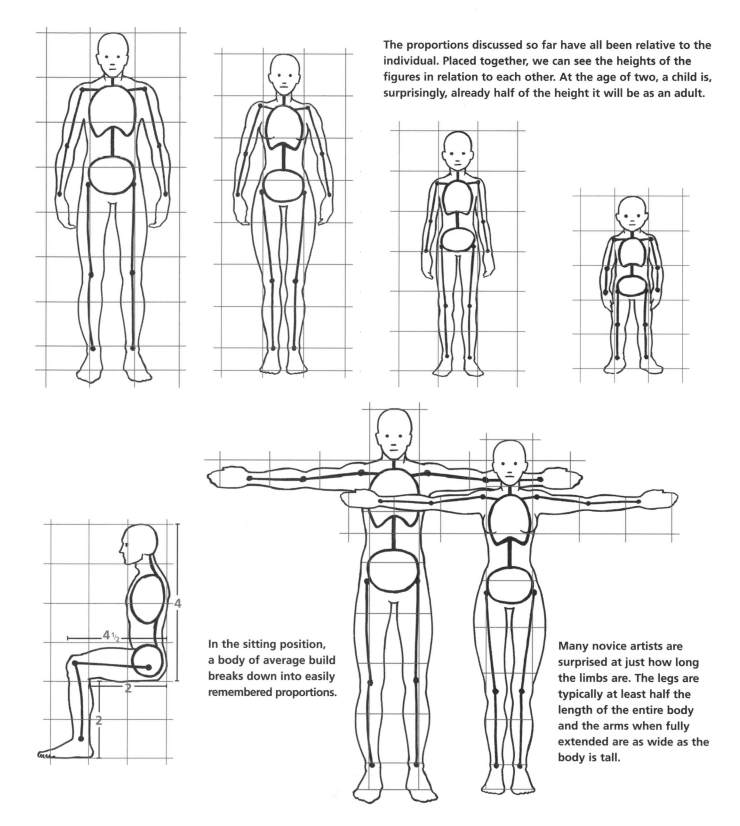

The proportions discussed so far have all been relative to the individual. Placed together, we can see the heights of the figures in relation to each other. At the age of two, a child is, surprisingly, already half of the height it will be as an adult.

In the sitting position, a body of average build breaks down into easily remembered proportions.

Many novice artists are surprised at just how long the limbs are. The legs are typically at least half the length of the entire body and the arms when fully extended are as wide as the body is tall.

207

Body types

Stature, gender, age, fat, fitness and natural body type all affect a person's overall build. Like faces, each body is unique, but they do often fall into general categories. Here are some life drawings of the different types, together with a few very basic pointers to how you might think about them when you come to draw them.

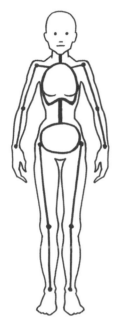

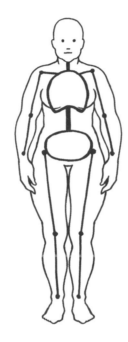

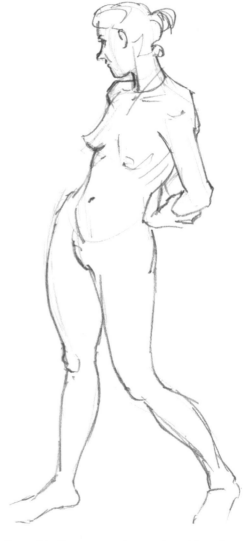

Very thin builds follow the form of the bones quite closely and the muscles, though not big, are quite defined because there is little fat to hide them.

In a larger person the muscles will be heavier, and a layer of fat smooths the contours and adds to the overall bulk. Like muscle, fat does not add bulk to the joints and extremities.

To describe a thin figure, angular marks with a sharp pencil can work well. Even very thin figures have some areas of curve and softness, so try to recognize them in the marks that you make.

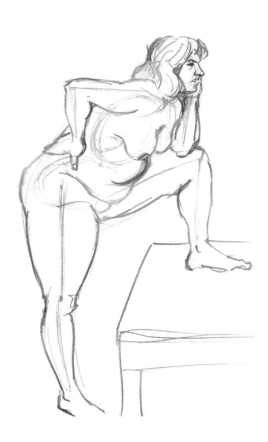

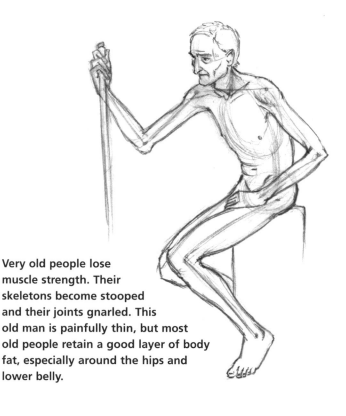

Very old people lose muscle strength. Their skeletons become stooped and their joints gnarled. This old man is painfully thin, but most old people retain a good layer of body fat, especially around the hips and lower belly.

I rounded off the tip of my pencil here to make marks that are softer and more rounded. Note how gravity pulls down the soft tissue of breasts, belly and upper arm. The thighs are much broader at the top than where they taper to the knees, and the ankles and wrists are comparatively delicate.

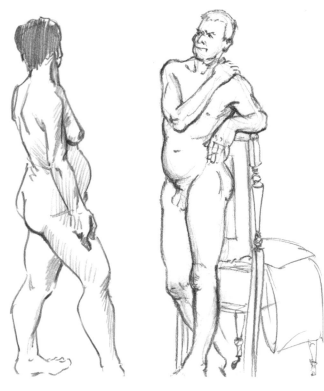

In middle age the body shows signs of decline. Musculature may still be strong, but less taut than in youth. Joints become more defined and knobbly and the neck and shoulders stoop a little. Middle-age spread affects men and women differently: women put on weight around the hips and belly, as well as the upper arms and thighs. Men's weight gain is mainly on the belly, but the buttocks and back also develop fat. Men's arms and legs tend not to gain weight with age.

Yourself as a model

The best way to gain proficiency in figure drawing is to work from a live model. To start with, take your clothes off and draw yourself. You'll need a mirror large enough to see your whole body at the same time. Don't worry about lighting, media or elegant poses; just start with a standing pose and use an HB pencil. It's a good idea to mark your position on the floor, in case you get called away mid-drawing. Draw yourself from various angles. Don't strive for polished pictures. Try to produce a whole series of informative studies of the proportions, angles, balance and contours of your figure.

STEP 1

Uncomplicated though it looks, this is the most important stage of the drawing. The skeleton must be correct in proportion and posture. Use your pencil for sight sizing and for judging angles. Because my eyeline is near the top, the proportions of the mirror and my reflection in it recede towards floor level.

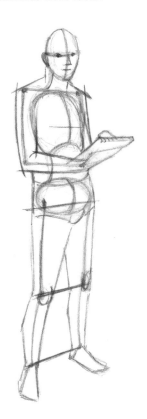

STEP 2

Now mark the rough masses of flesh, mapping out the general shape of your body. At this stage, don't worry about shape so much as the general mass and horizontal proportions.

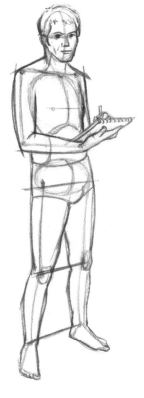

STEP 3

Over your guidelines, work on the curves and contours.

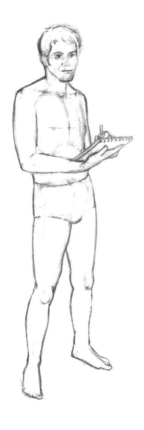

STEP 4

Carefully erase your unwanted guidelines, constantly checking in the mirror to make sure that you don't erase the good outlines. You should be left with a rough but reasonably accurate line drawing.

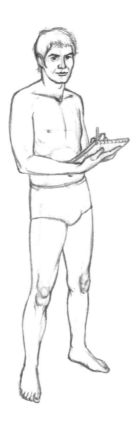

STEP 5

Now look hard at those contours. Try to envisage what's happening beneath the skin, the tension in certain muscles, the looseness of fat and the hardness where the bone is near the surface. As this is only an exercise, you could abandon your drawing at this stage. However, you may want to try your hand at shading.

STEP 6

Keep the rendering simple – a rough tone to give the drawing solidity and some modelling to capture the form of the contours, recesses and protuberances.

The figure in perspective

Perspective affects our view of the body as much as any other object. Even when you are looking at yourself in a mirror, perspective distorts proportions and angles – and when you come to draw other people the distortions can be extreme. Persuade friends to pose for you for quick perspective studies, as skeletons and as fully fleshed figures. They need not remove all their clothing for you to be able to identify the essential angles that their bodies form. Sketch the same pose from different levels – lying on the floor, sitting, standing and standing on a chair – and you'll very quickly build up an intuitive grasp of the perspective of figures.

This diagram shows a man holding a box. There is little noticeable perspective in operation. But our eye is level with the man's chest, which means that we are looking down at his feet and can see the tops of them.

If our eye level changes, so does our view of the figure. Here we see the figure from about ankle height so we have a front view of the feet. The legs seem proportionately longer and the chest largely disappears behind the box. The bottom of the box is now in plain view as is the underside of the man's jaw. The curvature of the head is apparent and this low angle makes the neck quite prominent.

From a viewpoint above the man's head, the opposite occurs. The head, being the closest part, is large and sits forward, rendering the neck invisible. The shoulders and chest are broad and prominent, while the legs and feet appear diminutive in comparison.

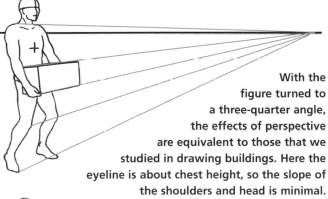

With the figure turned to a three-quarter angle, the effects of perspective are equivalent to those that we studied in drawing buildings. Here the eyeline is about chest height, so the slope of the shoulders and head is minimal.

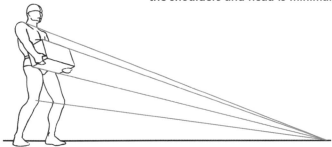

A very low viewpoint produces the effects we might predict, with the body's angles sloping down towards a distant vanishing point and, naturally, the opposite occurs from a very high viewpoint. Unlike buildings, people may bend, twist and skew, throwing any attempt at mapping vanishing points into chaos. These diagrams are intended to show general perspective effects and are not demonstrations of how one would go about a drawing.

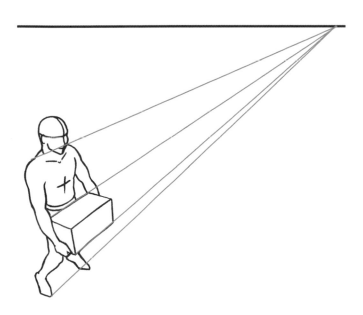

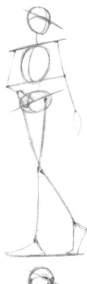

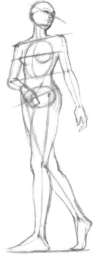

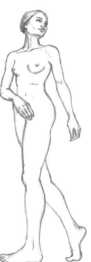

STEPS 1–3

In practice, the perspective angles on a figure are best judged individually, using the upheld pencil as you learnt on page 26.

Look for convenient reference points, such as the line of the eyes, shoulders, hips and knees, and make as many guidelines as you need.

Check the angles of your skeleton, bearing in mind your viewpoint relative to a model. As your drawing progresses, keep assessing new angles as you draw new features. On some parts the perspective effect may be very subtle, so don't be tempted to overstate an angle to prove to yourself that you have noticed it.

213

Balance and tensions

In your early attempts at drawing figures you may find that they appear to lean or to lack weight. The mechanisms of muscles that control our balance are very complex and not always easy to get down on paper. In a standing pose, the body has a centre of gravity, an imaginary point usually in the area behind the navel. A vertical line through this point is known as the line of gravity, either side of which the body's weight is equal. Identifying the line of gravity can help to assess the stability of a figure and the tensions within it. These drawings from life classes demonstrate some interesting poses and their tensions.

There's more tension throughout this figure. The raised arms slightly lift the breast and cause the back to arch. One buttock is tensed and the other more relaxed, but the weight is taken equally on both legs. Again the line of gravity runs through the centre, equidistant from both feet.

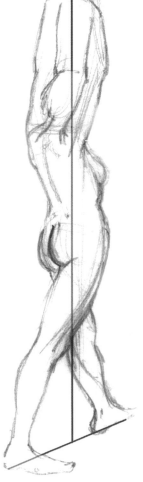

This model's weight is evenly dispersed on both legs and the upper body is relaxed in its natural posture. The line of gravity runs through her middle.

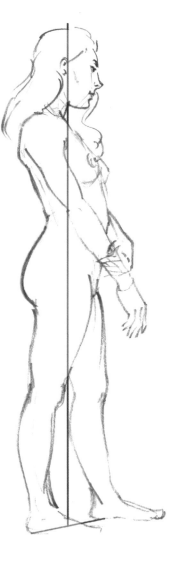

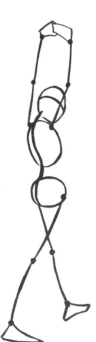

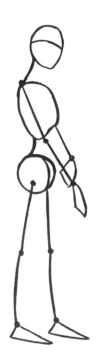

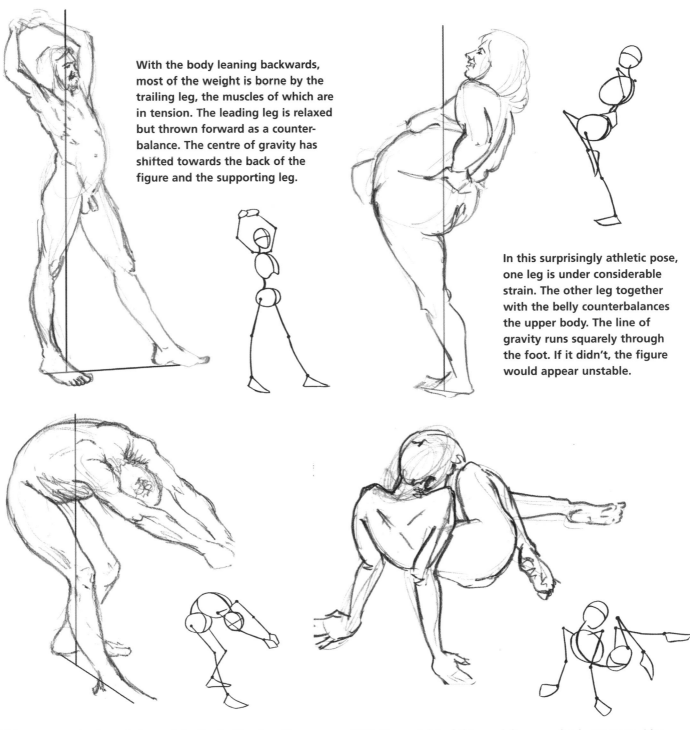

With the body leaning backwards, most of the weight is borne by the trailing leg, the muscles of which are in tension. The leading leg is relaxed but thrown forward as a counter-balance. The centre of gravity has shifted towards the back of the figure and the supporting leg.

In this surprisingly athletic pose, one leg is under considerable strain. The other leg together with the belly counterbalances the upper body. The line of gravity runs squarely through the foot. If it didn't, the figure would appear unstable.

This pose required great strength in the trailing leg, the leading leg again acting as balance. The arms help with this, but to hold them out puts strain on them and the shoulder muscles. The centre of gravity is in the middle of the chest.

With the weight of this model's upper body supported by her arms, the shoulder blades are forced together and the arms are fully locked. The twist in the trunk puts more weight on the left arm than the right.

Foreshortening

So far we have looked at figures of which the limbs are generally outstretched and the proportions clearly discernible. Different viewpoints or poses can be more complicated to draw, though not necessarily more difficult if you are able to interpret what you see.

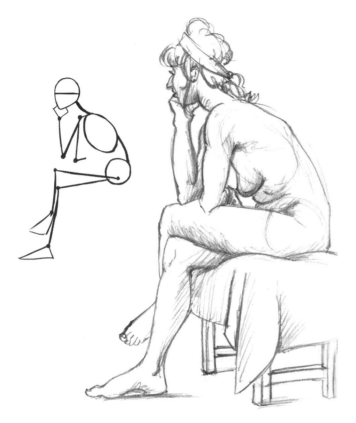

There are a couple of points to be aware of in this fairly simple pose and viewpoint. The model's left forearm is presented at such an angle that it is virtually invisible. Looking at the skeleton, her lower left leg appears noticeably shorter than the right. This phenomenon, where the angle of view reduces the apparent length of things, is known as foreshortening.

Foreshortening is more pronounced from the front. The arms and lower legs are equally proportioned, but the thighs seem a fraction of their true length. Viewers have enough experience of looking at the world not to be confused by this representation. However, careful sight-sizing and close observation of contours is required to create the successful illusion of depth.

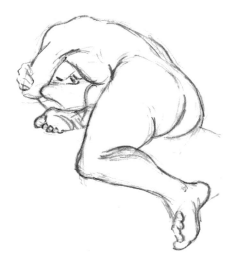

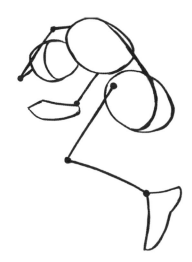

Sometimes it's more appropriate to draw a figure in the manner of a still life object, approaching the body in terms of its masses and angles. You will find this described in more detail on the next page.

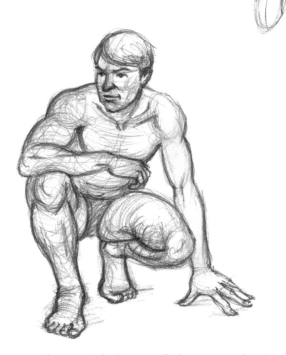

When presented with a view like this, with heavily foreshortened body parts overlapping each other, it might be difficult to interpret the skeleton form so a different approach might be required to start a drawing.

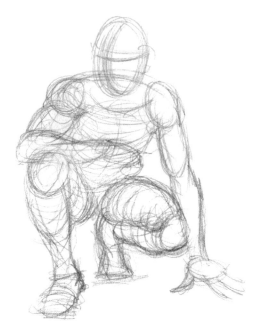

Another approach is to let your pencil rapidly spiral across the paper, searching for the forms and masses that make up the whole. It's surprising how quickly you can build up a convincing figure.

Once you are happy with the overall shape, press harder (or use a softer pencil) to draw out details from the mass of lines. In the finished sketch, the exploratory marks can aid the description of musculature and solid form.

The figure and pictorial depth

A drawing can be inhibited by preconceived ideas of what the subject should look like. Drawing extremely foreshortened figures, it may be necessary to set aside what you know about the body and its proportions and try to see the model with fresh eyes.

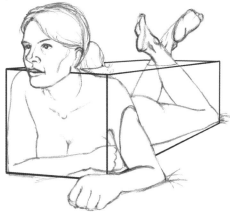

BEFORE STARTING

It may be helpful to think of a pose in terms of its overall perspective. Try to visualize a box surrounding the figure and its angles of recession. This will get you thinking three-dimensionally and accepting of unexpected dimensions.

STEP 1

Looking at the figure as a set of shapes and angles will help you to dissociate it from your expectations and measure the proportions with accuracy. Break the figure down into geometric shapes and use your held-out pencil to judge the angles and check measurements. Expect to be surprised by your findings. Here, for example, the height of the head is greater than the measurement from knee to buttock.

CHECKING STEP

This is a well-tried method for checking a drawing's accuracy. Look for triangles within the model and, once again, measure their angles and dimensions with the pencil. It may seem convoluted, but the principle is easy to grasp, and it can highlight errors very efficiently.

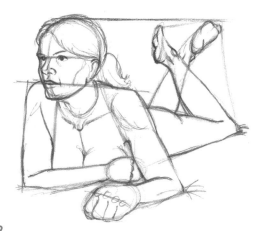

STEP 2

With a solid framework established, the hard work is done and it should be relatively quick to turn your geometric blocks into soft fleshy curves. Sometimes curves bring shortcomings to light, so keep an eye on proportions as you go.

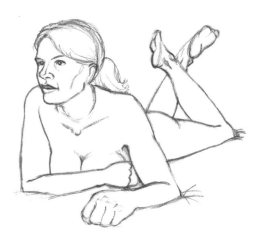

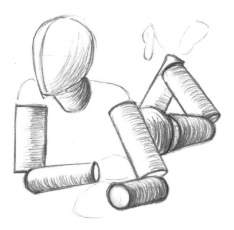

STEP 3

Erase your angular guidelines before going on to finish the drawing, especially where they run through and conflict with subtle curves. Then again, you may favour an angular constructed look to your drawing and decide to incorporate them into the drawing.

Before you start shading, you might benefit from making a small sketch on scrap paper of the cylinders within the figure. This will help you identify the angles at which they recede. You could roughly shade them following the cylinders' curves.

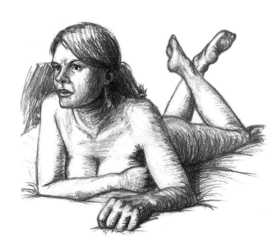

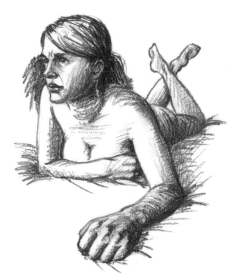

STEP 4

The shading pattern can be translated onto the drawing to aid the description of the body's curvature. Even though the distance is not great, the effects of aerial perspective can still be applied to reinforce the illusion of pictorial depth. Lines and shadows in the foreground should be rendered more strongly than those further back with the strongest contrast reserved for the closest part, in this case the hand.

The previous picture was drawn from a viewpoint about 1.5m (5ft) from the model. Here, I sat much closer, at a distance of about 50cm (20in). The differences in the proportions are dramatic, with the closer elements greatly increased in size while those more distant are further diminished. The result is a more arresting image. The closer the viewpoint, the more exaggerated the perspective and the proportional contrasts.

Hands

I often hear people say "I can't draw hands". If you are capable of drawing the rest of the body, the hands shouldn't be too difficult. For quick figure sketches, it's practical to reduce hands (as well as feet and faces) to their basic shapes. A few lines can adequately describe proportion and gesture, but hands are complicated structures with amazing articulation and worthy of close study. As you'd expect, it is helpful to know something about the underlying structure of hands as well as ways to approach drawing them.

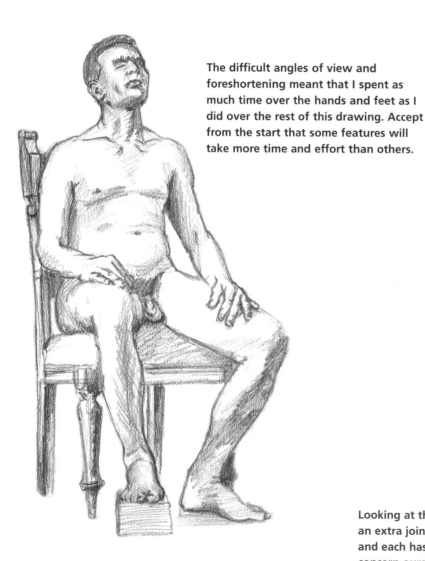

The difficult angles of view and foreshortening meant that I spent as much time over the hands and feet as I did over the rest of this drawing. Accept from the start that some features will take more time and effort than others.

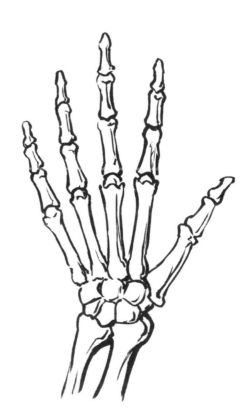

Looking at the bones of the hand, the finger bones seem to have an extra joint; this is because the fingers radiate from the wrist and each has three joints, including the knuckles. We need not concern ourselves with the cluster of small wrist bones, but where they join the arm is interesting. The two bones of the forearm end in knobbles that show as distinctive features either side of the wrist.

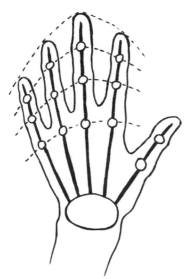

You will usually have to consider every joint. The joints are arranged in arc formations, to account for the fingers' differing lengths. The thumb, which also stems from the wrist, has only two joints. The flesh of the hand, seen here in outline, follows the contours of the bones, with more or less pronounced bulges around the joints.

In the external appearance of the hand, there are many visible clues to its internal structure. The finger and thumb joints are marked by wrinkles and the knuckles are pronounced bumps. Ligaments run down the back of the hand, tracing the paths of the bones.

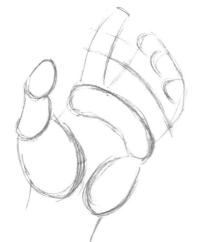

The inside of the hand has three distinctive fleshy masses that make up the pad of the palm. Sketch them in your under-drawings to contribute to the hand's structure. Care must be taken when drawing fingers from certain angles, such as those bent forward here. Shading is a good tool for suggesting changes of plane. Nails have distinctive curves that immediately convey the angle of the fingertips.

Beginners often start drawing hands with the pre-conception that they are flatter than they really are. Think of the hand as having definite thickness and each digit as a cylinder. Breaking the hand down to a series of boxes reinforces this sense of the hand's three-dimensionality.

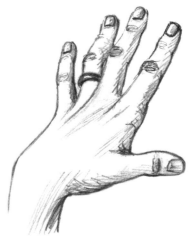

221

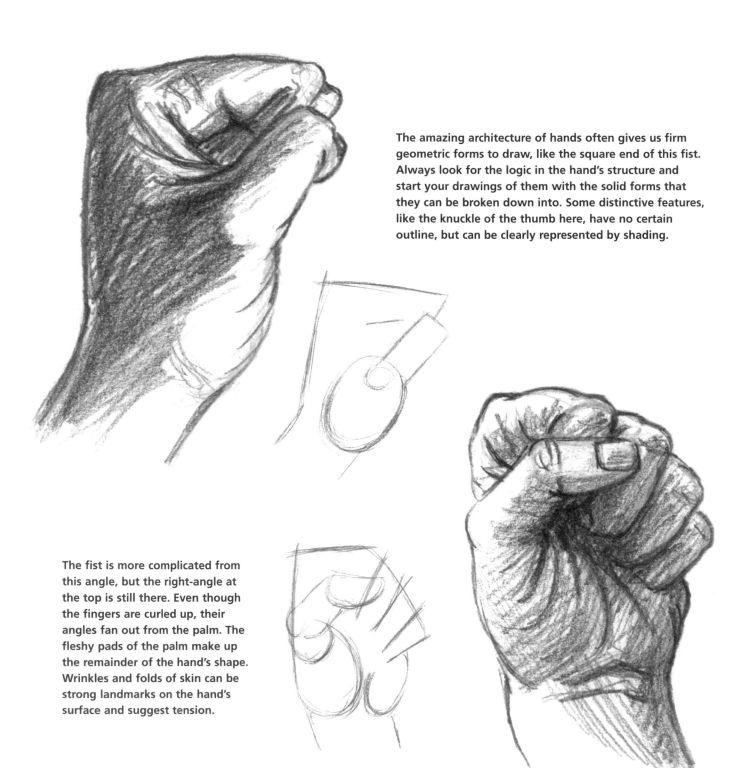

The amazing architecture of hands often gives us firm geometric forms to draw, like the square end of this fist. Always look for the logic in the hand's structure and start your drawings of them with the solid forms that they can be broken down into. Some distinctive features, like the knuckle of the thumb here, have no certain outline, but can be clearly represented by shading.

The fist is more complicated from this angle, but the right-angle at the top is still there. Even though the fingers are curled up, their angles fan out from the palm. The fleshy pads of the palm make up the remainder of the hand's shape. Wrinkles and folds of skin can be strong landmarks on the hand's surface and suggest tension.

The fanning of the fingers is observable in many of the hand's functions and is an important part of drawing believable hands. Notice how the tips of the fingers bend back slightly when held out rigid. This is my left hand drawn with the aid of a mirror.

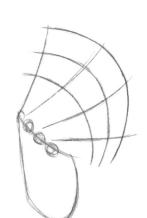

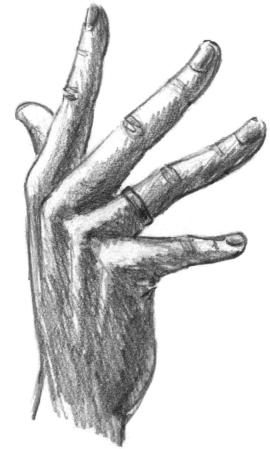

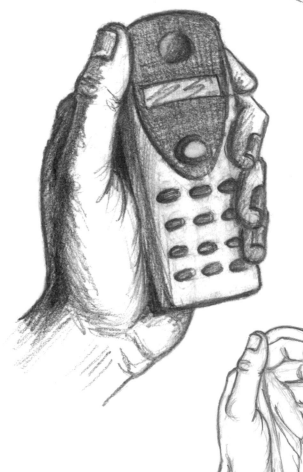

We hold things in many different ways, depending on the size, shape, weight and material of the object, which can result in hands of complicated shape. My hand holding a telephone looks simple enough, but it would be easy to place the fingers too high, too low, too far left or right. Do not assume that you know what hands look like – keep looking and think about the underlying structures.

If we make the telephone invisible, the shape of the palm and the fanning of the fingers lend logic to the positioning of the gripping fingertips.

Feet and ankles

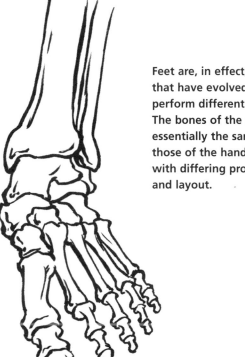

Feet are, in effect, hands that have evolved to perform different functions. The bones of the foot are essentially the same as those of the hand, only with differing proportions and layout.

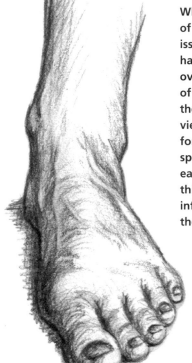

When drawing feet, articulation of the toes is much less of an issue than with the digits of the hand. More important is the overall shape and a sense of weight and connection with the ground. Feet are often viewed in various degrees of foreshortening, which means that special care must be taken over each curve and knobble. Compare this drawing to the skeleton to inform yourself about some of the structures involved.

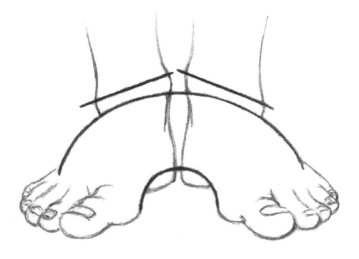

This diagram shows a common view of feet and shows their structural form for drawing purposes. Like wrist bones, ankle bones stick out. The protuberances inside the ankle are significantly higher than those on the outside of the ankle. The top of the feet forms an arc and a smaller arc indicates the curve of the feet's arches.

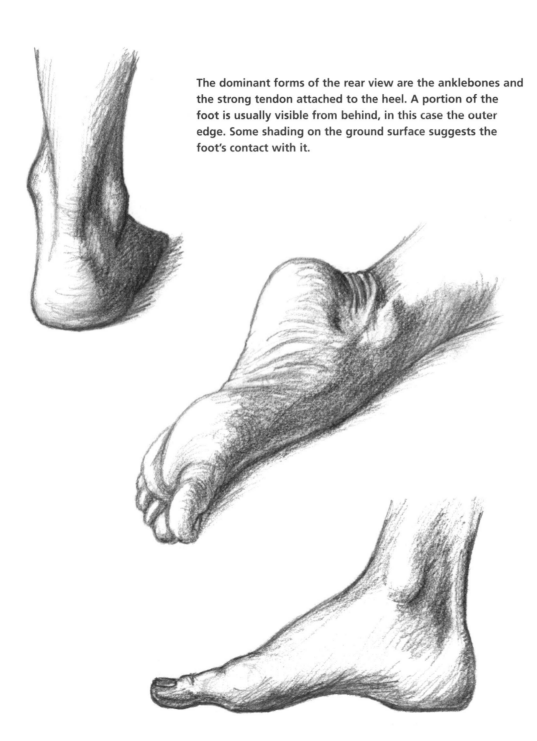

The dominant forms of the rear view are the anklebones and the strong tendon attached to the heel. A portion of the foot is usually visible from behind, in this case the outer edge. Some shading on the ground surface suggests the foot's contact with it.

The sole is mainly characterized by the fleshy masses of the heel, ball and pads of the toes. Note the wrinkles under the arch and those behind the ankle.

From this view the foot has a distinct wedge shape, but the curves within the overall shape are important. The inner edge of the foot does not touch the ground and forms an arch. Similarly, the toes are clear of the ground, only touching down at their ends.

In the life class

Life drawing classes can be found in most towns and cities. They are not cheap, but are very much worth the expense. The intensive learning environment will allow your drawing to progress quickly and enjoyably.

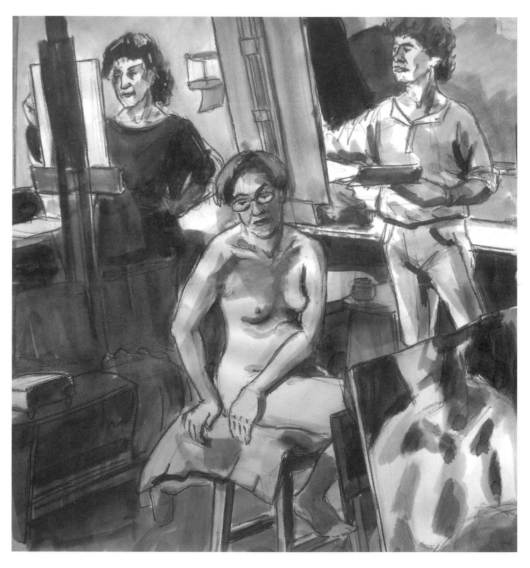

The figure here is treated as one element of a larger composition. Adding extra figures and background details is good practice for drawing the figure in relation to others and can provide interesting contexts and contrasts.

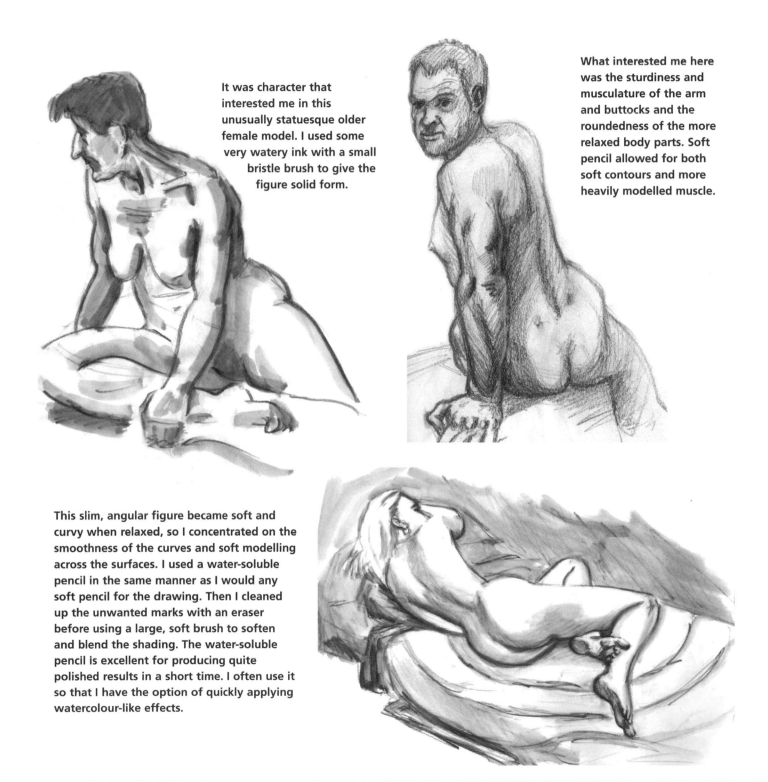

It was character that interested me in this unusually statuesque older female model. I used some very watery ink with a small bristle brush to give the figure solid form.

What interested me here was the sturdiness and musculature of the arm and buttocks and the roundedness of the more relaxed body parts. Soft pencil allowed for both soft contours and more heavily modelled muscle.

This slim, angular figure became soft and curvy when relaxed, so I concentrated on the smoothness of the curves and soft modelling across the surfaces. I used a water-soluble pencil in the same manner as I would any soft pencil for the drawing. Then I cleaned up the unwanted marks with an eraser before using a large, soft brush to soften and blend the shading. The water-soluble pencil is excellent for producing quite polished results in a short time. I often use it so that I have the option of quickly applying watercolour-like effects.

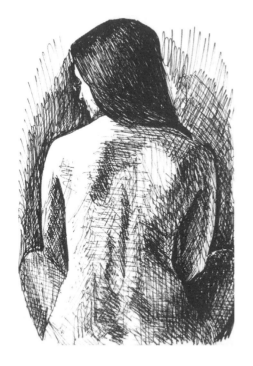

Anything that makes a mark is a valid sketching tool. The hastily scratched marks here are done with a ballpoint pen and describe the subtle features of the model's back, picked out in raking side lighting.

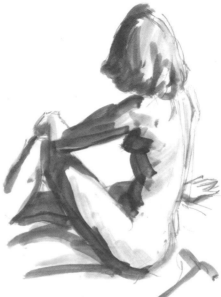

I was struck by the delicacy of this model's build in contrast to the powerful direct light. For both of these studies, I used watered-down ink with a medium bristle brush over very basic pencil work. The results of this simplification are bold and almost abstract.

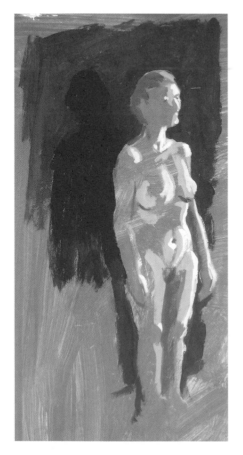

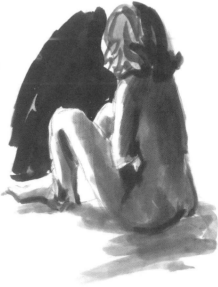

Without using pencil first, I did this drawing with paint, on paper that I had previously painted grey. Poster paint is very cheap to buy and fun to experiment with. You only need black and white to mix the full range of greys. I used the paint neat and opaque with a fine bristle brush and was careful to leave a lot of the original grey in the figure.

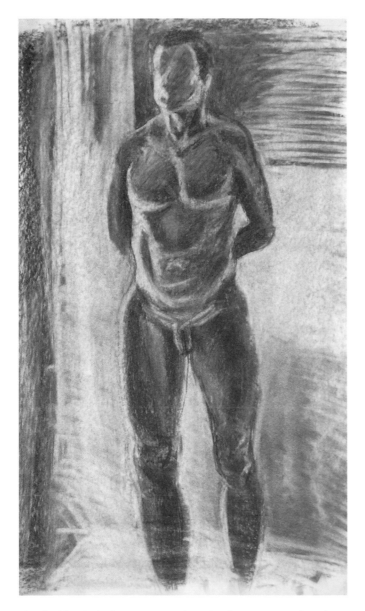

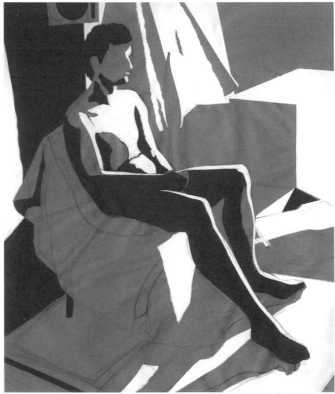

This pose gave me more time to experiment. Again, the strong lighting reduced the range of mid-tones, so I chose to work with strictly one tone of grey, plus black and white. After a rough drawing on grey paper I cut out and tore black and white paper for block shadows and highlights.

This bold side lighting meant that the figure was reduced to only very pale and very dark tones. I covered the paper in charcoal and then used an eraser and my fingers to draw the light out of the black.

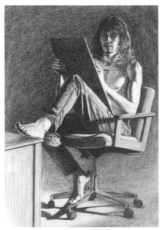

If you want to do highly detailed drawings, life classes may not provide the time you need. Some classes repeat poses in following sessions, otherwise you can always resort to your most loyal model. This old self-portrait, took me seven or eight hours.

Going up in scale

Virtually all of the pictures shown in this book so far are in reality no bigger than A3 size (42 x 30cm/16 x 12in) and most are much smaller. However, access to a life drawing class with easels, large drawing boards and space to move around affords the luxury of producing larger drawings. With increased scale, especially when you work quickly, you will find that you bring a physical energy to your drawing, you draw with more freedom and you fuss less over small details.

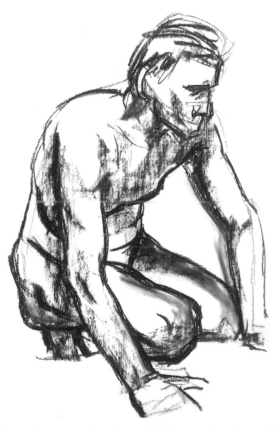

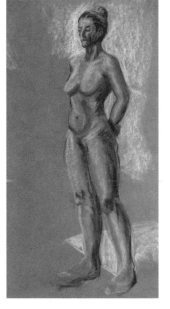

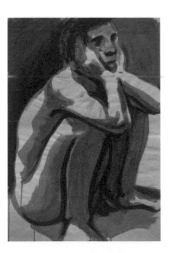

This five-minute drawing is on A2 (42cm x 60cm/16 x 24in) cartridge paper. I used thick charcoal and turned it on its side for the shading. It is not a careful drawing or any kind of finished statement, but I think the energy and pleasure of its production is evident. Small drawings can look tight and constricted because the movements are made by the wrist and fingers. Working bigger means that your whole arm can swing freely from the shoulder.

Using charcoal and chalk on grey paper, I did this drawing at A2 as well, but it feels very different in flavour from the previous example. For a more feminine feel, I softened the line and tones with my fingers. Although the drawing is the same size, the scale of the figure is much reduced and I think it suffers for it. The pose was longer but the results are not so direct or interesting.

Here's a ten-minute sketch at A2. I used a fairly big bristle brush and painted the mid-tones in thinned black poster paint. Then I used the same brush and neat paint to draw the outlines and solid blacks. I like the heavy, bold line and the way the figure is contained within the frame of the paper.

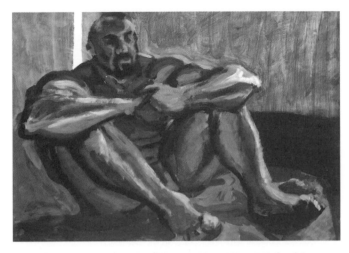

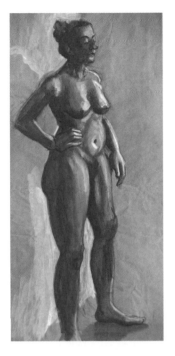

This picture started as A1 (84cm x 60cm/33 x 24in) white cartridge paper. With a fat house-painting brush I covered the whole surface with thinned black acrylic. A kitchen tray served as a palette for black and white acrylic paint, which I used for the figure. Roughly mixing the paints, I continued to draw into the painting and a very solid figure emerged.

Brown packing paper is a pleasant surface to draw or paint on and can be bought in rolls. This piece is just over 1m (39in) in length. Over quick pencil guidelines I did the drawing in acrylic paint with a thin bristle brush and then used washes of the same paint to scrub in the tone with a 25mm (1in) house-painting brush. For highlights I used thinned white acrylic paint.

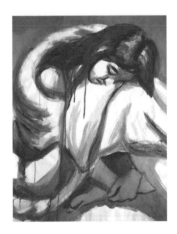

Using a house-painting brush and very low-grade newsprint paper, I drew this very rapid sketch in watery poster paint. I like the abstract design quality of the duvet with a few details of a body emerging from it.

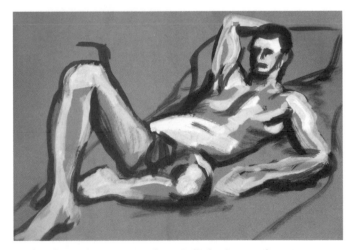

With a five-minute pose, there is little time to fuss. However, you may surprise yourself with some very spirited results. There is a real solidity and vigour in this A2 poster paint sketch that a longer pose and a smaller scale would not allow to come through.

Clothing – folds and wrinkles

Outside the specific discipline of life drawing, you are unlikely to regularly draw people naked. In everyday life, people cover most of their bodies, so if you want to draw people, drawing clothing plays a large part. Clothes hang, drape, fold, wrinkle and flow in complicated ways that are dependent on many factors, the most significant of which are the build, pose and movement of the body within. This is where experience of drawing the nude pays off. The sketches below demonstrate many of the kinds of folds that are typical in everyday fitted clothing. Study them carefully.

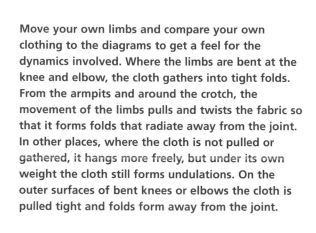

Move your own limbs and compare your own clothing to the diagrams to get a feel for the dynamics involved. Where the limbs are bent at the knee and elbow, the cloth gathers into tight folds. From the armpits and around the crotch, the movement of the limbs pulls and twists the fabric so that it forms folds that radiate away from the joint. In other places, where the cloth is not pulled or gathered, it hangs more freely, but under its own weight the cloth still forms undulations. On the outer surfaces of bent knees or elbows the cloth is pulled tight and folds form away from the joint.

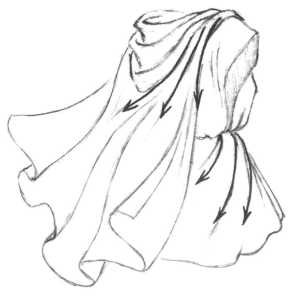

On a standing figure, garments will hang with the vertical pull of gravity. With movement or in wind, however, the fabric will swing or even flap. In this sketch the folds of the fabric fall away from the hanging points, in this case the shoulders and waist. Where the cape flies freely, it forms into flowing, tube-like folds.

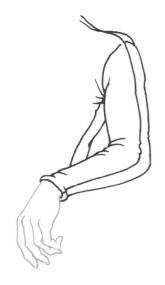

It is essential to bear in mind the cut and weight of the cloth if you want your drawings to look convincing. Thin, tight-fitting garments closely follow the body's contours and form small wrinkles inside the bends. Generally, heavier fabric makes bigger folds, but large folds can also occur in thin fabric where it is loose-fitting.

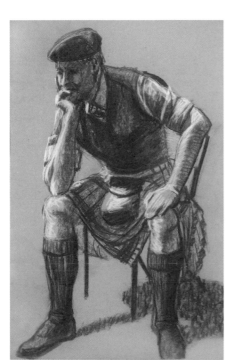

Here the tight trousers closely follow the shapes of the girl's legs, whereas her pullover is loose and gathers in folds. But the form of her upper body is visible in the shading of the pullover, aided by the raking angle of light.

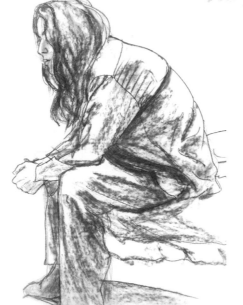

This man's outfit is rendered quite simply in charcoal and chalk. The rendering adds texture, detail and richness, such as the ribbing of the socks, the tartan design and the soft surface of the pullover.

One hand and a bit of face are all that's directly visible of the figure in this large charcoal sketch. The picture is all hair and cloth, but it reads as a figure because the underlying structure is convincing and the folds and shading of the garments are consistent with the implied body mass.

A full-figure portrait in water-soluble pencil

It's a good idea to involve your sitter in the creative process of setting up the pose. This model is a performance artist who had her own very definite ideas about how she wanted to be portrayed, and even dressed specially for the occasion. I chose the medium of water-soluble pencil, which would allow me to speedily build up the tonal richness that the subject demanded. These pencils are not expensive and feel exactly like an ordinary soft graphite pencil in use. Intending to get it wet, I used a paper of heavy weight and worked at about A3 (42 x 30cm/16 x 12in).

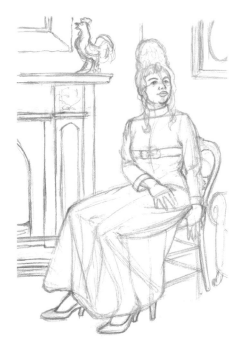
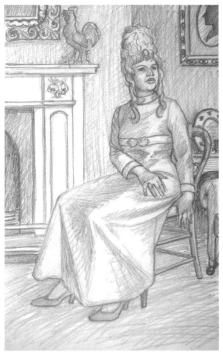

STEP 1

The model's dress covers most of her body and makes it difficult to picture her figure underneath. Even so, I started by making a framework that includes the rough shape of a body within the main shapes and angles of the dress.

STEP 2

With the main shapes established, I gradually honed the details, still working in line. If a background is to be a feature of a drawing, it should be worked up at the same time as the figure.

STEP 3

I erased the unwanted guidelines and roughly shaded in the tones of the whole picture. I was not worried about following any shading pattern because the pencil marks would all be smoothed out later.

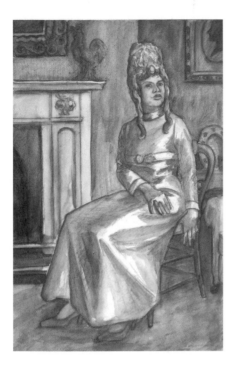

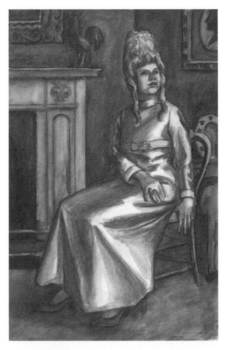

STEP 5

Once the paper was dry, I used an eraser to clean up some scruffy marks and smooth out some of the tones. After a good look at the picture, I decided that the background needed to be darker to let the figure stand out, so I worked into it with the pencil and also deepened some of the tones of the dress. After another treatment with brush and water, the picture had more satisfying tones and contrast.

STEP 4

With a large soft brush (No.10 round sable) I painted clean water onto the picture, holding the drawing board quite flat to avoid streaks. I took one section at a time and used the water to smooth out the pencil marks and bring out deeper, richer tones. I was keen to make a feature of the bright highlights on the model's dress, so I ensured that no water or pigment was allowed to touch those areas. While the paper is still wet, mistakes can be sponged off with some tissue paper.

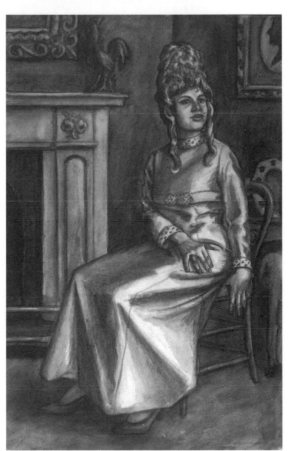

STEP 6

Once it was dry again, I used an eraser to clean off and pick out some highlights. Stubborn pigment can be removed with an ink eraser. I then worked across the picture with a sharpened pencil, firming up outlines and picking out details and textures. It's very enjoyable to do these last stages over the top of a stable base. The end results look like a watercolour painting, but done more quickly and with greater control of the tones at every stage.

A full-figure portrait in bamboo pen and ink

In the previous drawing I sought a degree of richness, albeit through a simple medium. In this demonstration, I'll introduce another very basic drawing tool and allow its characteristic mark-making to dictate the feel of the resulting picture. Art materials don't come much more basic than the bamboo pen, but it makes its own unique mark and is quite easy and strangely satisfying to use.

If you can't buy one at your local art shop, you can make a bamboo pen from a short length of garden cane fashioned with a sharp knife. Just below a knot in the bamboo, cut into it at a shallow angle. If the bamboo is very hard, you'll probably need to whittle it down in several cuts (always cutting away from your body!).

When you have the right shape, carefully cut a long, fine notch into the tip. Dip the pen into ink and make some practice marks on scrap paper. If it seems too thick or too thin, you can reshape the tip.

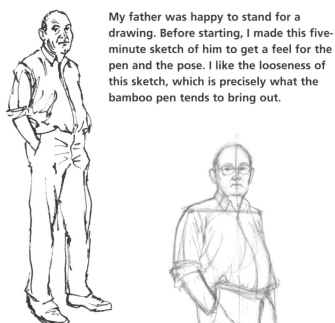

My father was happy to stand for a drawing. Before starting, I made this five-minute sketch of him to get a feel for the pen and the pose. I like the looseness of this sketch, which is precisely what the bamboo pen tends to bring out.

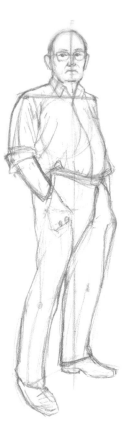

STEP 1

I wanted an accurate enough under drawing for me to do the inking with confidence. I adjusted the proportions and the pose and marked some of the clothing wrinkles. I marked the shapes of the hands to check their proportions and to assist with the shading later.

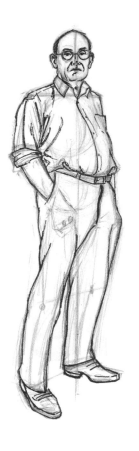

STEP 2

Drawing the detail directly in ink will produce a freshness of line that you might lose if you draw every detail in pencil first. With black ink, I outlined the main features of the drawing, constantly rechecking the drawing by looking at the model.

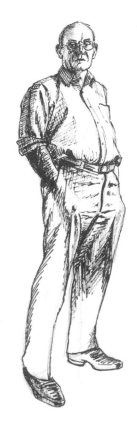

STEP 3

For the first stage of shading, I cleaned off the pen and changed to a paler, brown ink (you could use any other mid-toned colour). Using two inks makes some of the subtler shading easier than using black alone. With brown ink I shaded the areas of mid-shade and the transitions from plain white, largely ignoring local tone. I had to firmly establish the wrinkles, however much they might shift with future movements of the model.

STEP 4

Going back to the black ink, I stated the deeper shading: the transitions from mid-tone to black, the deep folds and the interesting shading on the face. That's all the information I needed from the model.

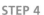

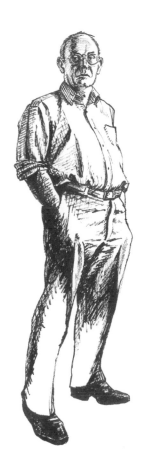

STEP 5

When the ink was thoroughly dry (aided by a hairdryer), I erased all my pencil marks. I used a brush to fill in the solid black tones on the trousers. Then I went over the rest of the picture with the pen and both inks to strengthen some of the marks and generally balance out the tones. To finish off, I added ground shadow with the lighter ink to root the figure to the floor.

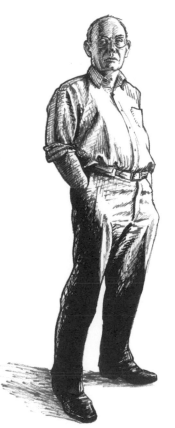

Sketching people

Having gained some experience, you may feel ready to tackle impromptu figure sketching. Sketching the unwitting subject is a different activity to drawing those who are obligingly posing: you have to be quick and decisive to capture a pose or character before your subject moves. Rarely will you produce beautifully crafted images, but this is not the aim. Sketching increases your knowledge of the figure, its articulation, and body language. It also sharpens your eye and increases your confidence.

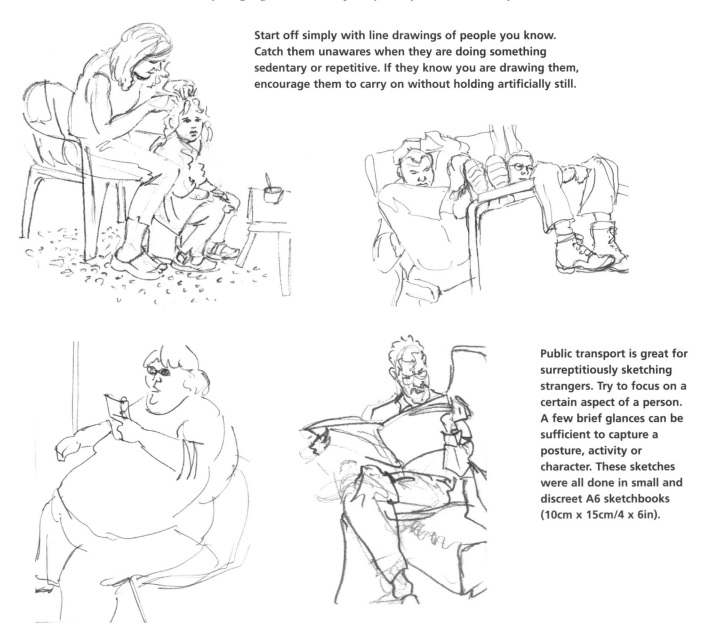

Start off simply with line drawings of people you know. Catch them unawares when they are doing something sedentary or repetitive. If they know you are drawing them, encourage them to carry on without holding artificially still.

Public transport is great for surreptitiously sketching strangers. Try to focus on a certain aspect of a person. A few brief glances can be sufficient to capture a posture, activity or character. These sketches were all done in small and discreet A6 sketchbooks (10cm x 15cm/4 x 6in).

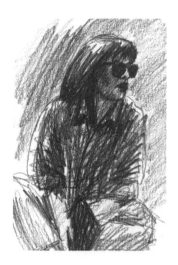

For this tonal sketch I used a very soft pencil and went straight in with the shading after the most vague of guidelines. The speed of application resulted in pleasingly vigorous mark making.

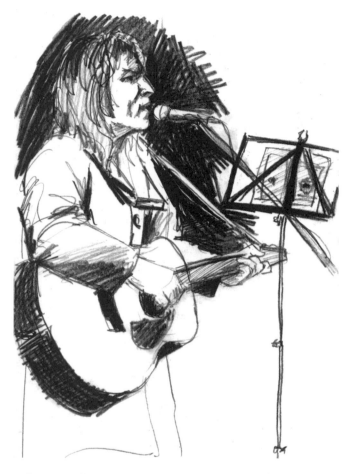

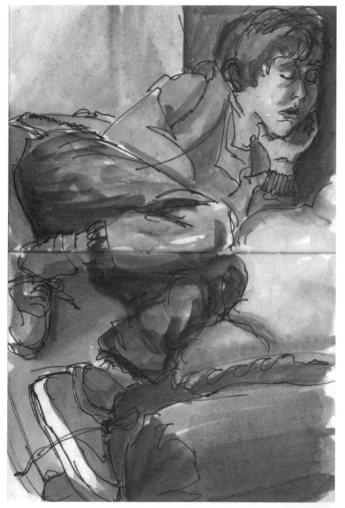

Performers offer many attractive qualities to the sketchbook artist: they make for instantly dramatic images, they can't roam very far, the lighting is usually strong and they don't mind being stared at. I sketched this rock singer from the side of the stage, using a soft pencil. I ignored local tone and drew the shadows to emphasize the powerful spotlighting.

With this boy being asleep, I had time to fetch some paint and add tone to the initial pen line drawing. I used black watercolour in varying degrees of dilution.

Sketching children

Drawing and sketching children presents particular challenges and rewards. A common failing is the tendency to draw them as miniature adults. In fact, a child's proportions and posture are quite distinct and it may take many spoilt drawings to master that certain essence of child-likeness. Another difficulty is the speed with which they dart from one position to another, but there are ways of overcoming this.

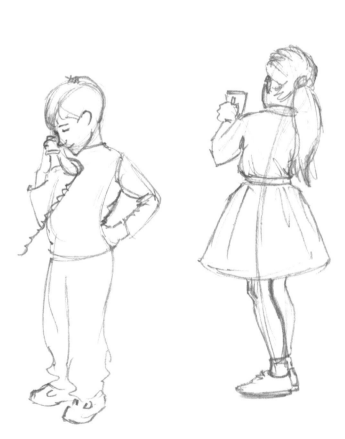

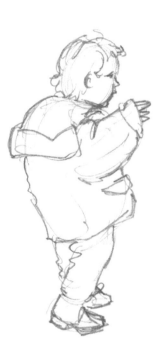

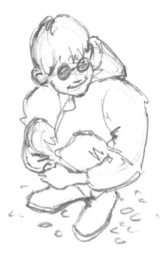

When a child is standing upright, the arch of the back is exaggerated and the belly is pushed forward. Sometimes it helps to first draw the curve that runs through the body and build the figure around it. Drawing the limbs too short is an easy mistake to make; the measurement from foot to waist is about three fifths of the overall height.

On their small frames, children's clothing can be quite bulky, ill-fitting and scruffily arrayed. Such details can be quite charming and not at all difficult to draw.

Many aspects of behaviour are unique to children, such as the way this boy is squatting. As with most of the drawings here, I rapidly sketched the main lines that made up the pose and invented some of the detail after the boy had moved.

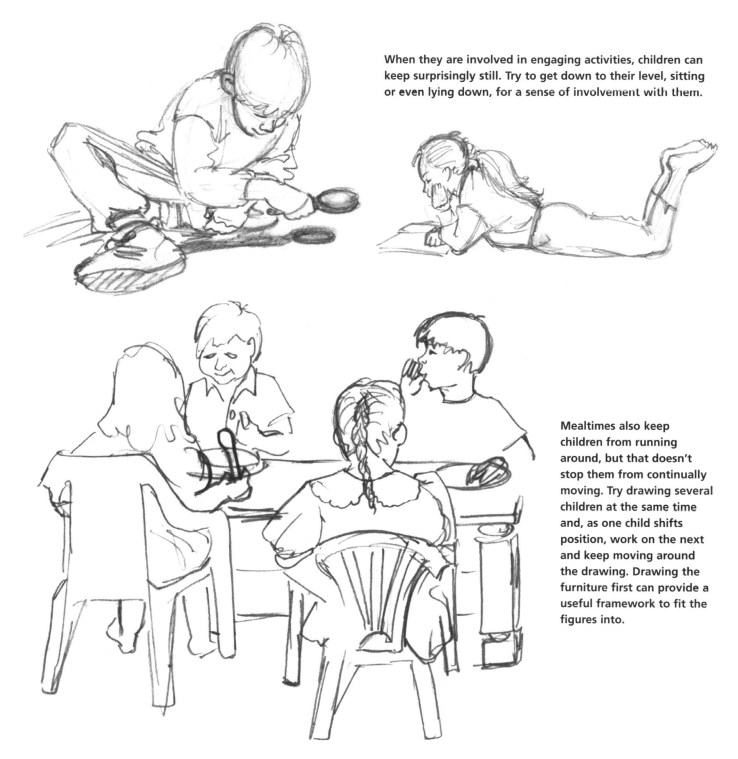

When they are involved in engaging activities, children can keep surprisingly still. Try to get down to their level, sitting or even lying down, for a sense of involvement with them.

Mealtimes also keep children from running around, but that doesn't stop them from continually moving. Try drawing several children at the same time and, as one child shifts position, work on the next and keep moving around the drawing. Drawing the furniture first can provide a useful framework to fit the figures into.

Reportage

Once you've made the brave move of getting out among people with your sketchbook, it's only a short step to the next level – reportage. This term dates back to the times before photography when artists were employed to attend events and produce drawings for publication, rather like today's courtroom artists. We can think of it as sketching to capture a whole scene: people interacting or involved in an activity, usually in a certain setting and often with a narrative or atmosphere implied. Reportage brings together skills in drawing figures, faces, landscapes, interiors and descriptive details.

This is reportage in its simplest form. The subject is a man driving, but the ambition is greater than that. Spread across two pages of a sketchbook, the drawing shows the van's interior and the motorway outside. A dull subject is thus elevated to one of detail and interest.

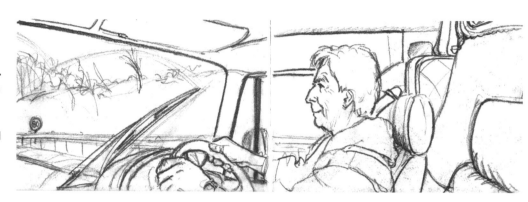

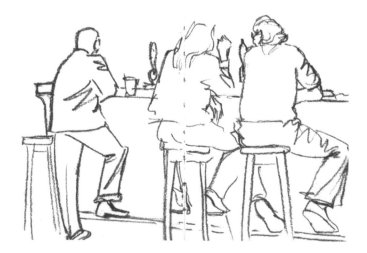

Though we can only see the backs of the figures in this setting, there is interest in their juxtaposition. In only a few lines a social dynamic is captured in the groupings and body language.

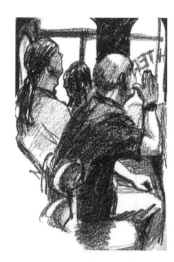

This conté crayon tonal drawing treats a similar subject in a different way, concentrating on the light and shade of the bar. Again, little detail is needed to define the setting.

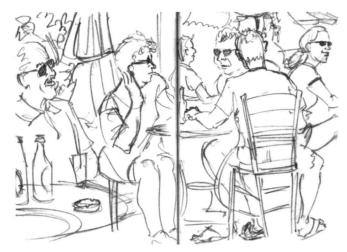

Drawing old men playing bowls in the park was a very pleasant way to spend half an hour, I used a fine black drawing pen, then I scribbled in some shading and shadows with a soft pencil.

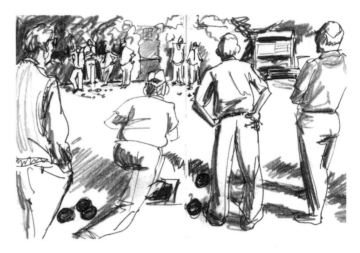

The strangely fragmented interplay of the central figures in this picture caught my eye. I added figures in the foreground and background to give the image depth and contribute to the setting. The scene is an invention in that the characters were not all seated at the same time, but put in at different times during the half hour or so the sketch took to complete.

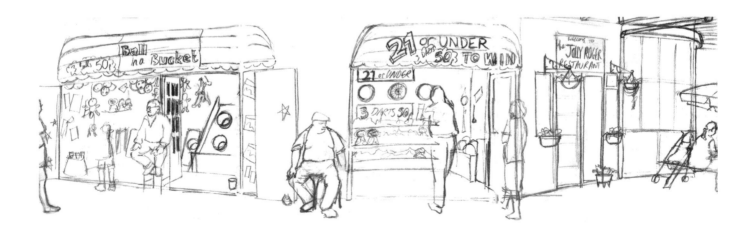

I set out to draw these seaside stalls as a background onto which I would draw the customers, but barely anyone came during the hour or so of my sketching. I quite like the emptiness of the scene and the boredom of the attendants. I drew this in HB pencil over several pages of an A4 sketchbook and joined them up later.

If you have made some good sketches, you may want to develop them further. It may be that you simply erase the rough marks and make the drawings more presentable. Perhaps you'll trace them onto better grade paper or redraft them into new compositions and render them in a different medium or add tone and colour.

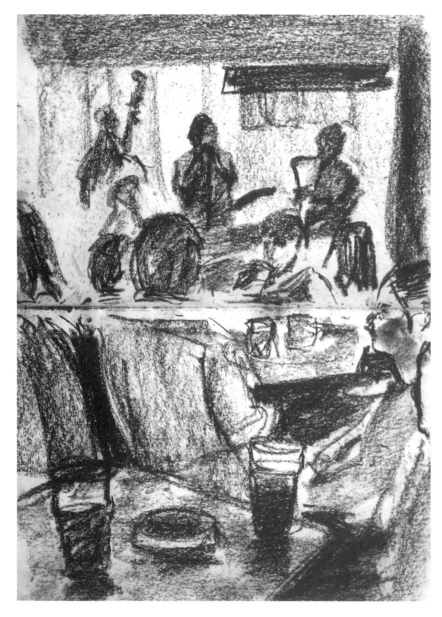

Some details may demand more attention. I often back up my reportage drawings with small studies that allow me to take away a more detailed picture of the occasion.

This sketch sacrifices detail in favour of tone and atmosphere. With the flat edge of a conté crayon I gently stroked in the general tonal shapes and then increased the pressure to build up layers of tone. In this way you can keep the drawing loose and flexible. With the point of the crayon, a few details can be worked up to give form and setting to the abstract shapes.

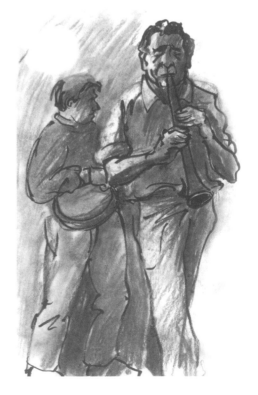

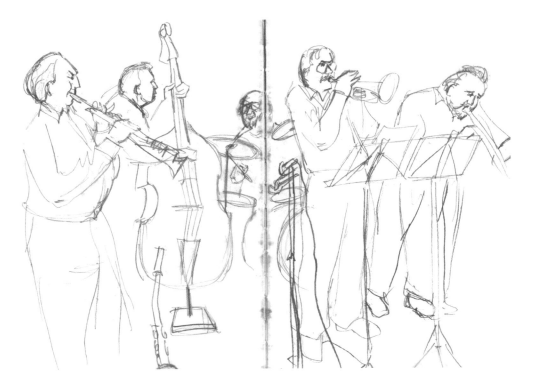

I concentrated on capturing something distinct about each of the musicians in this sketch. It may be tempting to use a camera to gather reference material, but you will miss out on the direct involvement with the subject and spontaneous character of 'live' drawing. Out of the many pictures I drew at a jazz club, this one best captures the charm of the musicians. Its simplicity would translate easily into a finished picture.

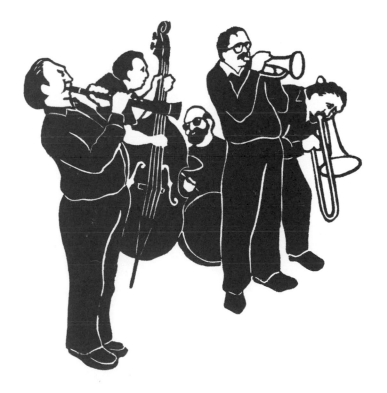

I liked the overlapping of the figures in the sketch, but thought it could be more compact. To redraft it, I took some tracing paper and traced the trumpeter. I then moved the paper before tracing the trombonist closer to his side. I repositioned the paper to draw each of the other musicians so that they fitted tightly together without any important details being obscured. Then I redrew some of the details and generally smartened up the drawing. This final image is a linocut print for which I traced the design onto a block and cut the image. Linocut is a time-consuming and crude medium that allows little fine detail. You could more easily produce images such as this by transferring your designs to drawing paper and inking with pen, brush or felt-tipped pens.

From waxwork to artwork

At one time, making detailed studies of statues and casts of body parts was a staple of the art schools. Nowadays it is rarely practiced, but it is a worthwhile activity. Statues don't move or get tired of posing and, unlike photographs, they allow you to move around them and choose your angle of view. On a visit to a waxworks museum I drew these poses and characterizations. They provide a good subject for demonstrating how raw sketches can be brought together and developed into lively finished artwork.

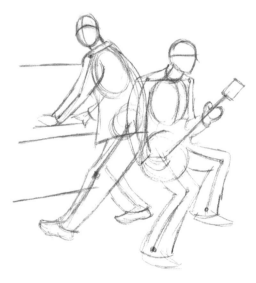

STEP 1

I drew the figures onto a large sheet of heavy watercolour paper. Starting from basic skeletons, I corrected the proportions and then outlined the shapes of their distinctive baggy suits. I deliberately kept the heads small to emphasize the broad shoulders of the jackets.

STEP 2

After finishing the drawing, I inked the outlines. Thinking of the direction of the light, I made the outlines thicker on the shadow side of the figures. I favour brush line, but you may be more comfortable with pen.

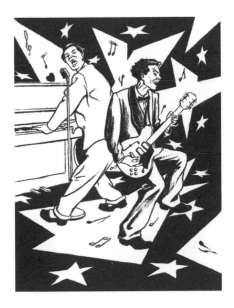

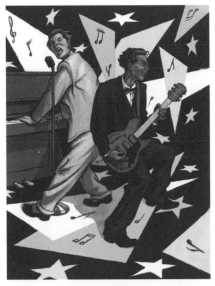

STEP 4

On top of detailed and ink drawing, keep any mid-tones quite simple, otherwise a picture can look too fussy. Here, I used watercolour in broad flat washes, just enough to establish some local tones and simple shadows. It is important to keep the lighting distinct and consistent so as to make the different elements sit naturally together. For deeper tones, like the dark suit, I used watered-down ink.

STEP 3

I wanted to set the figures against an appropriate background, so I looked to some books about the 1950s for inspiration. I drew the large triangles in perspectives that suggest they are on floor and wall surfaces and organized them to contrast with the areas of light and shade on the figures. I then inked in the areas of solid black.

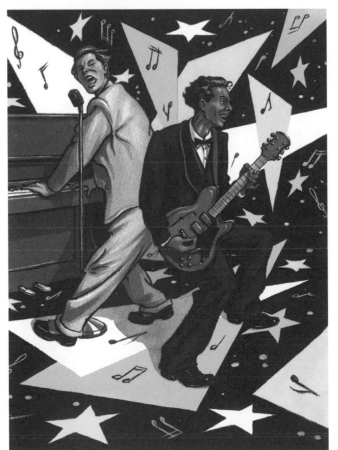

STEP 5

With pure white drawing ink and a fine brush I painted some highlights on the shiny surfaces of the figures and instruments, always keeping the direction of the light consistent. For a bit of extra pizzazz on the background I painted some symbols and dots on the solid black areas. Finally, I used a fine black drawing pen to carefully inscribe the guitar's frets and strings.

CREATING CHARACTERS

The more proficient you become at drawing people and elements of the real world, the better equipped you will be to adapt them to your own ends. So far we have covered many facets of figure drawing – body types and proportions, articulation, foreshortening and body language, as well as all the aspects of faces and character. We have come a long way, but there is a further hurdle to be got over.

This chapter will focus on teaching you to visualize basic figures without reference to models. With that facility added to your repertoire, you can be genuinely inventive with your figure drawings, breathing life into characters from fiction, history or the outer limits of your own imagination and endowing them with personality, expression and motivation.

Figurative illustration is too broad a subject to cover in great detail in this book, but here is a taster of what directions you might choose to allow your creative urges to follow.

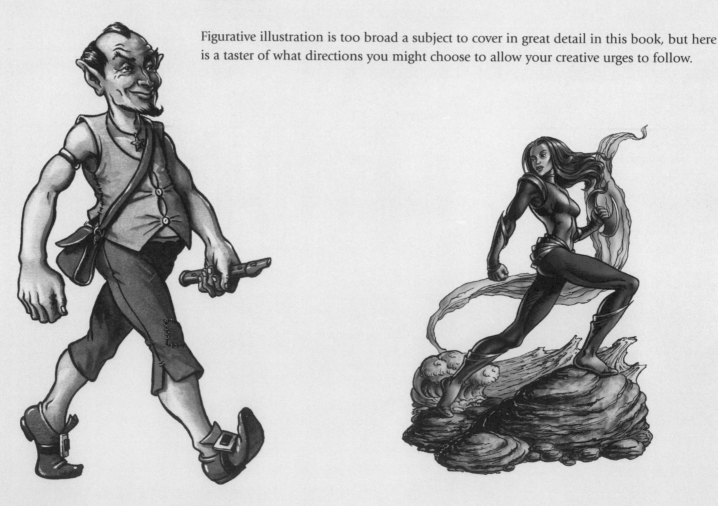

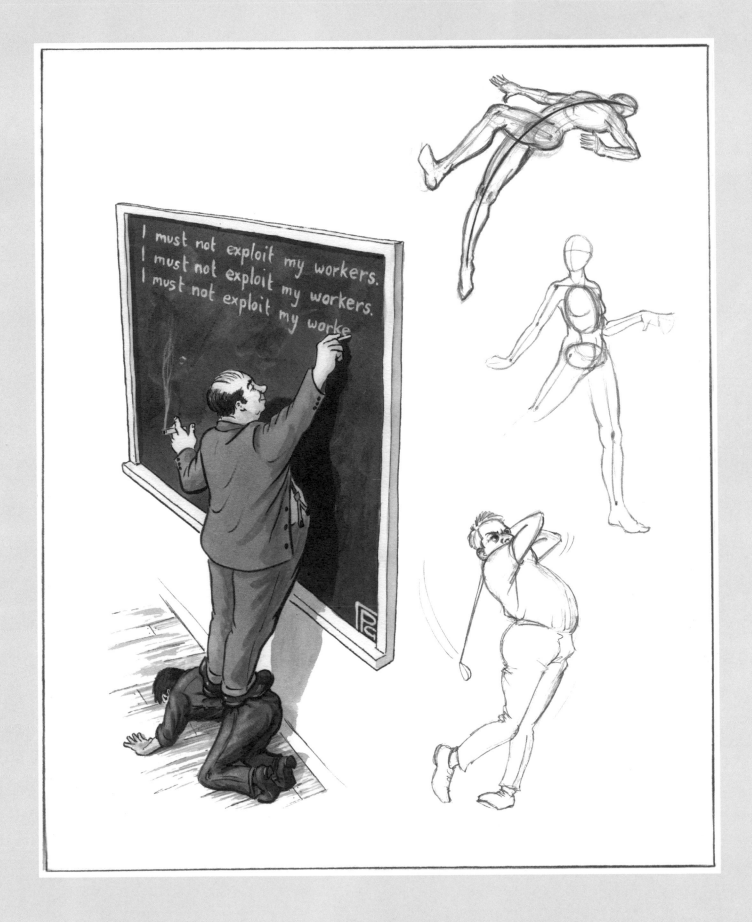

Drawing figures without a model

The principles for drawing people from your imagination are the same as those you have already learnt except that you are no longer bound by the properties of an observed figure. Having no model to refer to may be a struggle initially, but ultimately liberating. The skeleton provides a framework for you to draw a person of any build or sex around. It won't necessarily be easy to draw all the contours in the right places, but start with a hard pencil and keep feeling your way around the frame and a believable figure will eventually emerge.

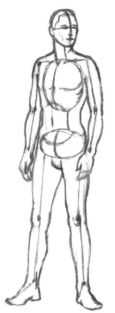

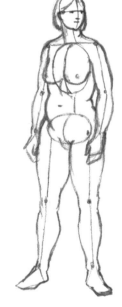

You should be able to draw a skeleton in a life-like pose with correct proportions. Maybe start with a simple, relaxed standing pose.

For a younger person, make sure that you start from a skeleton of appropriate proportions.

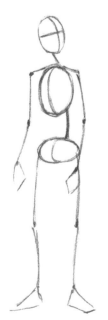

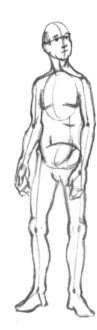

To draw an old person, the skeleton should be drawn to sag and stoop. It should look like an old person's frame before you start fleshing it out.

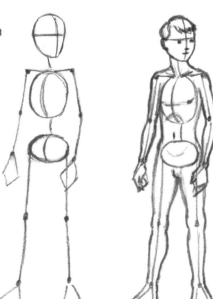

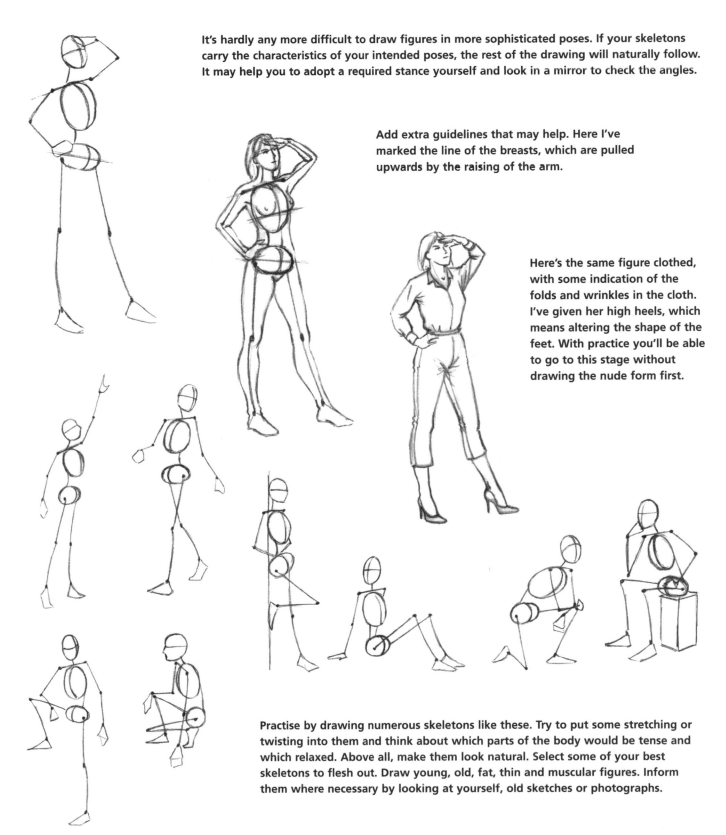

It's hardly any more difficult to draw figures in more sophisticated poses. If your skeletons carry the characteristics of your intended poses, the rest of the drawing will naturally follow. It may help you to adopt a required stance yourself and look in a mirror to check the angles.

Add extra guidelines that may help. Here I've marked the line of the breasts, which are pulled upwards by the raising of the arm.

Here's the same figure clothed, with some indication of the folds and wrinkles in the cloth. I've given her high heels, which means altering the shape of the feet. With practice you'll be able to go to this stage without drawing the nude form first.

Practise by drawing numerous skeletons like these. Try to put some stretching or twisting into them and think about which parts of the body would be tense and which relaxed. Above all, make them look natural. Select some of your best skeletons to flesh out. Draw young, old, fat, thin and muscular figures. Inform them where necessary by looking at yourself, old sketches or photographs.

251

Introducing motion

All of the figures we've covered so far have been relatively static – not necessarily motionless, but always standing or sitting on the spot. From direct observation, even the slowest walking pace is difficult to draw. However, when you draw figures from your head, you can freeze them at any stage of any action and take as much time as you need. First, a quick run through of some general pointers about the moving figure.

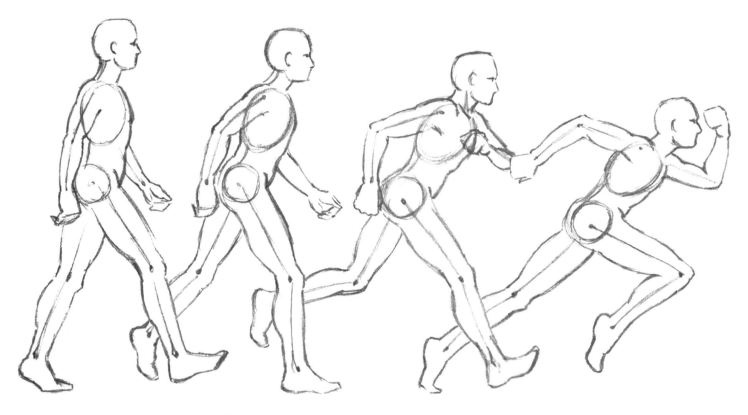

On page 214 we saw how any great movement by one part of the body is instinctively balanced by another part. The simple act of walking is an exercise in constantly readjusting the equilibrium. As one leg moves forward, the trunk follows and the opposite arm moves backwards.

At a faster pace of walking, the body leans forward, using the weight of the trunk to create forward momentum. Fast walking is effectively controlled falling, the legs moving constantly to arrest the fall. In walking of any speed, at least one foot is always in contact with the ground.

As someone moves into a trot, the trunk leans further forward and the arms swing through greater arcs. The legs are no longer swinging forward to arrest the fall, but pushing off, so that each pace is a leap and both feet may be off the ground at the same time.

In sprinting the body adopts quite a steep forward angle, but still the head is erect and forward-looking. The arms swing though 180 degrees or more. The legs push off from the ball of the foot and rise to a sharply bent knee, which allows the thigh to rise.

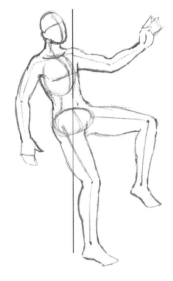

What doesn't work for static figures is vital to moving ones. Imbalance equals motion, like the running figures perpetually falling forward. Drawing a figure so that the line of gravity descends behind his feet shows him to be falling backwards.

I could fill pages with anatomical movements and never hope to cover the full range of human articulation. The best way to get a grasp of the subject is to draw lots of rough figures in various states of motion and action. Start by drawing them in profile or from views where foreshortening is minimal. Your instinct should guide you when a figure starts to go astray. Look at photographs of athletes and dancers and try redrawing them from different viewpoints. As you gain confidence, try some more complicated angles of view – front, rear and three-quarters. Also try to devise figures with pronounced twists in the planes of their bodies, where head, torso and legs face in different directions.

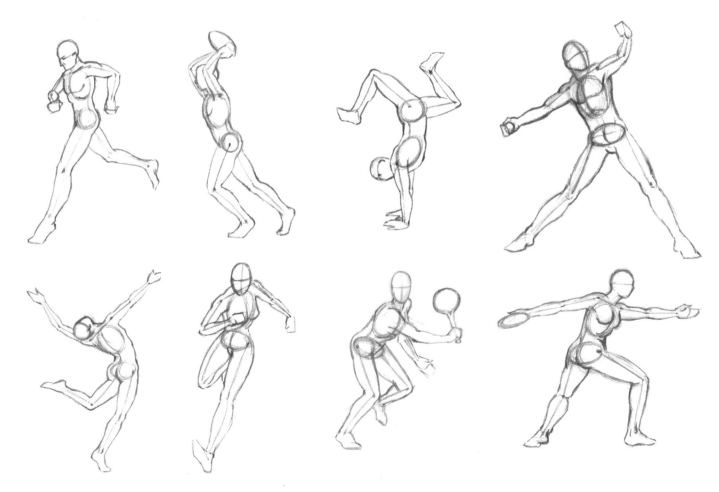

An illustrated figure

Shown here is some work I did for a film costume design that demonstrates some of the stages you might take to develop your figure drawings into finished artwork. The costume design was supplied and I had to come up with an appropriate character, in a pose that showed the costume off to its best advantage.

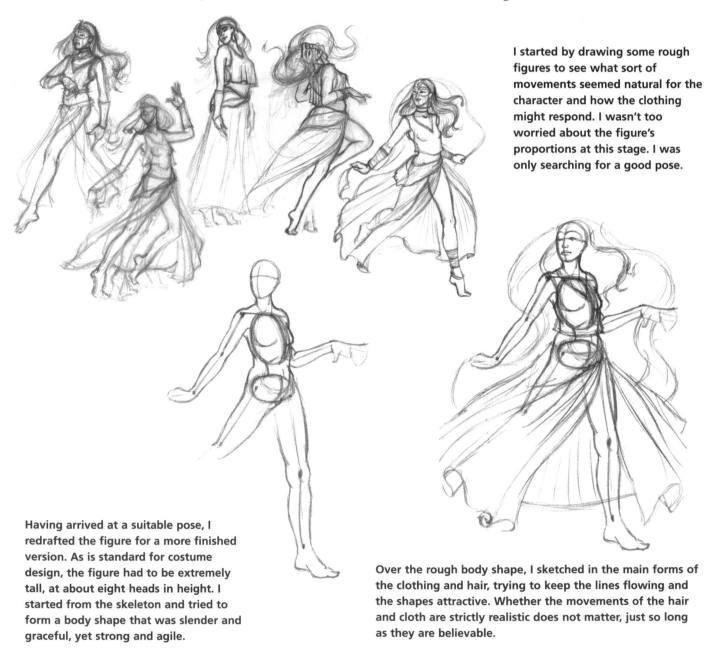

I started by drawing some rough figures to see what sort of movements seemed natural for the character and how the clothing might respond. I wasn't too worried about the figure's proportions at this stage. I was only searching for a good pose.

Having arrived at a suitable pose, I redrafted the figure for a more finished version. As is standard for costume design, the figure had to be extremely tall, at about eight heads in height. I started from the skeleton and tried to form a body shape that was slender and graceful, yet strong and agile.

Over the rough body shape, I sketched in the main forms of the clothing and hair, trying to keep the lines flowing and the shapes attractive. Whether the movements of the hair and cloth are strictly realistic does not matter, just so long as they are believable.

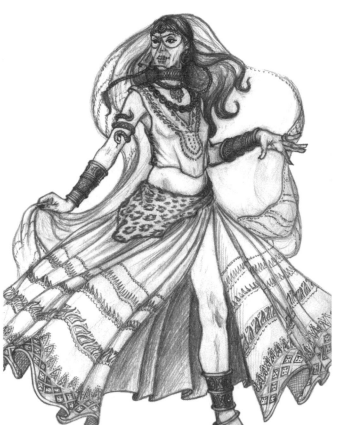

Before doing any detailed drawing of the figure, I made this study of an appropriate kind of face, using watercolour pencil and white ink on toned paper. I used pictures of Middle Eastern beauties as my reference.

On a sheet of good cartridge paper, I traced the outlines of my rough figure drawing. I spent a long time, with very sharp pencils, inscribing all the tiny patterns on the clothing and jewellery. This stage took almost as long as the rest of the process so far. I kept the shading minimal, so as not to over-complicate the image.

As is common practice in film design, I took several photocopies of the pencil drawing and added colour to them. This makes it quick and easy to produce versions in different colour schemes without any need for redrawing. I used professional quality marker pens and white ink to correct mistakes and add highlights.

Body language

The further you go with illustration, the more you'll appreciate the communicative facilities of the human form. Our bodies continually display our emotions and intentions. Introducing pertinent expressions and gestures into your figure drawings will endow them with credibility as well as emotional and narrative potential.

No part of this knight's body or face is visible under his armour, but his pose leaves us in no doubt about his mood. His glass and cigar could be removed and still he would appear relaxed and contented.

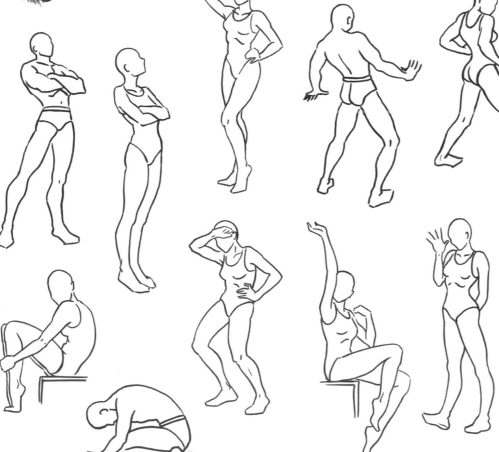

Recognizing body language is largely intuitive; if you capture an intended expression with a rough figure drawing, you know instinctively when it looks right. Study each of these outline drawings in turn and you'll detect a certain emotion in each, even though there are no facial expressions or clues beyond the arrangement of the body.

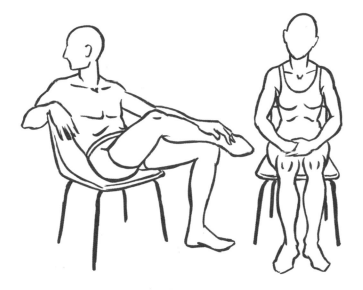

Here, it's not so much moods that are described as attitudes and character traits. The female is upright, attentive and earnest, whilst the male is slouched, distracted and uninterested.

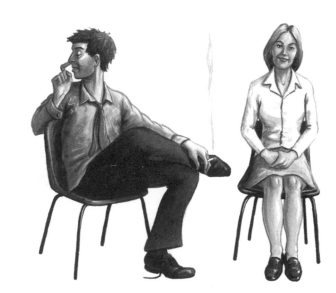

Developing the basic figures further into fully fledged illustrations allows enormous scope to enhance their characteristics. The fresh-faced woman is designed to be a direct contrast to the man, whose look I have augmented with a tired expression and sloppy grooming. Such extremes of conduct are rarely seen in real life, but in an illustration it can be effective to caricature behaviour.

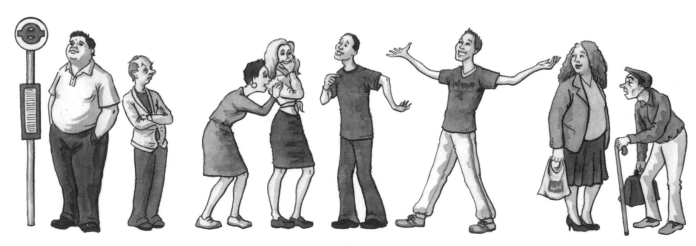

For this illustration, the brief simply called for eight people waiting for a bus. I tried to create activity and give each figure a different attitude. The drawing is not realistic, but still each character is distinct and readable. Body language also works in conjunction with facial expression. If you think clearly about the feeling you want to convey it's not difficult to come up with something close.

Illustration and communication

Illustration is normally inspired by, and aims to communicate, an idea or concept. The idea may not be profound or original, it may only be apparent in combination with a story or text that the illustration accompanies, but still an illustration conveys something beyond its own immediate subject and artistic merit. The following examples demonstrate some of the uses to which you could put your figure drawing.

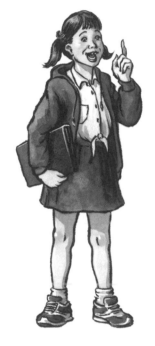

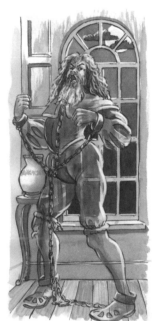

Conceptually, the simplest form of figurative illustration depicts a single character, but still the process may be far from simple. Here are a couple of very different characters, both from storybooks. In each case, the characterizations are carried by more than the faces; poise, body type, expression, clothing and props are all carefully assembled.

People can also be drawn in ways that show their emotional state. The younger woman (left) displays facial and bodily expressions of tension and harassment, exaggerated by the surrounding motifs that crowd in on her.

The minimal background details in the picture of the older woman suggest a narrative behind her thoughtful expression.

258

Bringing together two or more figures in a single image can provide scope for creating interplay. It can be tricky to get the faces quite right when you are conveying subtle character traits. Look for suitable faces in magazines and act out the characters in front of a mirror.

These illustrations utilize figures to convey abstract concepts. The pictorial charm of the imagery is not so important as its communicative function, but with a little thought, one can still draw interest from a given concept.

Drawing figures in improbable activities is always enjoyable, especially when you employ characterizations and situations that subvert expectations. This puzzle book illustration was inspired by the phrase 'rocking the boat'.

Composition – imagined scenes

If you are interested in illustrative artwork, the next logical step is to introduce full backgrounds for your characters' activities. In doing so, not only must you research appropriate settings and props, but also arrange the many elements into effective compostions within the frame of the picture.

The first of these two versions of the same picture is a competent vignette, but the second version – with the picture extending to the edges of the frame – has the effect of implying a much larger expanse of background.

Remember the suggestion of arranging compositions around divisions of thirds within the frame? Here it is employed with all the elements of the picture, the figures, faces and fish, leading the eye to the treasure chest, which is clearly the focal point.

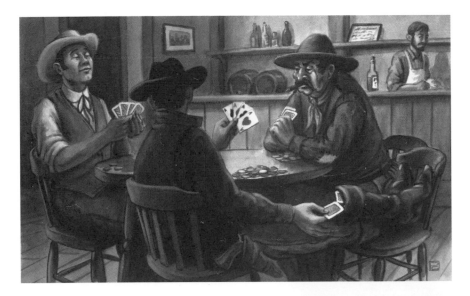

Here the focal point is dead centre. The figures – the good, the bad and the ugly – surround the central motif of the hand of cards. Weighting the figures to the left of the picture provides a counterbalance to the secondary focal point of the cheating hand on the right. The villain's face is not shown, which makes him seem all the more sinister.

This is a picture of halves: the grass and sky, and the woman and her money, but the divisions are all drawn on the slant to avoid a stiff perpendicular composition. The money extends onto the woman's half and the woman reaches for the money, which gives the composition some thrust and again establishes a focal point a third of the way in from the picture's edge.

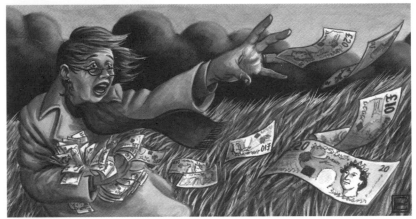

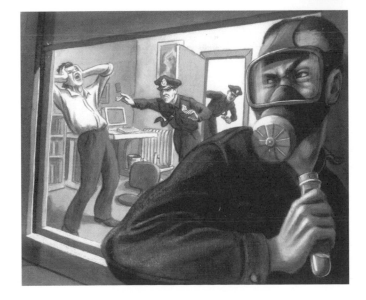

As a compositional device this is essentially a large foreground shape with a smaller scene of activity behind it. In terms of narrative, the viewer is shown two distinct parties simultaneously and the connection between them. The window acts as a secondary frame within the picture and a barrier between the protagonists.

Illustrative style

Everyone has a naturally unique drawing style, and the more you draw the more distinctly personal yours will become. A good way to develop is to try your hand at different illustrative applications. You may intuitively adapt to suit the subject matter or mood of a piece. Ultimately the way you draw should remain consistent and be identifiable, but it may take a long time before you find the real you.

Here is a collection of my illustrations, done over the years for various clients and purposes. The process of drawing each has, in some small way, informed the way I draw today. Try producing your own illustrations based on some of these mannerisms.

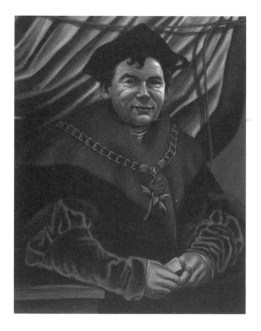

An artist's training used to involve making copies of the works of great masters, to learn from their techniques. This is a parody of a Holbein painting for which I substituted the head. Copying a large oil as a small acrylic forced me to use the paint in new ways to replicate textures of the original.

This is another copy of an old master, reduced to broken lines for a logo design. With the drawing and composition already done for me by Botticelli, I was free to concentrate on making the treatment loose and fresh.

For this waiter illustration, I had to mimic the style of a company's existing artwork. The fairy character was commissioned to be in the Japanese 'manga' style. It is not greatly satisfying to adopt another style of drawing, but can lead to discoveries that feed into your own work.

A very tight schedule made me draw this 'tap dancer' very quickly, straight out of my head, and taught me shortcuts I might not otherwise have discovered.

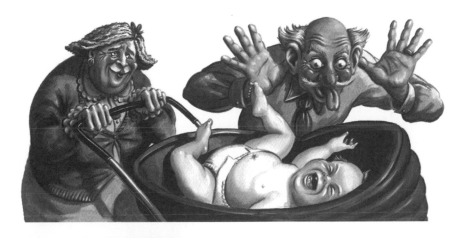

I had great fun drawing these old folks and pitching the level of caricature so that it would amuse rather than frighten young readers.

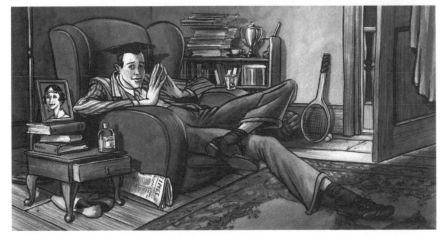

In this caricature the face is fairly naturalistic while the body is exaggerated. I designed this character after looking at some 1920s cartoons with their often elongated figures, to lend the picture an appropriate period feel.

Proportion and character

With the ability to draw figures without a model come opportunities to distort their proportions for illustrative effect. This approach is very commonly found in fantasy and comic book illustrations as well as cartoons and children's books. In the following demonstration the naturalistic human form is used as the starting point, going through some relatively subtle changes, to design an elfin character, a staple of the fantasy genre.

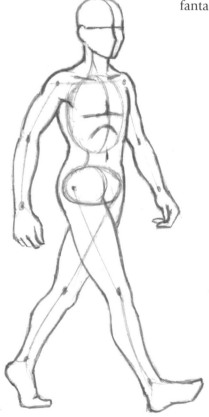

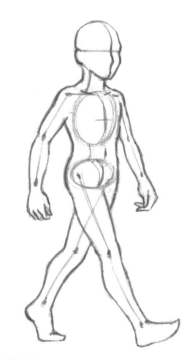

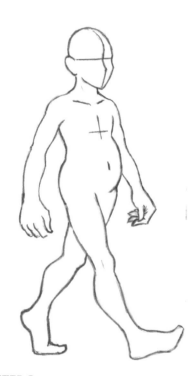

STEP 1

This is a rough outline of a young male, seven heads in height. As the basis for a new character, the three-quarter view allows me to show him from the front and side simultaneously. Setting him walking will give me the chance to develop some character in his movement.

STEP 2

Drawing him again at a reduced height of five-and-a-half heads produces a figure of child-like proportions.

STEP 3

I wanted the character to be adult, so I paid attention to the lateral proportions, enhancing the musculature and the belly. Enlarging the feet and hands moved the drawing further away from naturalistic proportions.

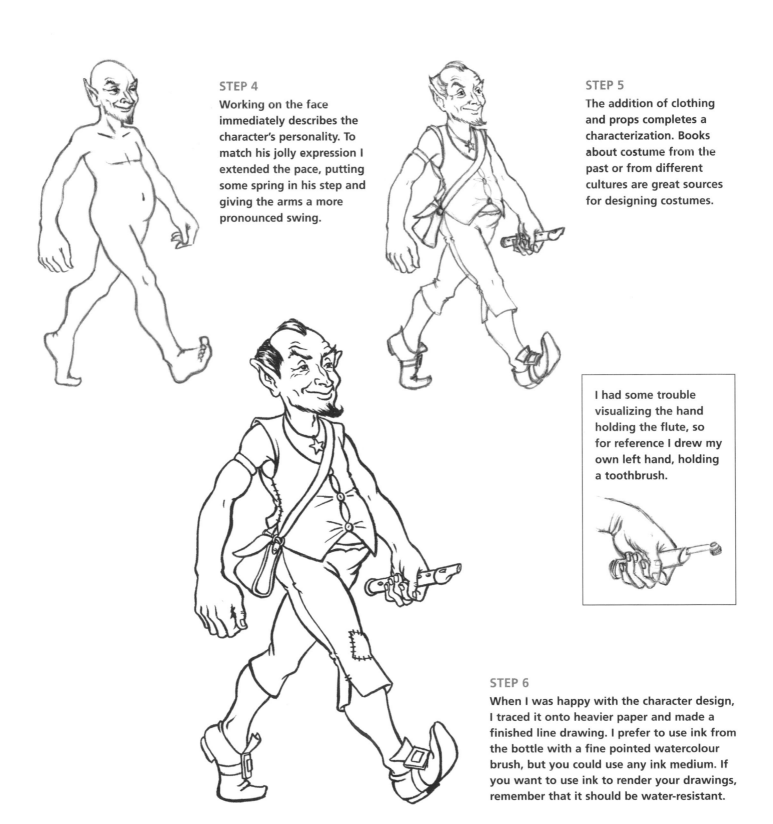

STEP 4

Working on the face immediately describes the character's personality. To match his jolly expression I extended the pace, putting some spring in his step and giving the arms a more pronounced swing.

STEP 5

The addition of clothing and props completes a characterization. Books about costume from the past or from different cultures are great sources for designing costumes.

I had some trouble visualizing the hand holding the flute, so for reference I drew my own left hand, holding a toothbrush.

STEP 6

When I was happy with the character design, I traced it onto heavier paper and made a finished line drawing. I prefer to use ink from the bottle with a fine pointed watercolour brush, but you could use any ink medium. If you want to use ink to render your drawings, remember that it should be water-resistant.

265

My favoured medium for adding tone to illustration is watercolour, in common with many illustrators. You may prefer to use felt-tips, tinted inks, pencils or even computer rendering, but whatever your preference, the following principles apply.

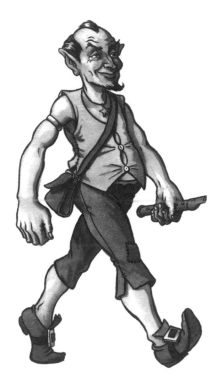

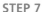

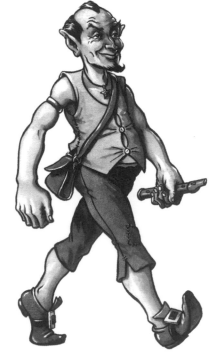

STEP 7

Decide on a direction of light that complements your figure and use a medium tone to block in the areas of shadow. This first stage of shading should also indicate the folds in clothing as well as modelling the features of the face. If you're unsure, use one of your earlier rough stages to practice on.

STEP 8

This stage is easier – applying local tone. Before you commence, think about the tones you want to use. Maybe some parts could be solid black and others plain white. Will a jacket be darker or lighter than the skin tone? Apply the tone across the whole of an area, including those parts already shaded. With watercolour, you can use tissue paper to sponge off areas of wet paint for soft highlights.

STEP 9

It's amazing what a lift a few highlights can give a picture. It's generally easier to add them at the end, rather than trying to leave spots of blank paper while rendering. I used white ink applied with a fine brush. When adding highlights, always bear in mind the direction of light and the intended textures. I've liberally highlighted the shiny shoes, while leaving the matt trousers dull, except to pick out some fine detail in the stitching.

Now we've gone through the stages of developing a diminutive character, how about one that's larger than life? The same principles apply. Here's a quick run-through of my stages to design a threatening warrior-type figure.

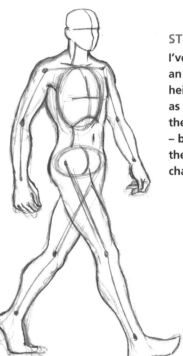

STEP 1

I've enlarged this figure to an enormous nine heads of height. This is about as far as distortions go before they look really freaky – but that might be just the look you want for a characters.

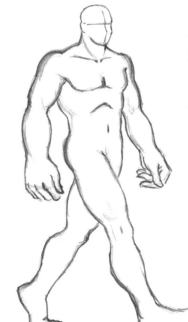

STEP 2

To suit his height and the kind of character I have in mind, I've considerably increased the figure's bulk and, again, enlarged the hands and feet.

STEP 3

Adding more character with every step, I changed the walk into a heavy-footed lumber and further developed the musculature. The hands are drawn to look aggressive, as is the face and expression.

STEP 4

The addition of clothing and props sets this character firmly in a fantasy world. The genre of fantasy illustrations is riddled with clichés; maybe you can breathe fresh life into your characters by avoiding well-trodden subject matter.

Dynamic figures

Over the years, fantasy and comic book illustrations have built up a set of conventions for poise and action. No opportunity is wasted to bring dynamism and drama to the figure. Beyond these specific genres, less exaggerated versions of these principles can be useful devices for many illustrative applications.

For the comic book realm this figure is suitably tall and muscled but his stance, though quite natural, is not dramatic enough.

With the stance adjusted, the same figure has the presence of a superhero. The feet are spread wide and the whole trunk is pushed forwards, arching the back and puffing out the chest. The arms and neck are held tense and the hands form fists.

Yet more impact can be had by dropping the eyeline and drawing the character as if we are looking up at him from the floor (see page 213). Film makers often employ this device to endow their characters with stature or power.

This is an example of the extreme foreshortening and close-up viewpoint that is commonly used to make the action almost leap out of the page. Such views are difficult to visualize and the fore-shortened elements may require you to ask a friend to model until you have sufficient experience to draw them out of your head.

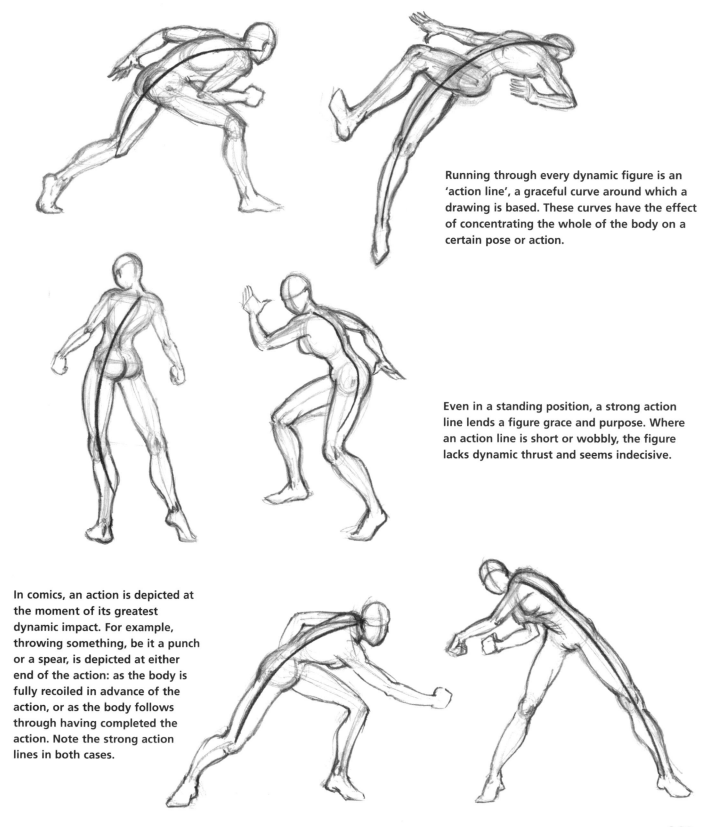

Running through every dynamic figure is an 'action line', a graceful curve around which a drawing is based. These curves have the effect of concentrating the whole of the body on a certain pose or action.

Even in a standing position, a strong action line lends a figure grace and purpose. Where an action line is short or wobbly, the figure lacks dynamic thrust and seems indecisive.

In comics, an action is depicted at the moment of its greatest dynamic impact. For example, throwing something, be it a punch or a spear, is depicted at either end of the action: as the body is fully recoiled in advance of the action, or as the body follows through having completed the action. Note the strong action lines in both cases.

A superhero figure

Drawing for comics is enormously rigorous, requiring for each project hundreds of tightly designed artworks, but that doesn't mean you can't dabble with single pictures of your own invented characters. No figure better exemplifes comics than the superhero. With dynamic posture and muscular build, such a drawing will provide a good introduction to producing finished artwork in the comic book style.

Before starting I thought about the sort of character and attitude I wanted to depict. I played around with various poses and viewpoints until I arrived at something suitable. Then I worked into the rough drawing, adding characterizations and details.

STEP 1

The first element to go down on the good paper was the action line, giving the picture a dynamic thrust from the outset. Then I drew in the rough skeletal shape.

STEP 2

I added the flesh and bulk of the character over the skeleton, still using a hard pencil.

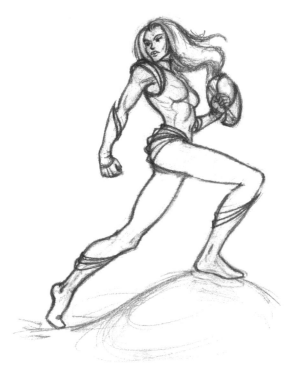

STEP 3

Once happy with the general body shape, I erased unwanted lines and developed the hands and face. Over the blank outline, I had fun adding the clothing and hair. I kept this costume to a standard superhero blueprint, but there are no limits to the kinds of costumes and accessories you can devise. It often works well to repeat a shape or motif on various parts of the body.

STEP 4

When designing the background, I devised some features that look alien but are still based loosely on natural landscape forms. I added a distant wisp of smoke to tie together the top and bottom parts of the picture and reinforce the composition's dynamic thrust. Having decided on a light source, I added pencil shading to guide me for the next stage.

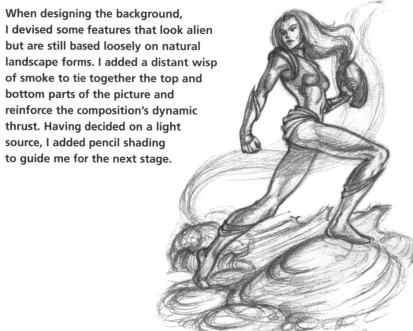

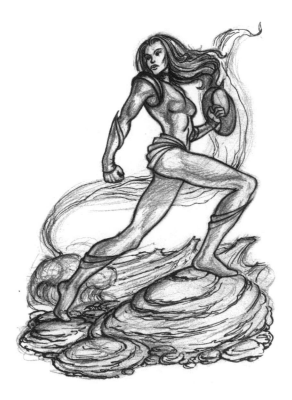

STEP 5

Inking comic artwork requires concentration and a steady hand. I used a steel-nibbed dip pen, the tool of choice for many comic book artists. It takes a while to get used to handling them, so practice on scrap paper is advised. The flexible nib means that the harder you bear down on it, the thicker the line. I employed this versatility in my initial inking of the picture, outlining the figure in bold lines, while pressing lightly to get a sense of aerial perspective for elements further in the distance.

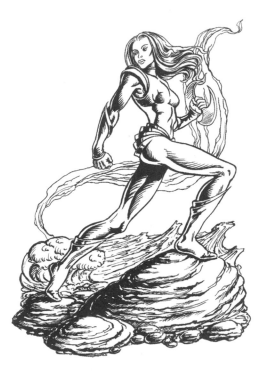

STEP 6

Shading with ink is not as easy as it might look. You have to be confident about the fall of light on surfaces and the form of muscles, folds and textures. Look at plenty of comics to see how different artists use solid black and hatching to give their drawings solidity and depth. Solid blacks should be painted in with a brush. Ink from a dip pen can take up to an hour to dry naturally, so make sure it is absolutely dry before erasing the pencil marks.

STEP 7

Having done some shading already at the inking stage, the tone can be simply applied. I painted on flat watercolour tones, leaving some parts white for highlights. When dry, I added a second tone to some areas.

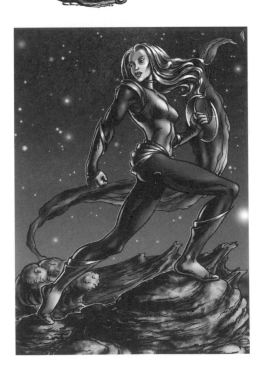

STEP 8

This version is rendered digitally. I scanned the inked line drawing picture into my computer and filled in the tones using Adobe Photoshop. Powerful graphics software can produce really impressive renderings, in the hands of a skilled operator.

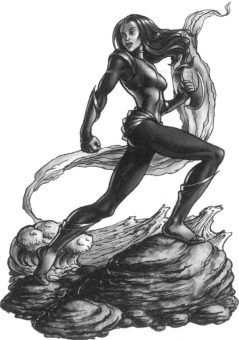

STEP 9

One of the benefits of computers is that they encourage experimentation. Changes to tone and texture that would be tricky on paper can be done and undone instantly. For this version, I played around with the background to turn the picture into a night time scene, resulting in a totally different atmosphere.

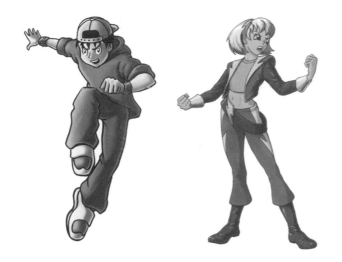

The finished look of comic book illustrations is very much dependent on many factors: the subject matter or theme, the age of an intended readership as well as the drawing style and materials. Here are a few examples.

These two examples are aimed at a younger readership and are appropriately more simply drawn. The boy is digitally rendered, without flashy technique. I used marker pens for the female figure to produce a similarly polished look, though she does lack something of the sheen of a digital rendering.

Here I used acrylic paint. For a slightly more realistic effect, I didn't use black ink outlines and treated it more like a painting than a rendered drawing.

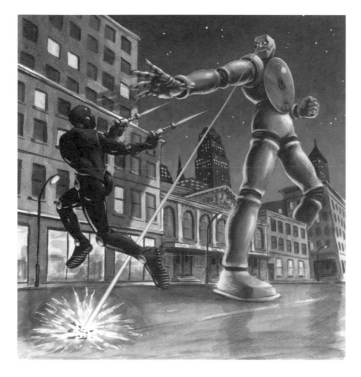

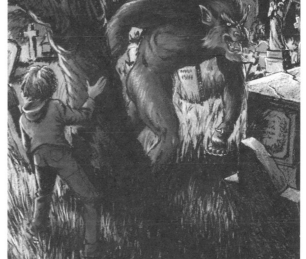

There's a lot of solid black ink used here for deep shadows and textures. I used watercolour and a few spots of white ink for the mid tones and highlights. The readership is quite young, but the theme is distinctly gothic.

Cartoon figures – action

The devices used in comic books are employed in cartoon drawing, but with even greater exaggeration of form and action. In general, comic-book figures are designed for dramatic emphasis, whereas cartoons aim at humour, and every element of the drawing may be designed for that effect. In their design, cartoon figures evoke established stereotypes that we can all recognize. For cartoon characters to be credible, their body, dress, attitude, behaviour and movement should be consistent with type.

This is a naturalistic portrayal of a golfer swinging through after driving off. Apart from the intrinsic absurdity of the game, this drawing is not funny nor is it dynamic.

By increasing the curve of the action line and lifting the arms higher, the swing is greatly exaggerated beyond its natural extent, looking awkward and a bit funny, especially in combination with the golfer's earnest expression.

The comedic effect of the pose can be greatly enhanced by the development of the character so that he becomes a figure of fun. In this case, I've given him a potbelly that further exaggerates the action line. The legs are short and skinny and his trousers a little too small. The head is redrawn with a more caricatured face and expression.

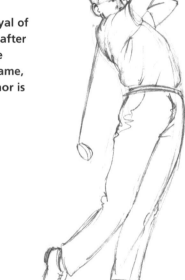

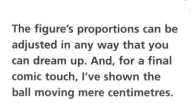

The figure's proportions can be adjusted in any way that you can dream up. And, for a final comic touch, I've shown the ball moving mere centimetres.

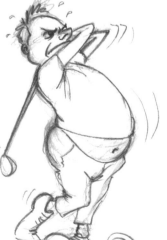

The actions of cartoon figures nearly always display a degree of exaggeration, based around a strong action line, which is usually the first element to be drawn. The way a character moves is dependent on character and physical build, as well as emotion. Here are some of the most common cartoon types and their walking postures.

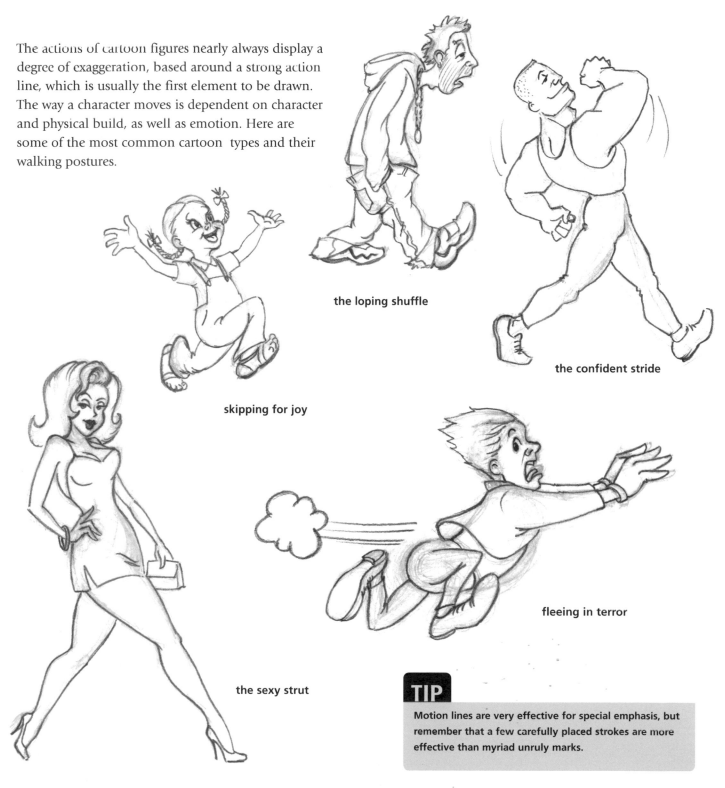

the loping shuffle

the confident stride

skipping for joy

fleeing in terror

the sexy strut

TIP

Motion lines are very effective for special emphasis, but remember that a few carefully placed strokes are more effective than myriad unruly marks.

Cartoon figures – expression

Just like every other aspect of cartooning, facial expressions are usually larger than life. The most emphatic parts of the face are the eyebrows and the mouth, all of which are much more mobile and flexible than in real life. Eyes and cheeks very much come into play too and the poise of the head is often used to support an expression.

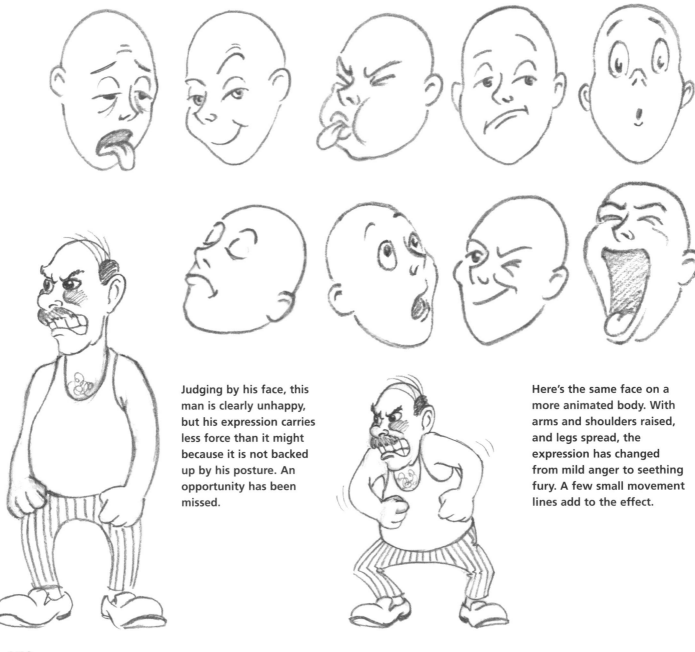

Judging by his face, this man is clearly unhappy, but his expression carries less force than it might because it is not backed up by his posture. An opportunity has been missed.

Here's the same face on a more animated body. With arms and shoulders raised, and legs spread, the expression has changed from mild anger to seething fury. A few small movement lines add to the effect.

I've shown here only the very barest introduction to what can be achieved in comics and cartoon drawing. They may look simple, but good cartoon and comic drawings are masterpieces of design, communicating personality, dynamism, expression, motivation, social and physical stereotype, narrative, wit and inventiveness.

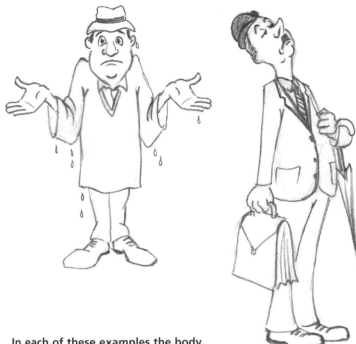

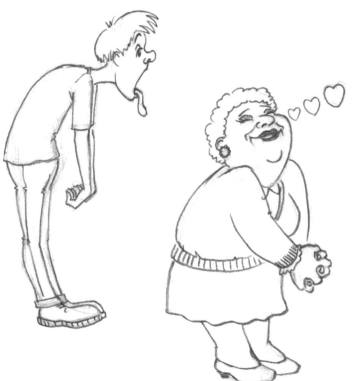

In each of these examples the body, through stance or gesture, supports the emotion or attitude displayed by the character and expression. Effects such as the dripping water and the love hearts are useful devices for conveying extra information. A great deal can be communicated through the simple visual language of cartooning.

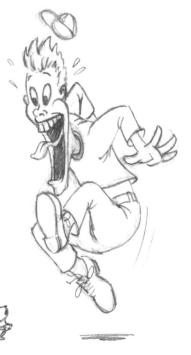

Perhaps the greatest degree of exaggerated action in frequent use is the expression of extreme surprise or terror where the mouth opens to several times its normal size and the body recoils and lifts off the ground. A few strokes of shadow are all that's needed to show the ground level. The sweat drops in this figure radiate from his face, echoing his raised hair and acting as movement lines.

THE ANIMAL KINGDOM

The earliest surviving of all the world's artworks are cave drawings of the beasts that represented life or death to early man. Though our fortunes are no longer so intimately linked, our fascination with animals continues to this day. The animal kingdom is vast and almost unimaginably varied, offering artists never-ending interests, but also many challenges. Animals rarely co-operate, they can be elusive and neurotic, complex in form and behaviour, subtle in expression, yet despite, and because of, these challenges, we are still drawn to them as subjects for art.

For this section, I advocate a different approach to that which informed your drawings of people; you will rely initially on photographic reference to master the essence of animal forms and then add the details of texture, markings and character.
As your confidence increases, I'll discuss strategies for
drawing animals direct from life and working up
to finished artwork.

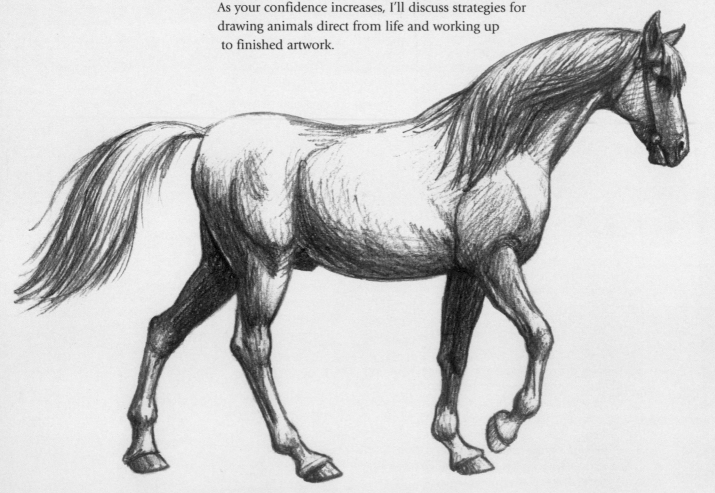

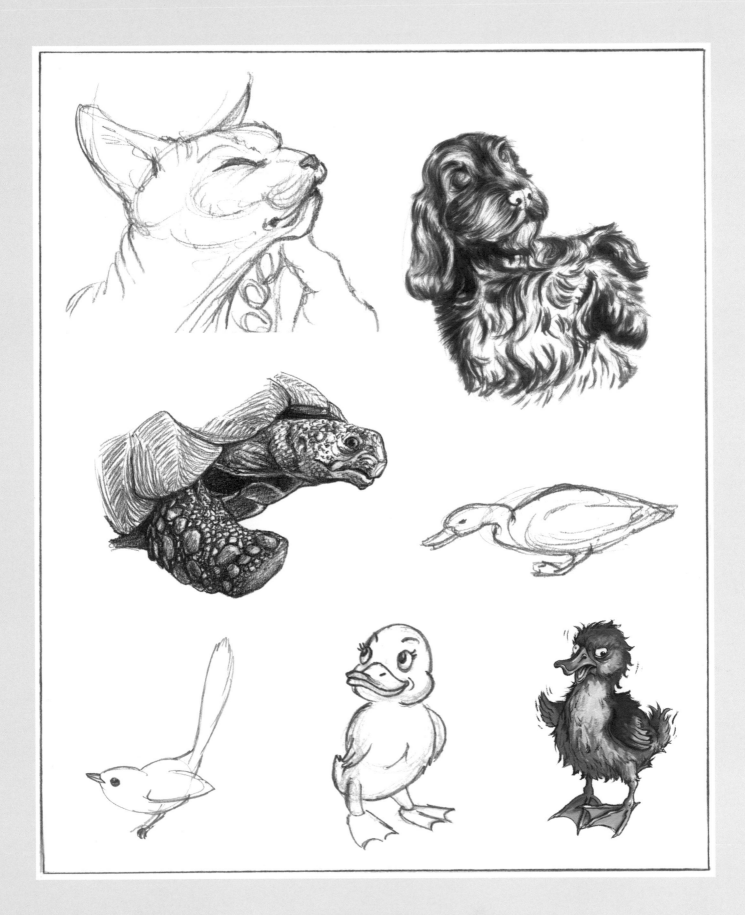

Body structure

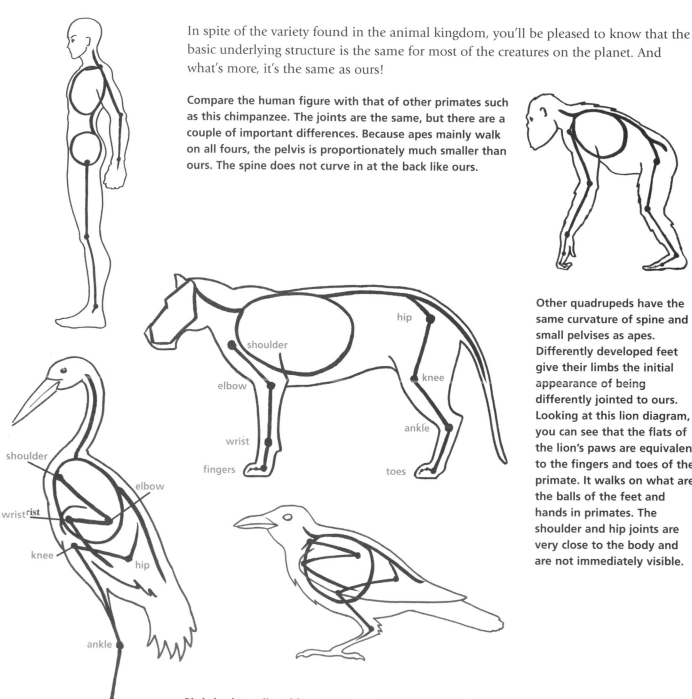

In spite of the variety found in the animal kingdom, you'll be pleased to know that the basic underlying structure is the same for most of the creatures on the planet. And what's more, it's the same as ours!

Compare the human figure with that of other primates such as this chimpanzee. The joints are the same, but there are a couple of important differences. Because apes mainly walk on all fours, the pelvis is proportionately much smaller than ours. The spine does not curve in at the back like ours.

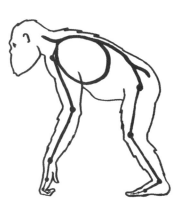

Other quadrupeds have the same curvature of spine and small pelvises as apes. Differently developed feet give their limbs the initial appearance of being differently jointed to ours. Looking at this lion diagram, you can see that the flats of the lion's paws are equivalent to the fingers and toes of the primate. It walks on what are the balls of the feet and hands in primates. The shoulder and hip joints are very close to the body and are not immediately visible.

Birds both small and large are similarly constructed. It's not so easy to discern the joints in a bird's wing, but each joint plays an important function, which it is useful to understand when drawing them, especially where the wings are unfolded.

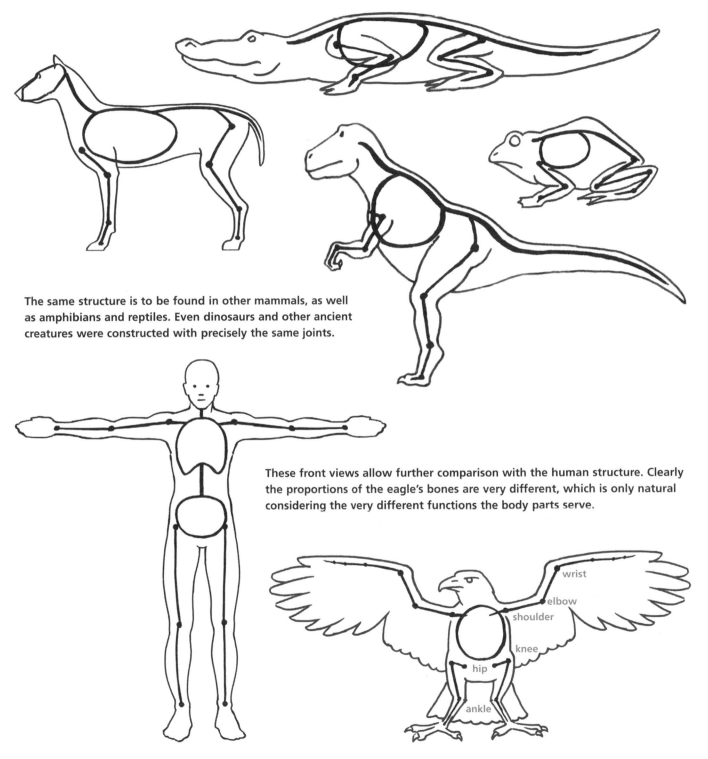

The same structure is to be found in other mammals, as well as amphibians and reptiles. Even dinosaurs and other ancient creatures were constructed with precisely the same joints.

These front views allow further comparison with the human structure. Clearly the proportions of the eagle's bones are very different, which is only natural considering the very different functions the body parts serve.

wrist

elbow

shoulder

knee

hip

ankle

Drawing basic animal form

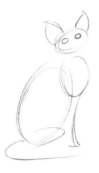

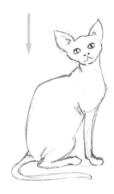

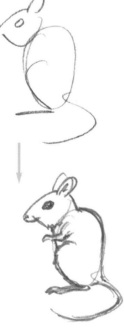

Drawing animals requires a different approach to that taken with human figures. Try your hand at this exercise: find photographs of animals, including mammals, reptiles, birds and amphibians. Select simple angles of view such as profiles to start with. Use only an HB (or softer) pencil and a wad of scrap paper. The aim is to fill your paper very quickly. Before starting each drawing, look carefully at the animal picture and mentally dissect it into the circles, ovals and curves that make up its form, then draw them very quickly. Each of my examples was drawn in under five minutes: a minute or so looking at the source picture, a few seconds to draw the basic shapes and a couple more minutes to complete the outline.

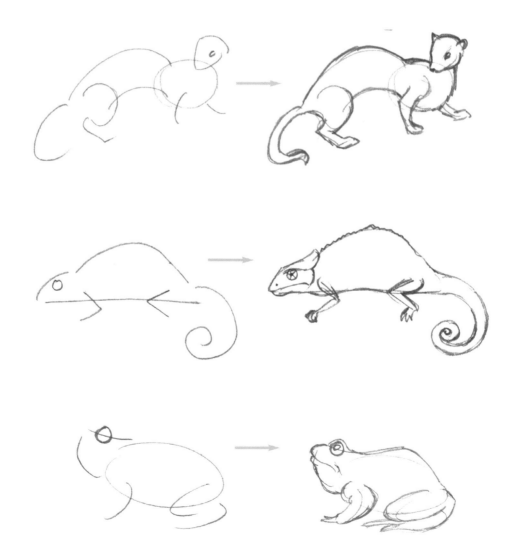

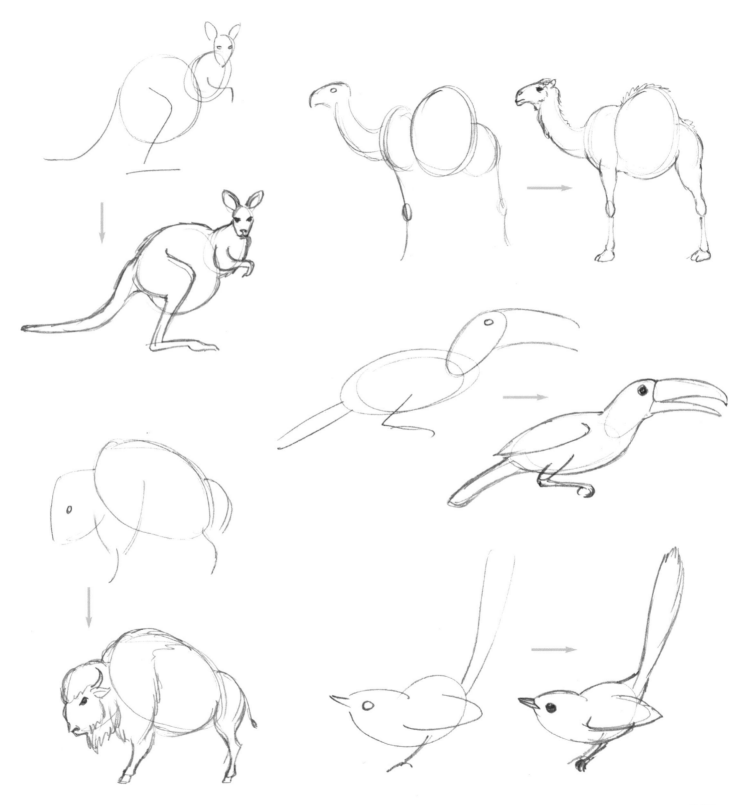

A horse in profile

When the aim is to make a more finished drawing, the same loose approach to form can be taken. Staying for now with an easy profile view, I have drawn a horse, with attention to correct proportions and pencil rendering. To follow these steps, find a good source photograph. Make sure that the details are unobscured, and the quality of light makes the contours of the animal clear enough for your rendering.

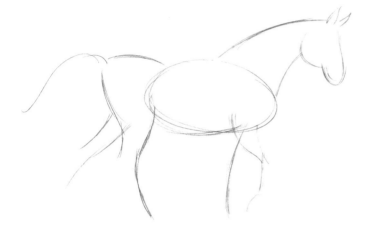

STEP 1

Having chosen a suitable picture, I studied it and mentally broke down its form into rough shapes. Before drawing these shapes, I rehearsed them with the pencil hovering above the paper and then sketched them in. Before continuing, I checked that my horse's shape was not distorted. I measured the head length on the photograph and compared it to other dimensions, then checked the same relative proportions on my drawing.

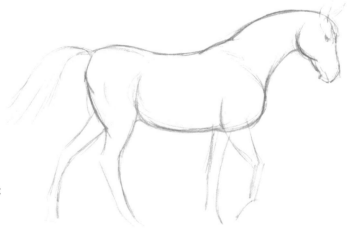

STEP 2

Happy with the rough shape, I smoothed out the horse's outline and gave the legs some width and form, all the while looking at the photograph. As you do this, don't let yourself get sidetracked by any detail.

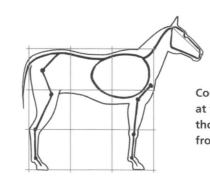

Conveniently, horses are roughly three heads tall at the shoulder and the same length in the body, though your chosen example may differ slightly from this generalization.

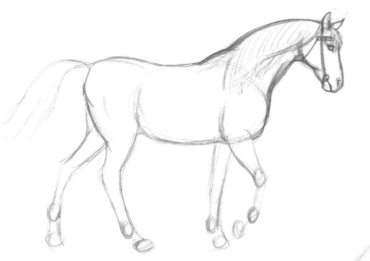

STEP 3

Next I refined the head and neck so that I had a definite measurement by which to check the length of the legs. I did more work on the overall length of the legs and the positions of their joints, which I marked as large ovals.

STEP 4

It's all too easy to draw animals' legs as weak and shapeless. Drawing the joints first as sizeable masses helps in the construction of the leg's contours. At this stage, I finalized the outline of the whole drawing and also marked the shape of the mane and tail.

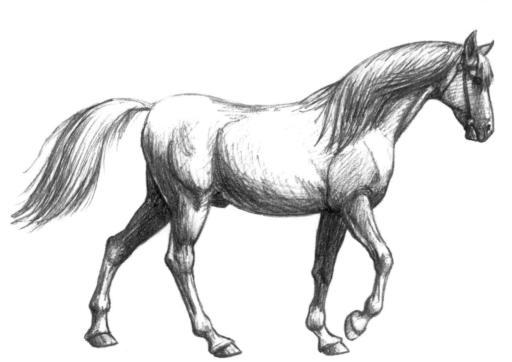

STEP 5

To finish the picture, I erased my unwanted lines and set about shading and rendering. I used a 2B pencil and was determined not to be too fussy over detail and smooth blending of tones. I varied the direction of the pencil marks to suit the contours of the animal. This was actually a brown horse, but I ignored the local tone and rendered only according to light and shade, leaving plenty of bare white paper.

285

New viewpoints

Drawing profiles is good for practice and for increasing your familiarity with different animals and their proportions, but other viewpoints reveal more about a creature's build, articulation, character, behaviour and so on. Working from photographs and breaking the subject down into abstract shapes, the process need be no more difficult.

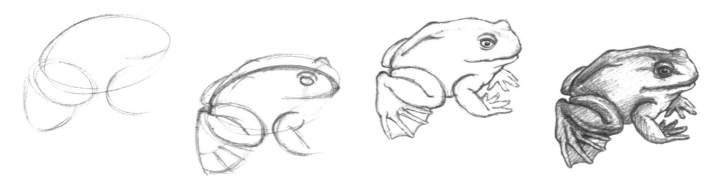

An angle of view doesn't need to shift far from the profile to make a drawing more interesting. After drawing the initial shapes, I lightly put in a centre line down the back to help place features either side of it. I then carefully sketched in the basic outlines before filling in the webbed feet and eyes in more detail. The shading helps to give the body more depth and solidity.

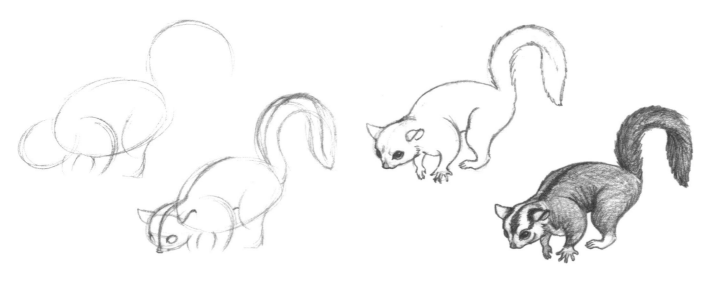

Again a carefully placed centre line was invaluable for drawing the face of this flying squirrel. It also helped me in constructing the tail. In my rendering I have chosen to concentrate on the markings. I have kept the shading minimal so as not to conflict with the local tones, with just a touch here and there to convey a sense of solid form.

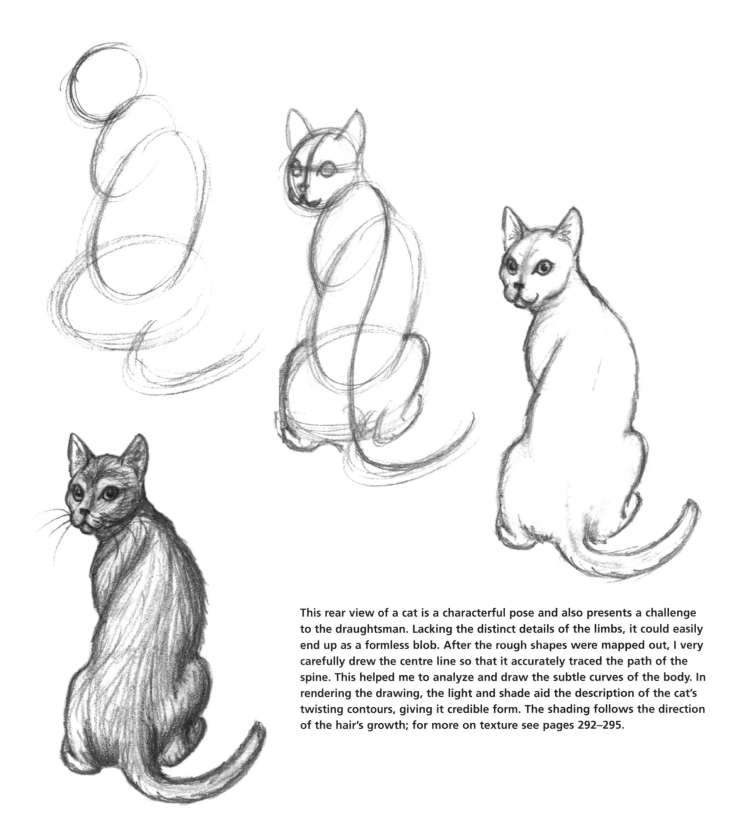

This rear view of a cat is a characterful pose and also presents a challenge to the draughtsman. Lacking the distinct details of the limbs, it could easily end up as a formless blob. After the rough shapes were mapped out, I very carefully drew the centre line so that it accurately traced the path of the spine. This helped me to analyze and draw the subtle curves of the body. In rendering the drawing, the light and shade aid the description of the cat's twisting contours, giving it credible form. The shading follows the direction of the hair's growth; for more on texture see pages 292–295.

Quick pastel studies

When you have mastered the art of analysing and drawing animal form you can approach the subject with sufficient confidence to make more loose and expressive drawings. Maybe you could experiment with different media to give your drawings a different feel. Here are a couple of examples in charcoal and pastel, both done very quickly – about 20 minutes each.

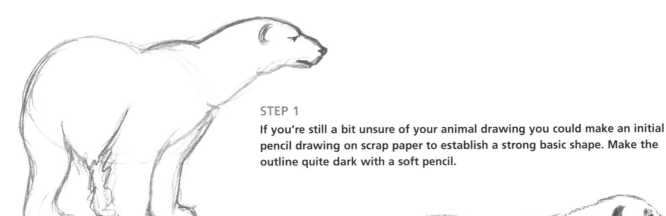

STEP 1

If you're still a bit unsure of your animal drawing you could make an initial pencil drawing on scrap paper to establish a strong basic shape. Make the outline quite dark with a soft pencil.

STEP 2

Place a fresh sheet of paper over your rough drawing and you should be able to see the outline clearly enough to trace it. Here I used the side of a short length of charcoal to depict the areas of shade. With the tip of the charcoal I then gently traced the outline of the bear's top edge.

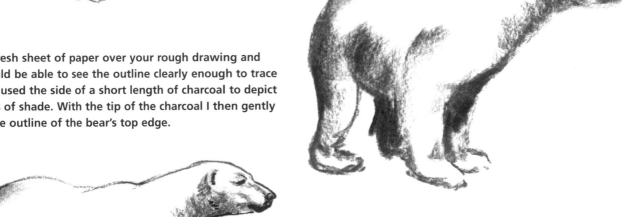

STEP 3

To sharpen up the drawing, I used a felt-tipped brush pen, selectively defining some of the more pronounced edges and adding some details to the face and feet. Try not to overwork the outlines and details, adding them only where more clarification is necessary. With the edge of a clean eraser, I carefully cleaned up a few stray charcoal marks.

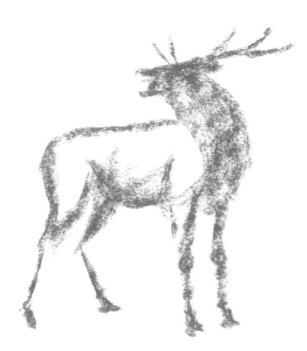

STEP 1

I prefer to skip the pencil drawing and work directly. Small mistakes can be easily erased and big mistakes become evident very quickly so you can just start again before devoting too much time to the drawing. I used a mid-grey pastel here, again broken to a short stump and used on its side. As with the bear, I tried to convey shade and outline in a single motion, while setting down only the elementary form of the stag.

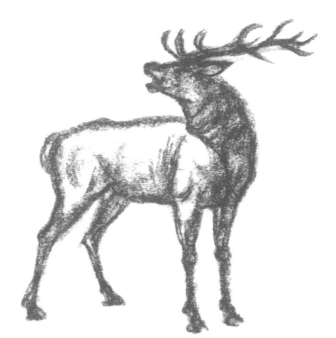

STEP 2

With the end of the pastel, I then drew in more detail and strengthened the shading where necessary. All the while, I referred to the photographic source and corrected the form as I went along. I could happily have left the picture at this stage as a finished piece, but thought that maybe I could yet bring out more character and solidity.

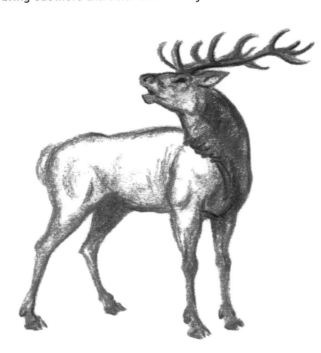

STEP 3

I used the end of a charcoal stick to add a few details and embellishments to the stag's head, antlers and hooves. I also turned the charcoal on its side to deepen a couple of areas of tone, under the stag's neck and chest and inside the hind leg. I had to be very careful when erasing stray marks in order to avoid smudging the drawing, which I then sprayed with fixative.

Drawing animals from life

Animals are apt to move constantly, and one of the greatest challenges the artist faces is to draw them from life without the freezing facility that photographs offer. Difficult though it is, this activity sharpens the drawing skills like few others. Some simple methods and tricks can be employed to help.

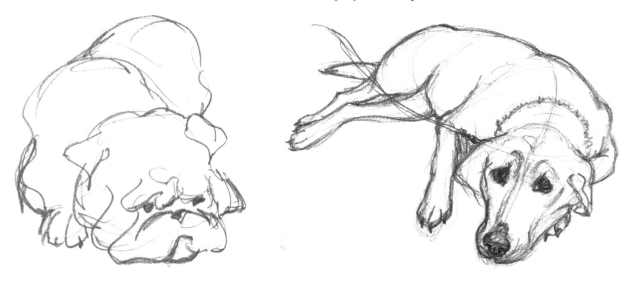

If an animal is tired or bored, it's unlikely to move too much, but make sure that your drawing activity doesn't excite its interest. I sketched this bulldog at a dog show, late in the day after it had been waiting around for hours. The labrador was a young guide dog, selected for its placid temperament. It lay on a café floor and didn't move a muscle while I drew it.

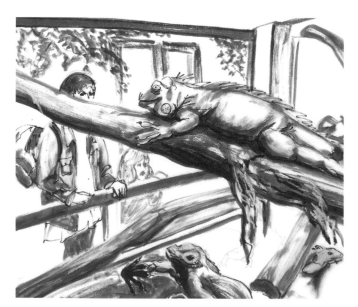

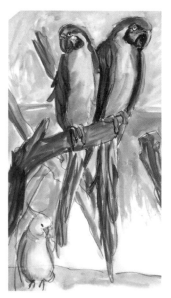

In a zoo, the animals will often sit motionless for long periods. For the iguana enclosure I used a permanent ink brush pen and watered-down ink applied with a broad bristle brush.

The parrots were drawn very quickly with a charcoal pencil. I then scrubbed on some water-soluble crayon and blended the tones with brush and water.

Food is always good for keeping animals in one place. I observed this lioness vigorously tugging at some meat, then drew most of the picture without looking up. With the basic shape in place, I could then refer to the moving animal and glean enough information to add details. It's not an accurate drawing, but it does have something of the creature's attitude.

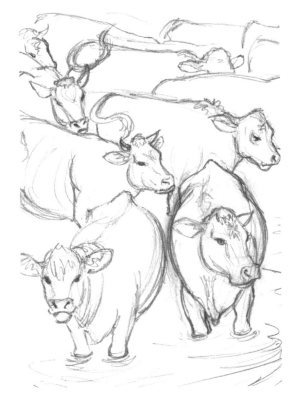

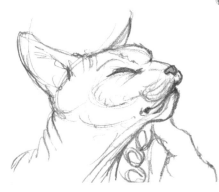

An excitable pet can often be made to sit still for a short time if it is stroked and petted.

On a hot day, these cows stood for a long time in a pond to keep cool. I attempted to draw the cows as a scene, roughly drawing the foreground animals first and working backwards, filling in the gaps. The cows' heads moved a lot and I had to keep turning my attention from one to another.

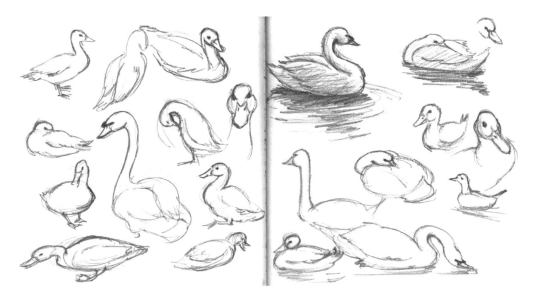

Water birds won't remain static, making close study difficult. A good way to draw them is to work on several pictures at the same time. As one bird moves abandon the drawing and work on another. Soon another bird will adopt a similar position for long enough for you to complete the first sketch.

Detail and texture

The animal drawings presented so far have mostly been concerned with form but there is more to drawing animals than recognizable shapes; the essence of a creature is to be found in the details. That is not to say that drawings have to be highly detailed, but that they should show evidence of a given animal's distinctive characteristics. Possibly the best way to study animals intimately is to draw from mounted skins. Many town and city museums have displays of stuffed animals that you can get very close to, providing opportunities for observation that live animals and photographs can rarely equal. All of the following examples have been drawn from museum exhibits, but the same lessons may be learnt from books by looking at numerous pictures of your chosen subjects from as many different angles as you can find.

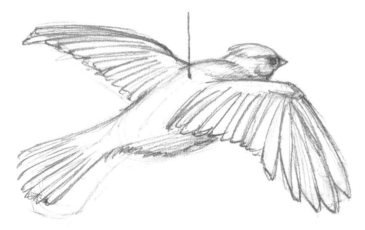

To draw birds convincingly, the artist should know about the arrangement of their feathers, which is not always clear in photographs. Since most flighted birds have similar feather patterns studies like this can be referred to for clarifying later drawing difficulties.

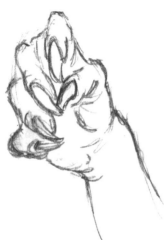

Maybe small details catch your eye, like this opossum's claws. Just as with people, animal hands can lend a great deal of character to their drawings so it's worth jotting down such details, which are not always easy to see in photographs.

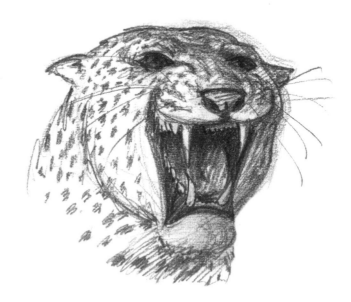

The heads of big cats are very powerful and expressive. Sketches of their faces will pay off when you come to do finished drawings, and with their strong shapes they are fun to do.

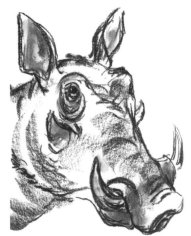

I sketched this warthog for no other reason than enjoyment, as it possessed such interesting contours. Charcoal on rough paper seemed the right medium for the coarse leathery texture. I didn't bother with erasing mistakes, but simply smudged them with my finger.

Getting close to a model allows for quite detailed drawings. In this one I wanted to record the direction of the hair growth around the head, which would be useful knowledge for future animal drawings.

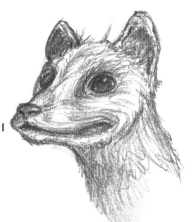

The texture of the fur is all-important here, impressionistic rather than closely observed. I drew with the edge of a soft pencil and then smudged the hair with my finger for that fluffy look. Then I worked into the face with the tip of the pencil for contrasting hard-edged and angular marks.

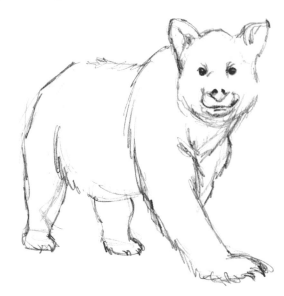

It should be second nature to you by now to draw a textured line where the subject demands it. But, of course, the marks will not be the same for the whole outline, as there will always be parts where the fur is shorter or lies flatter.

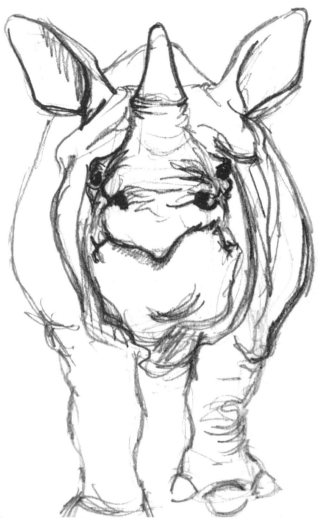

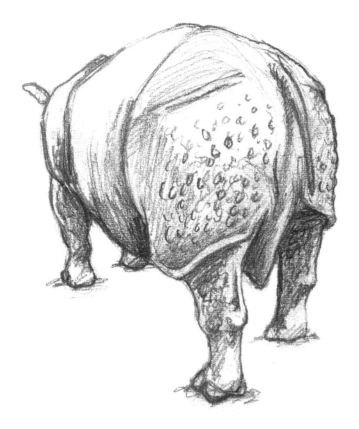

Looking at photographs and illustrations of animals, you'll soon realize how limited the angles of view are. In a museum, I was able to choose my views of this rhino, resulting in an unusual head study and a rear view. In the latter I tried to capture an impression of the texture, through a combination of mark-making and shading.

To draw the heavily textured skin of this tortoise, I used a very soft blunted pencil, pressing down quite hard around each scale for strong definition. I then shaded over more lightly to show the play of light over the deep relief of the surfaces.

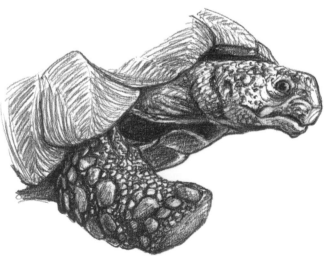

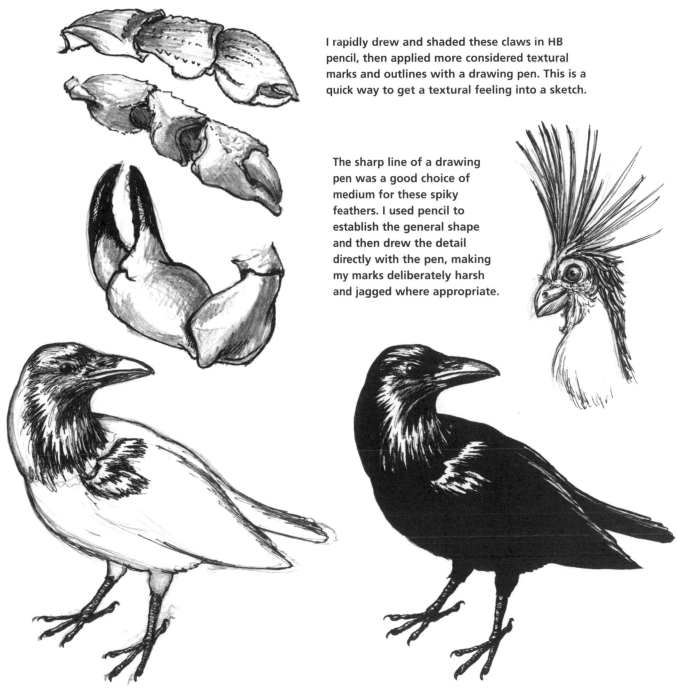

I rapidly drew and shaded these claws in HB pencil, then applied more considered textural marks and outlines with a drawing pen. This is a quick way to get a textural feeling into a sketch.

The sharp line of a drawing pen was a good choice of medium for these spiky feathers. I used pencil to establish the general shape and then drew the detail directly with the pen, making my marks deliberately harsh and jagged where appropriate.

In a dim display case, most of this crow was little more than a silhouette except where the head and shoulders caught the light. I drew it roughly in pencil, marking the direction of plumage, and then drew around the highlights and outlines in drawing pen. I recorded enough detail to enable me to finish this picture later.

Back at home, I erased the pencil marks and then blocked in the solid black with brush and ink. A drawing doesn't need much textural mark-making to convincingly suggest the texture of the whole.

A pet portrait

When you know an animal well, you recognize its individual character. Drawing a beloved pet, then, is a slightly different matter to drawing other animals because you are depicting individual traits alongside the general characteristics of the species. For this portrait of my neighbour's spaniel, I used a technique known as dry brushing. It requires no special equipment, just a pencil, some ink and a brush with stiff bristles – I used a No. 2 hog's hair filbert.

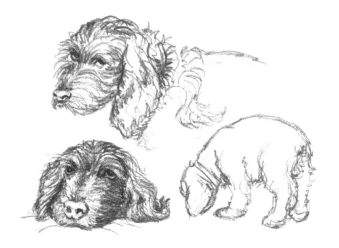

To begin with, I made a dozen or so quick sketches. I was keen to jot down the waves of his fur and his distinctive sleepy eyes. Once he was comfortable with my presence, I took some digital photographs to work from for the finished piece. I was hoping for a natural look, but he kept posing in his begging position, which seems to capture something of his playful spirit.

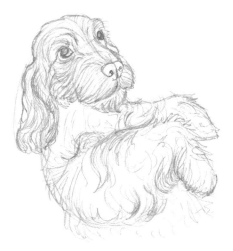

STEP 1

I put my photographs on screen and was ready to start work almost immediately. I chose a fairly stiff cartridge paper that wouldn't buckle too much, and drew the rough shapes of my chosen photograph, taking care over the placement of the eyes and nose.

STEP 2

As I developed the drawing, my main aim was to set down the direction and waves of the fur. There's little else in the picture, so I had to draw the fur convincingly. I also wanted to establish a strong outline.

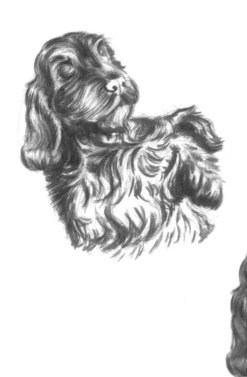

STEP 3

The secret of dry brushing is to have very little ink on the brush. This means that each bristle leaves its own trace, emulating the dog's hairs. I used ordinary drawing ink slightly watered down and, after dipping the brush, dried it on tissue paper. I tested the flow of ink on scrap paper to check that it left the desired hairy mark, then used it to draw the darker areas of fur, always following the hair's natural direction of growth.

STEP 4

With a fine watercolour brush, I painted the detail of the eyes and nose. When the ink was dry, I erased all my pencil marks. I mixed a much weaker ink solution and broadly washed on the areas of shade. I wanted some parts to be less shaded, so I dabbed those areas with a tissue to partially lift off the ink before it dried. I was also careful to leave some areas of white on the dog for a full tonal range.

STEP 5

I generally refined the picture, mixing a darker solution of ink and restating some of the deeper shadows in the fur. I also washed on more shade where it was needed. To finish off, I used white ink to add highlights to the nose and to correct a few errant marks around the outline of the face.

Animal interpretations

Our animal drawings thus far have been based on depicting animals in a naturalistic way, not necessarily realistic, but always with an eye on natural proportions and attributes. However, animals have always offered the artist enormous scope for interpretation for the purpose of design, illustration or pure artistic invention.

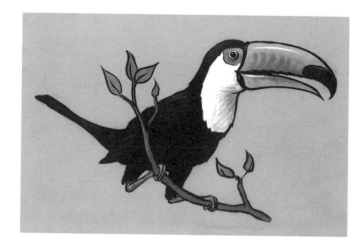

Strong images can come out of simplifying animals in terms of form, texture or mode of rendering, stripping away superfluous detail. I painted this toucan on toned paper in solid black ink, with a few touches of watercolour. I then applied pure white ink for the white plumage and highlights.

The cheetah is simpler still. I used a felt-tipped drawing pen for the outline, which I thickened in places to emphasize certain contours. Leaving the hindquarters unfinished and adding movement lines creates a sense of speed.

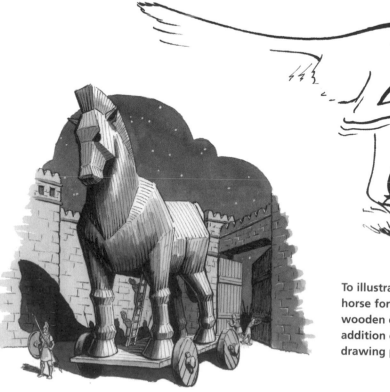

To illustrate the myth of the Trojan horse, I made the horse form angular and marked it to suggest its wooden construction. A low viewpoint and the addition of some figures emphasizes its scale. I used drawing pen and watercolour wash.

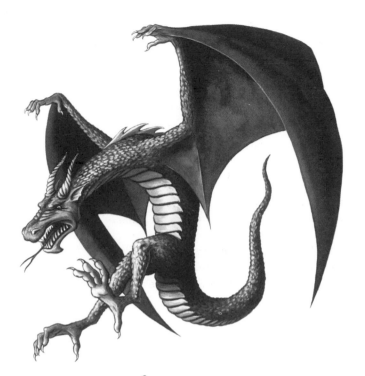

It's a rewarding challenge to design an animal that doesn't exist and to depict it so that its articulation is credible and dramatic. This dragon was designed from photographs and sketches of reptiles, bats and eagles. It is rendered entirely in ink, used at different degrees of solution and applied with soft watercolour brushes.

It's not that easy to make a duckling look ugly. I had to change many aspects of the face and texture and give it an awkward posture to ensure that it looked intentionally ugly and not just badly drawn.

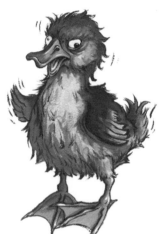

Although its proportions are fairly naturalistic, there's something distinctly human about this rabbit. Endowing animals with human characteristics is a staple of illustration, animation and cartooning and is very frequently used for humour or pathos.

The human elements of these illustrations are reinforced with the addition of clothing, expression and action. It can be fun to give animals human qualities, but I always try to maintain a strong sense of the animal's own characteristics.

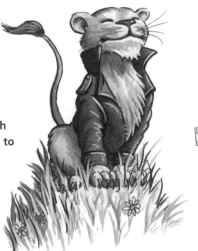

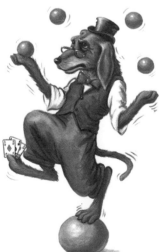

Animal cartoons

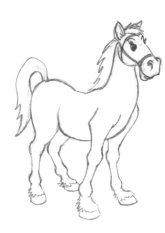

With their interesting shapes and qualities of charm, ferocity, grace and humour, it's no surprise that animals feature strongly in the canon of cartooning. At the heart of an animal's transformation into cartoon caricature is anthropomorphism. We naturally project human characteristics onto animals – the wise owl, the cheeky monkey – and the cartoonist's job is to reinforce these perceptions and to create new ones.

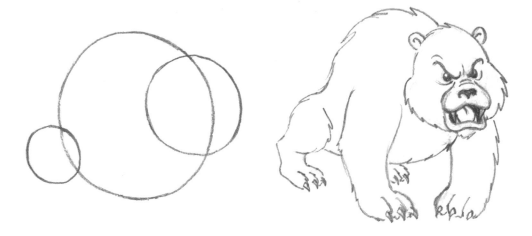

This is a fairly straight caricature of a horse. The proportions remain generally naturalistic, but the form is simplified and streamlined. Changes to the head, the enlarged eyes and mouth, make the animal more cute and appealing and also flexible enough for human facial expressions.

In cartooning, some standard body shapes are used as shortcuts to personality types. This bear is designed to be powerful and fierce and demonstrates the typical cartoon build of such characters. The head, shoulders and forelegs are dramatically enlarged, while the rear end is reduced in size. The body type is based around circles and is often used for such beasts as bulls, apes and big cats.

The natural body types of animals can be used as the basis for their characterization. This cheetah is made extra lean and its natural curves are exaggerated. The large teeth and a maniacal grin give him a personality.

The large head and short legs of the pig are exaggerated and his body is simplified to a round oval. The face is designed for friendliness and jollity.

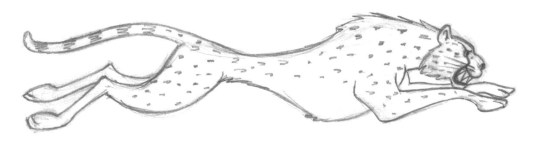

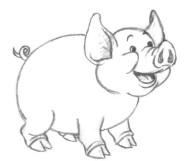

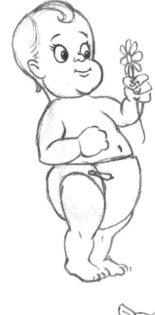

Another common body shape used for cute characters is based on the proportions and features of cartoon human babies. They are usually about two and a half to three heads tall. The body is a pear shape, which dips in at the spine and pushes out at the belly. The same proportions can be used to design virtually any creature by merely changing the features and details.

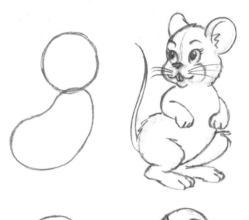

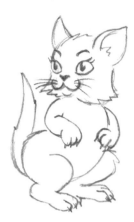

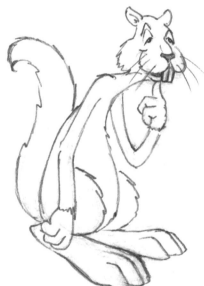

For some cute animals, particularly birds, it's a good idea to invert the pear shape to reflect their natural body shape – but the proportions and the curve of the spine remain unchanged

Any animal can be adapted to be dopey, even the normally nimble and quick-witted squirrel. Dopey characters often have goofy teeth, large feet and sleepy eyes. For that round-shouldered, pot-bellied look the pear shape curves the opposite way and the head hangs forward off the shoulders.

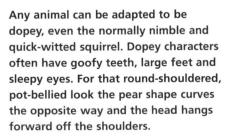

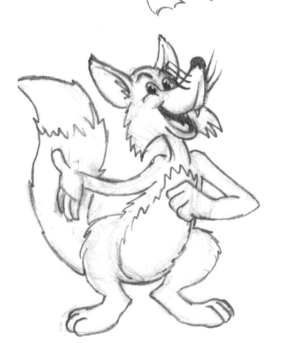

The wise-guy cartoon type is an elongated version of the cute character shape. They are usually lithe and animated with close-set eyes. You'll notice that these and many other types stand on two feet, like humans.

Index

Index